Shoes

A Lexicon Of Style

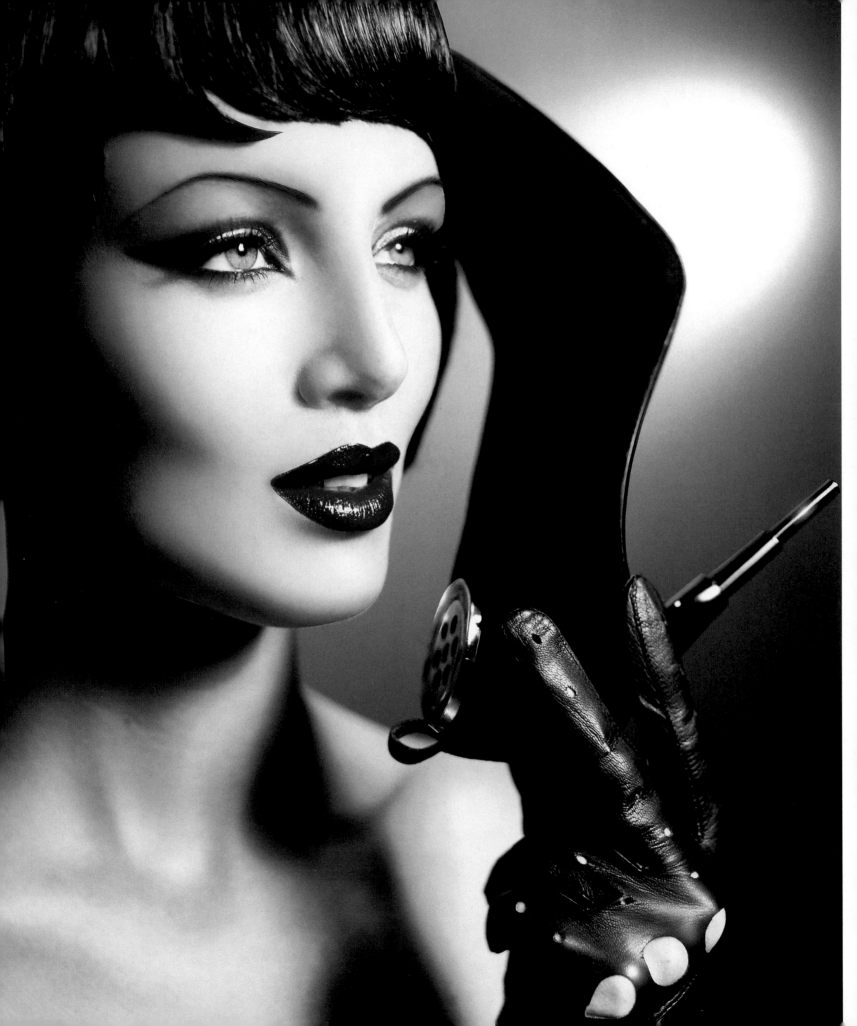

Shoes
A Lexicon Of Style

WRITTEN BY VALERIE STEELE

SCRIPTUM EDITIONS

LONDON · HONG KONG

This book is for Laird because she loves shoes

Publisher *Beatrice Vincenzini*

Executive Director *David Shannon*

Editorial Director *Alexandra Black*

Art Director *David Mackintosh*

Project Coordinator *Francesca Pisani Massamormile*

Picture Researcher *Laird Borrelli*

First published in the UK by Scriptum Editions

Created by Co & Bear Productions (UK) Ltd.

Copyright © 1998 Co & Bear Productions (UK) Ltd.

Printed and bound in Novara, Italy by Officine Grafiche de Agostini.

First edition

10 9 8 7 6 5 4 3 2 1

ISBN 1-902686-00-4

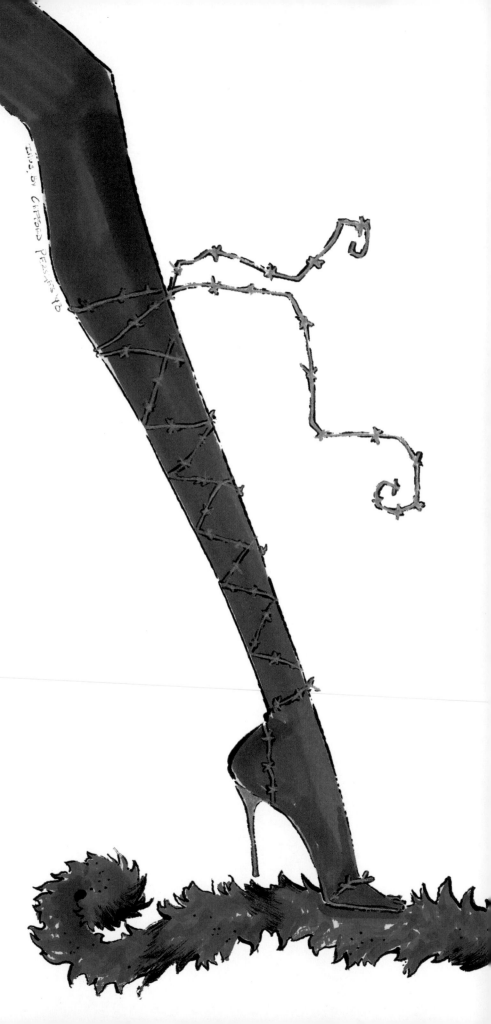

CONTENTS

introduction

"The more shoes I get, the more I want."[1]

Amy Fine Collins

There is a bit of Imelda Marcos in many women. How many pairs of shoes do *you* own? None of us really needs more than one or two pairs of practical shoes. But when it comes to shoes, does the word *need* mean anything to you? Research indicates that the average American woman has twelve pairs of shoes in her closet, more than twice as many as the average man.[2] However, there are many women who have over 100 pairs of shoes ... and counting.

Shoes are better than sex, claims cartoonist Mimi Pond. "Shoes are totems of Disembodied Lust. They are candy for the eyes, poetry for the feet ... They stand for everything you've ever wanted." Buying shoes, she added, is "the highest form of shopping."[3] Shoes, or at least certain shoes, also exert an almost Pavlovian influence on men. "Women may scour the world for the shoes of their hearts' desire, but it's men who swoon at their feet," writes Jody Shields.[4] There is more than a bit of the shoe fetishist in many men. As Geoff Nicholson puts it in his brilliant novel *Footsucker*: "What a good shoe crucially does, must do, is *reveal* the foot, enhance and display it, offer a frame and a setting for it. And this is precisely the nature of my erotic obsession. I crave the intersection of art and nature, of the human body and the created object, the foot and the shoe, flesh and leather ..."[5]

Shoes: A Lexicon of Style is not your ordinary history of shoes. This book focuses on our attitudes toward shoes, which are surprisingly complicated considering that shoes have an apparently obvious function — to protect the feet. In reality, of course, shoes serve a variety of other functions as well, from conveying status and enhancing sex appeal to indicating membership in a

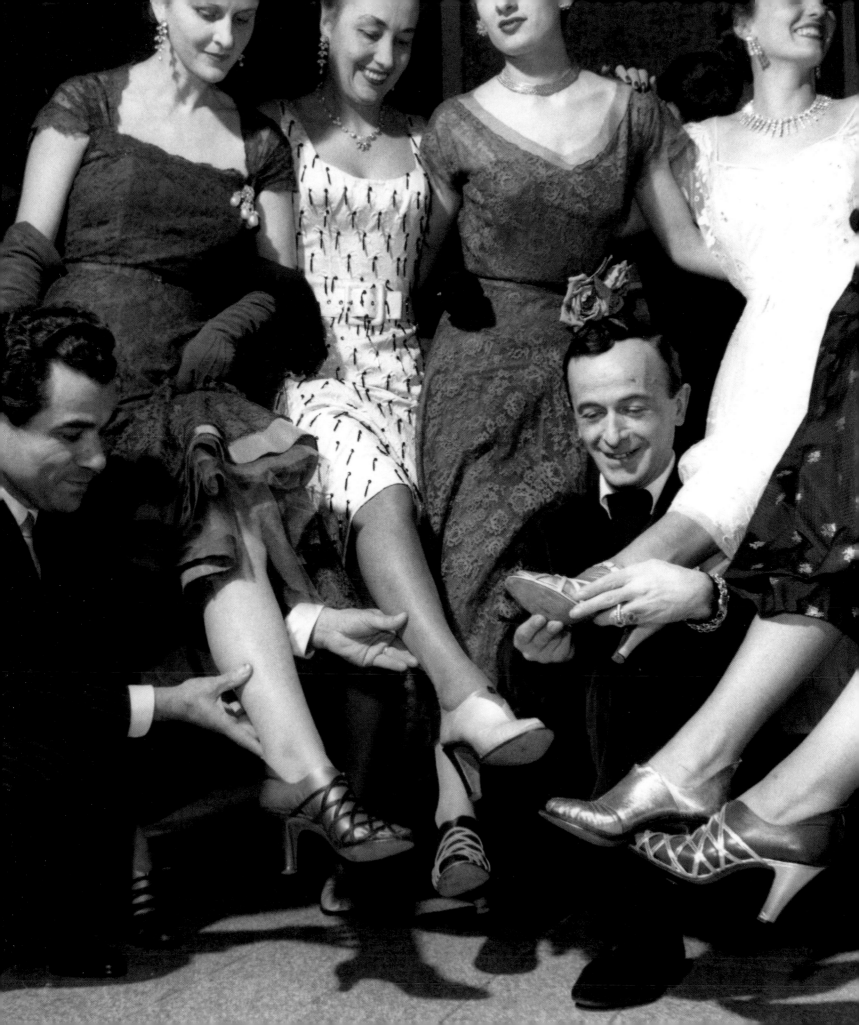

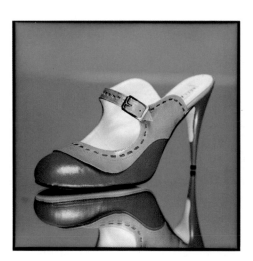

ABOVE A stiletto, mule, pump, Oxford or Mary Jane? Bella Freud's

shoe mixes different style categories to create a new variation.

particular "style tribe." You will find no pictures of ancient Egyptian sandals or Renaissance platform shoes in this book, which focuses, instead, on modern shoes. Unlike fashion magazines or forecasting reports, which just tell you which styles are currently trendy, we will explore the social and psychological significance of various kinds of shoes.

Despite the title, *Shoes: A Lexicon of Style* is not intended to be a technical lexicon, explaining the terminology used by professionals in the shoe industry. Rather, it is for the ordinary person who wears and loves shoes, and who is reasonably familiar with most of the shoe terms in common usage. Yet even the most basic terms can be confusing. Shoe terminology is complicated and every book provides different definitions. Thus, according to the popular literature, pumps are essentially the same as court shoes — and under both names have been described as "the little black dress of shoes."[6] But when I happened to ask my teenage son if he knew the difference between pumps and court shoes, his answer demonstrated how language evolves: "Pumps are the athletic shoes that you pump up," he answered confidently, "and you wear court shoes on a basketball court."

There are apparently only eight basic shoe designs: 1) pump; 2) Oxford; 3) sandal; 4) boot; 5) moccasin; 6) mule; 7) monk strap; and 8) clog. According to renowned shoe scholar William Rossi, the thousands of "new" shoe styles that appear every year are only variants of these eight. Thus, "most lace-up shoes are simply off-shoots of the Oxford; shoes with instep straps are merely pumps with straps attached; a slingback is part of a pump or sandal; a men's slip-on

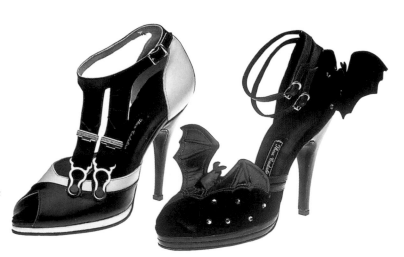

is actually a pump; platforms or thick-soled shoes are essentially clogs; and backless shoes on high heels are updated versions of the ancient mule."[7]

Other writers have divided shoes into slightly different categories. *A Century of Shoes: Icons of Style in the 20th Century*, for example, is arranged according to the following chapters: 1) court shoes and pumps; 2) slippers and mules; 3) evening shoes; 4) stilettos; 5) sandals; 6) clogs, platforms and wedges; 7) brogues; 8) loafers and moccasins; 9) boots; and 10) functional and cult. Significantly, this last category included training shoes, as well as Dr. Martens and other "cult" styles.[8] *Shoes: A Celebration of Pumps, Sandals, Slippers & More*, Linda O'Keeffe's best-selling book, has a slightly different organization: 1) the sandal; 2) the heel; 3) slippers, including mules; 4) pumps; 5) the sensible shoe; 6) the boot; 7) *chopines* and platforms; 8) fetish and lotus shoes; and 9) one-of-a-kind art shoes.[9] Meanwhile, my friend Mary Trasko chose to organize her book *Heavenly Soles* chronologically, marching decade by decade through the twentieth century. Naturally, after all this, I gave considerable thought to my own arrangement of chapters. Ultimately, I decided to focus, not on the history or construction of shoes, but rather on the way we perceive shoes today. I decided to devote my first chapter to high heels, on the grounds that this is one of the first criteria women — and men — consider when thinking about shoes. I realize that heels are not a "kind" of shoe, but the controversy about high heels made it seem imperative to address the subject at length, exploring why some women love heels — and others hate them.

ABOVE These tongue-in-cheek styles — the garter belt shoe and the vampire bat shoe — designed by Thea Cadabra-Rooke evoke the sexual personae of the sex kitten in lingerie and the Goth girl in her trademark black.

ABOVE & OPPOSITE Shoes say more about the wearer than almost any other item of apparel. They can indicate refined taste and nonchalant chic, as in Nancy Geist's pastel rendering of a slender mule, or, like Vivienne Westwood's red patent high-heel pumps, they can break all the rules of "respectable" women's footwear, positively screaming, "look at me!"

In the second chapter, I wanted to draw attention to the way we regard some kinds of shoes as "feminine" and others as "masculine." Yet why should an Oxford be considered any more masculine than a pump? The third chapter is devoted to sandals, which are the closest thing to being barefoot. The fourth chapter deals with boots, which are the ultimate power footwear for the Fashion Commando. It seemed to me that boots and sandals deserved chapters of their own, because we think of them differently than other shoes. No one goes to the shoe store, thinking, "Hmm, I'm *either* going to buy a pair of boots *or* some sandals, I can't decide which." By contrast, I decided that platforms could be treated as a type of sole, which could be discussed in more than one place, although mostly, as it turned out, in the chapter on sandals. Finally, I was sure that sports shoes were significant enough to warrant being the focus of the fifth and last chapter, because these are the *only* shoes that many young people wear. Yet despite the ubiquity of athletic shoes, it was clear that other kinds of shoe styles are also proliferating. Indeed, we are in the midst of a veritable shoe Renaissance.

"Apart from pure fashion trends, there is a business explanation for the explosion of footwear diversity," observes Jennifer Steinhauer of *The New York Times.* "Many apparel companies, as part of their maxed-out global expansions, have begun adding shoes to their collections, sending out new shoe looks more often than fresh hemlines, which encourages stores to stock a myriad of styles."[10] I must confess that I approached this book less as a scholar than as a shoe enthusiast. What a great excuse to go shopping and call it research.

chapter one High Heels

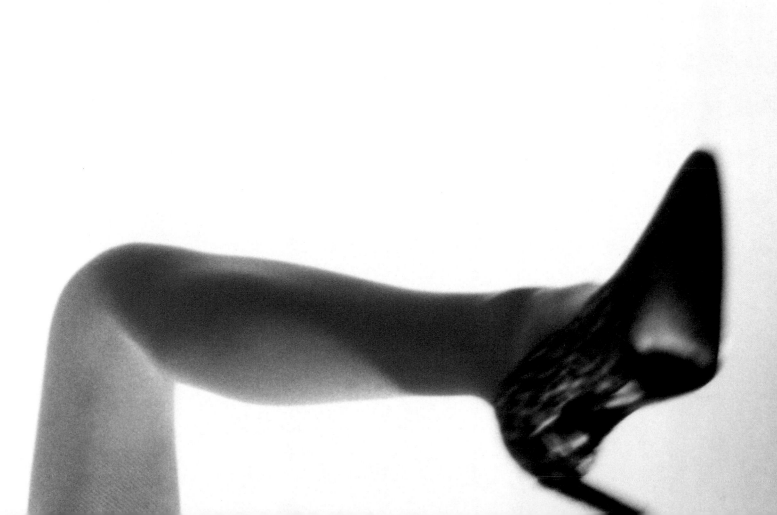

high heels

"When women ask me about heels, I say, try a pair on.

If you don't see the magic, stick to Reeboks."[1]

Manolo Blahnik

ABOVE The vertiginous heel of this pump by Free lance hints at the pleasures and dangers of wearing high heels. The leopard print presents the wearer as sexual predator. OPPOSITE Helmut Newton's image of Nadja Auermann in Chanel shoes speaks of both the crippling incapacity of the most severe heels and their erotic allure.

When it comes to shoes, women generally fall into two groups — those who love heels and those who hate them. High heels are associated with sex, status, femininity, and fashion. But many women find them uncomfortable to wear, and feminists tend to interpret them as symbolizing female subordination. Doctors, meanwhile, warn that high heels can cause stress fractures, deformed feet, sprained ankles, and back problems. Yet, despite all the criticism, high heels remain popular.

"It's hard not to be sexy in a pair of high heels," says Tom Ford, the designer at Gucci who has been responsible for launching some of the most vertiginous steel heels of the 1990s.[2] Many other people agree that heels have the power to transform even the most practical woman into an elegant *femme fatale*. Once at a shoe store, I kicked off my loafers and slipped on a pair of high heels. A man walking past paused and noted approvingly, "*Now* you're sexy." But just what is so sexy about high heels?

High heels are the prime sartorial symbol of femininity. "I adore girls in high heels," says photographer Mario Testino. "They can ... wear high heels, and we can't. It's the one thing that differentiates men and women."[3] Actually, in the past both men and women wore high heels. Louis XIV, for example, wore red high-heeled shoes, which were a symbol of nobility. As men's fashions became more subdued, however, during the late eighteenth and nineteenth centuries, high heels were increasingly associated with femininity. As a result, in modern times they have assumed an immense erotic significance for many men.

One reason high heels are considered sexy is because they produce an erect

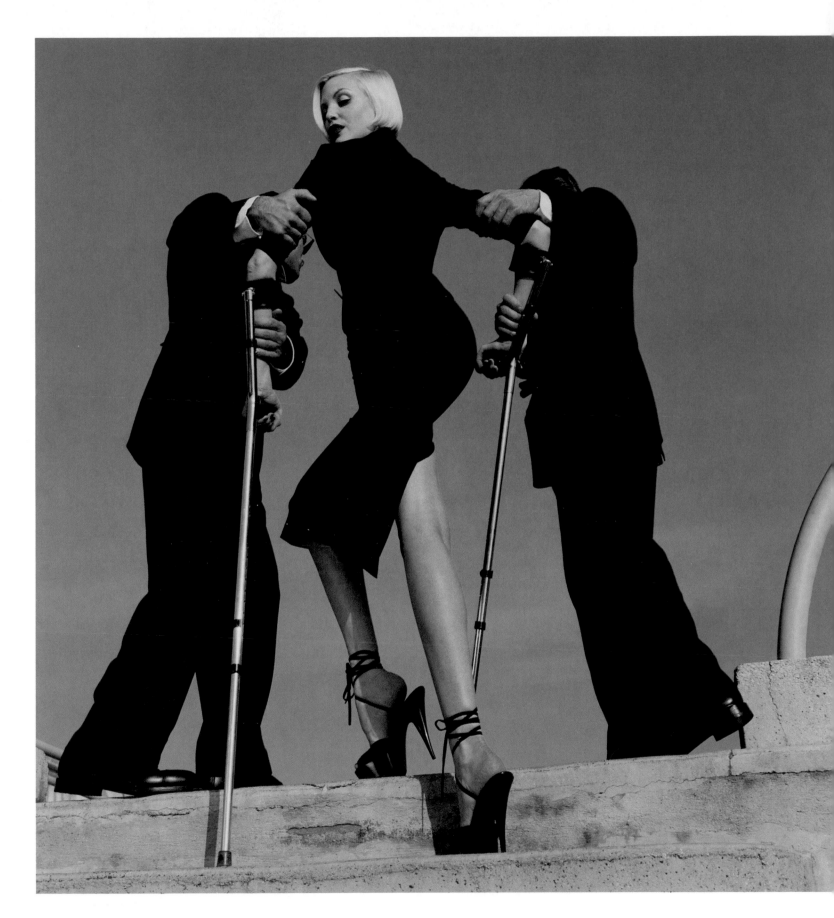

OPPOSITE There is no denying the erotic pull of these stilettos by Manolo Blahnik. The thin black straps encase the taut muscles of the leg as they work to keep the ankle erect.

BELOW Ferragamo was constantly experimenting with heel shapes and structure to push shoe design to its limits, as in this model dating from 1930 for a heel of brass layers.

ankle and an extended leg. The arch of the foot is radically curved — like a ballet dancer on point. The entire lower body is thrown into a state of tension resembling that of female sexual arousal. By tilting the pelvis, high heels cause the lower back to arch. The breasts thrust forward, and the derrière protrudes. As the fashion model Veronica Webb says, "High heels put your ass on a pedestal — where it belongs."[4]

Even before she moves, a woman in high heels has transformed her body. She looks taller and thinner. Her secondary sexual characteristics are flagrantly emphasized, while her legs — the pathway to the genitals — are as long as Bambi's. As the leg muscles tighten, the calves appear shapelier. And because they are at an angle, her feet look smaller and more pointed.

The erotic appeal of high heels cannot be separated from their association with the physical attributes of "femininity." According to the fetishist magazine *High Heels*, "Flat is … a dirty word! And you'll find nothing 'flat' in this issue of HIGH HEELS except the tummies of the models — who wouldn't be caught dead in 'flats,' who all have FULL bosoms, CURVY torsos, ROUND hips, LITHE legs, and … HIGH HEELS!"[5]

High heels also change the wearer's gait. "Your body balances differently if you are wearing two-inch heels or six-inch heels," observes Manolo Blahnik, master of the skyscraper heel. "You can see this especially with mules, because you haven't got support at the heel, so you have to contort yourself when you walk. Thinkof Marilyn Monroe!" Balanced on narrow stilts, a

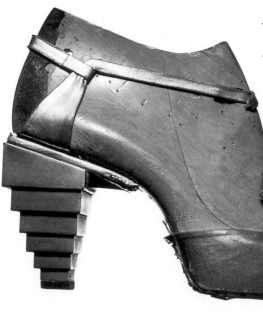

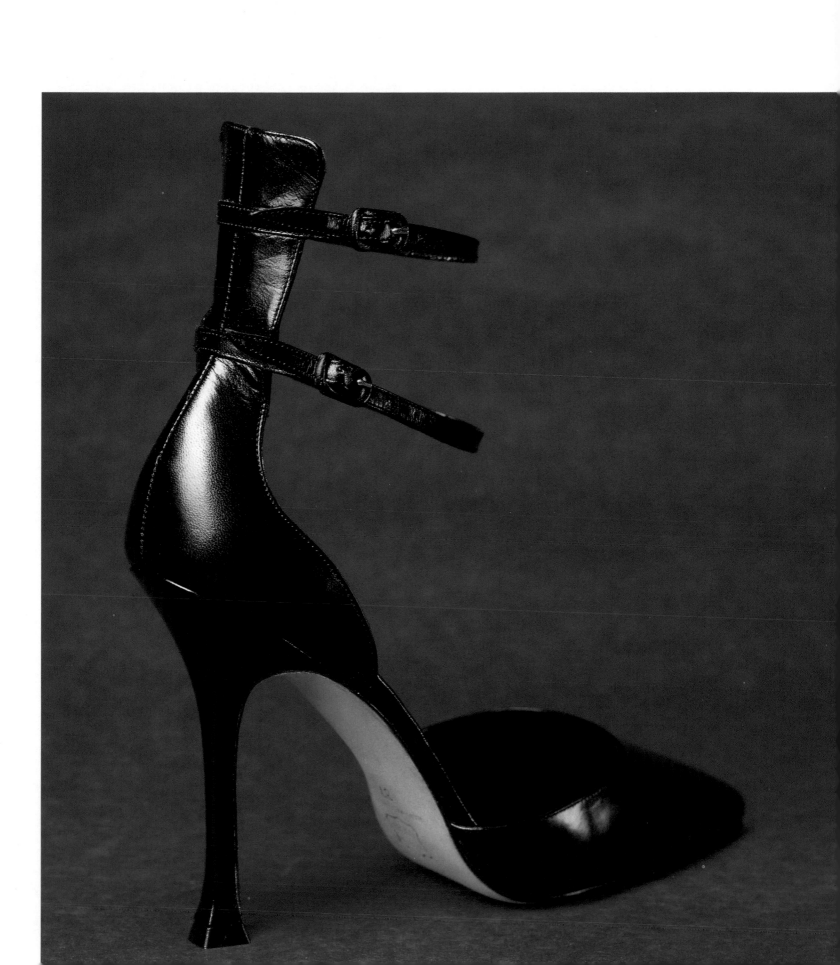

woman wearing high heels moves with an artificial grace, hips and buttocks swaying. As Ann Magnuson put it:

> *The bones in my ankles cracked ... and my Achilles tendons bent backward ... Hobbling down the avenue, I became acutely aware of ... my body. My breasts jutted forward, while my back was severely arched. My ass felt bigger than a Buick, and my thighs, or rather my flanks, swung back and forth like a couple of sides of beef ... Are these shoes disempowering? Do they enslave us? Are we rendered helpless by wearing them?*
>
> *The answer is yes! Yes! Of course! What other point would there be in wearing them!*[6]

ABOVE Most women have adopted the uniform of the suit in order to compete in male-dominated corporate culture, but some find an alternative source of sartorial power in high heels like these teetering black Mary Janes by Sergio Rossi.

Yet the heels also made her feel "mythically omnipotent." Wearing spike heels, she reported, "I felt a surge of power, knowing that I could lay waste to any man I chose to destroy." She fantasized about being a dominatrix: "Down on the floor, you worm! I said *now*, you worthless CEO!"

High heels are not a type of shoe. They are a type of *heel*, which can be attached to a variety of different shoes — pumps, sandals, mules, boots, even sneakers. The classic high heel raises the back of the foot about three inches off the ground (measuring from the inside of the heel). But for many people the term "high heels" means something a bit more extreme — more like the stiletto heel. The stiletto tends to be both higher and thinner than the average

OVERLEAF Performance artist Vanessa Beecroft exhibited a room full of near-naked women posing in high heels, recording the event with grainy, close-up photographs.

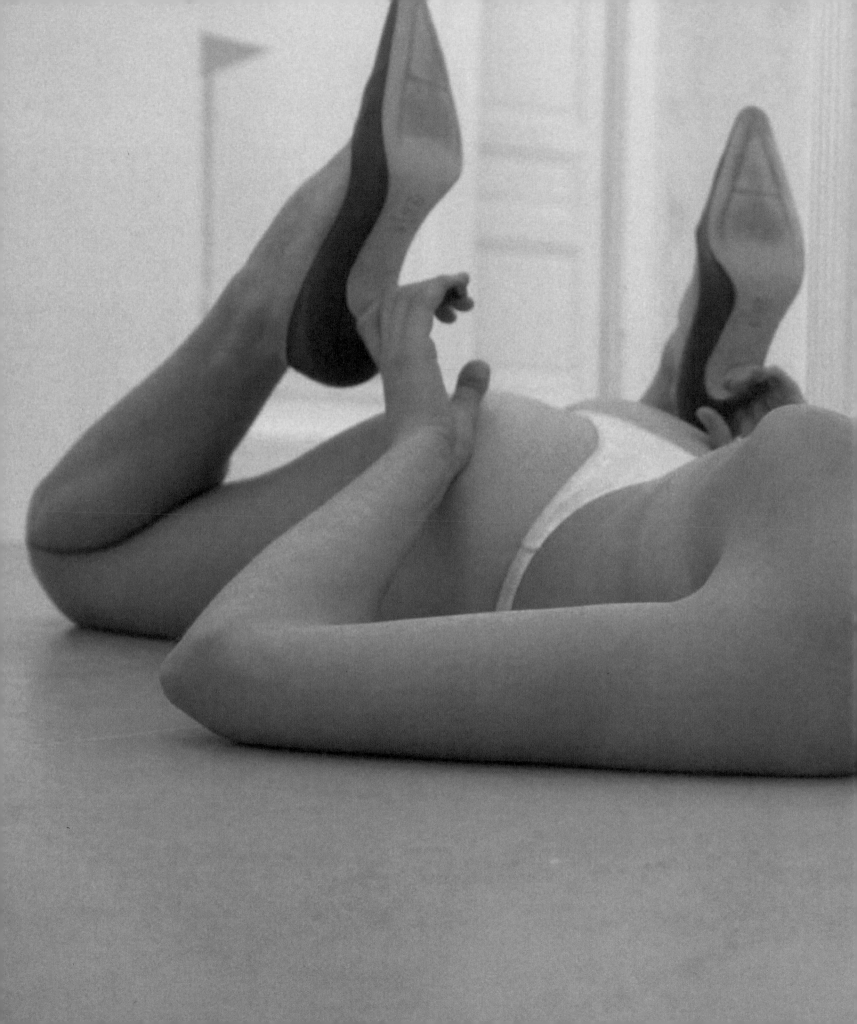

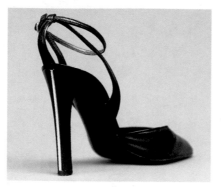

ABOVE RIGHT The heel of this ankle-strap stiletto designed by Charles Jourdan in the late 1970s reveals a knife-edge sliver of metal that hints at the origin of the very word "stiletto."

BELOW A blueprint from the Ferragamo studio in Florence. The Italians are credited with engineering the stiletto heel.

high heel. It has the surface area of a thumbtack and is usually at least four inches high, sometimes as much as seven inches.

Also known as the spike or needle, the stiletto is the quintessential high heel, beloved by shoe fetishists. High-heeled shoes have existed for centuries, but the technology of creating stilettos was only perfected in the 1950s, when Italian shoemakers inserted a metal stick which extended almost the full length of the heel to prevent it from breaking. As the name implies, these are heels capable of piercing or penetrating, and, in fact, stilettos were sometimes banned from airplanes and public buildings because of the damage they caused to floors and carpets. Doctors warned that they could also cause medical problems. Yet stilettos became immensely popular.

Throughout the 1950s and early 1960s, stilettos were associated with sex symbols like Marilyn Monroe and Jayne Mansfield. "I don't know who invented the high heel," said Marilyn Monroe, "but all women owe him a lot." Betty Page, the queen of pin-ups, was frequently photographed posing in extremely high stilettos. Indeed, she made at least one stag film, *Betty Page and Her High Heeled Shoes* (1954), which was entirely devoted to the erotic allure of heels. Although stilettos fell out of fashion in the late 1960s — to be replaced by flats, and subsequently by platforms, sensible pumps and athletic shoes — very high heels became fashionable once again in the 1990s.

"Can a pair of skyscraper heels turn you into a sex goddess for the night?" asks fashion journalist Julia Mottram. In the name of research, she dons a pair of stiletto "f**k me shoes" and heads off for an upmarket bar in London where

she hopes the "clientele … will appreciate that my shoes are on the very cutting edge of fashion (and won't just think I'm a tart)." The result: "Suave men stare at my feet in what can only be described as an excited manner."[7]

What (else) do high heels "say" about the women who wear them? According to an article in *The New York Times*, "High heels are for those who pay other people to do their walking for them."[8] Indeed, very high heels are popularly referred to as "limousine shoes," with the implication that they are worn only by ladies who don't actually have to walk anywhere. "I hate that, I really do," says Manolo Blahnik. "What is the meaning of this limousine shoe? Like you're totally an invalid and you can't walk,

or what?" Of course, you can walk, but as Blahnik himself emphasizes, "People walk differently in high heels … You walk in a sensuous way. Your body sways to a different kind of tempo."[9]

According to Blahnik, "Women who love high heels used to be like a tribe. There were women who wore high heels all of the time, and then there were other women who always wore flats. Now that line is being crossed. Many women wear tiny heels during the day, and then for evenings and glamorous occasions, they wear very high heels."[10] Yet although high heels are no longer associated so clearly with a certain feminine type, they have

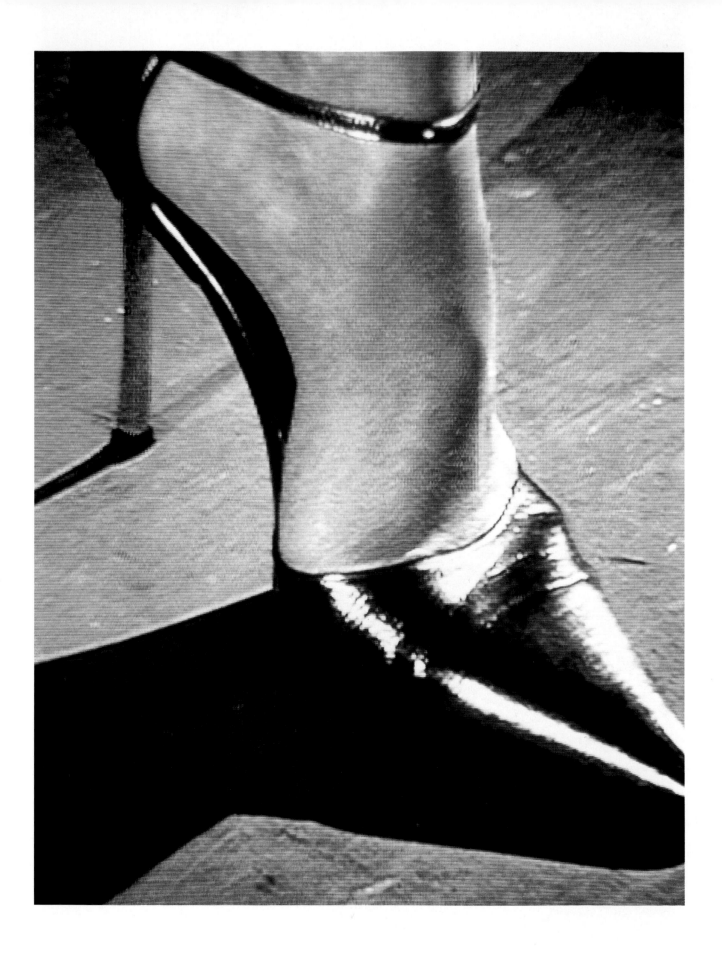

OPPOSITE Gucci's metal-heeled stiletto — photographed by Mario Testino in the style of grainy, surveillance-video footage — embodies the view of many shoe fetishists that high heels transform the wearer's foot into a dangerous weapon.

recently acquired a new constituency: executive women.

"High heels connote a level of authority," argues Simon Doonan, the creative director of Barney's New York.[11] Certainly, expensive shoes are an obvious status symbol, and high heels require much greater care than flats. (At the very least the bottom tips need frequent re-placement.) High heels also literally elevate the wearer. Moreover, high heels were historically associated with the aristocracy, and we still talk about people being "well heeled" or "down at the heels." In point of fact, however, shoes are the most affordable high-fashion fix for many women. Only a few people can buy a new Gucci suit every season, but the latest Gucci shoes sell out immediately.

ABOVE Likewise, these ultra-chic stilettos by shoemaker Jimmy Choo appear both dainty and deadly.

The erotic literature on shoe fetishism often associates high heels with the image of the "phallic woman." This ambiguous figure combines attributes associated with both ultra-femininity and hyper-masculinity. In particular, she has the power to dominate and even penetrate her submissive male partner. The shoes she wears are delicate in shape, but they also carry a dangerous weapon. The high heel is "a symbol of love" — and also "domina-tion," declared the magazine *High Heels*. Clad in a high-heeled shoe, "the foot becomes a mysterious weapon which threatens the passive male, who glories in being so conquered."[12]

"I like high heels," the photographer David Bailey once said. "I know it's chauvinistic. It means girls can't run away from me."[13] Because of statements like this, many feminists have interpreted the stiletto as "symbolizing female

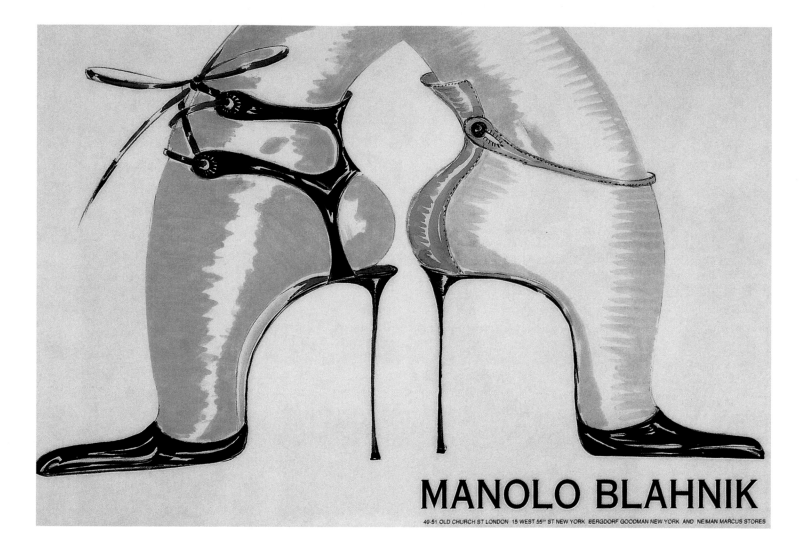

MANOLO BLAHNIK

49-51 OLD CHURCH ST LONDON 15 WEST 55TH ST NEW YORK BERGDORF GOODMAN NEW YORK AND NEIMAN MARCUS STORES

ABOVE Provocative, sharp-as-a-tack stilettos by Manolo Blahnik

often seem almost too delicate to wear.

OPPOSITE Helmut Newton's photograph of a stockinged woman

wearing Valentino evening shoes emphasizes the phallic symbolism

of the heel and the erotic allure of the leg.

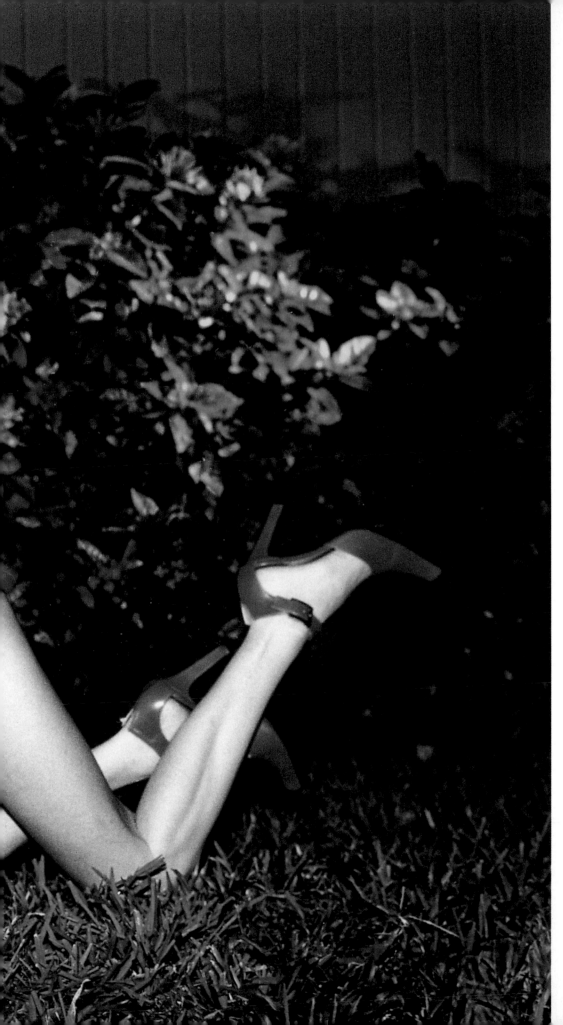

LEFT The model for Cesare Paciotti's campaign mimics a pornographic pose, buttocks and feet elevated to create an invisible line drawn between the genitalia and the stiletto heel. Photograph by Luis Sanchis.

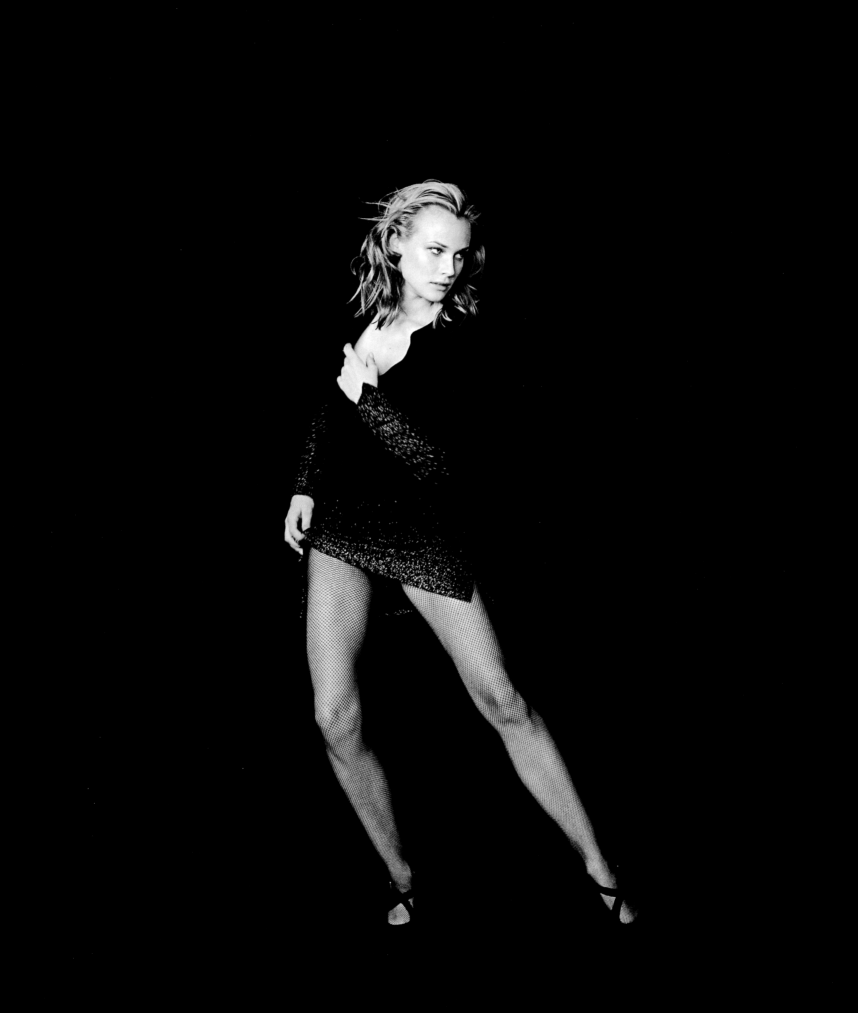

subordination."[14] Yet fetishist pornography tends to emphasize female sexual power, with titles such as *High-Heeled and Dominant*, *High-Heeled Sluts*, and *Spikes Domination*. One must, of course, distinguish between the perception of female sexual power and the reality that high heels can impede women's mobility and freedom. Nevertheless, it is clear that the meaning of high heels depends very much on the specific context, and they cannot simply be reduced to objects of female enslavement.

There is the hardness of the heel, and also the woman's precarious balance. Just as she stands on shaky footing, so also is the meaning of high heels ambiguous. As a recent study of pornography points out, "The spike heel elongates the leg, but it rezones the body for pleasure in another way as well. The pornographic model is not typically depicted with lower limbs extended; more often than not, her legs are bent at the knees to point the foot and heel at the genital region and thus create a triangle. The framing of the legs and heels in this way invites the movement of glances from genitals to heels and back again. Alternatively, the heel is poised in the direction of the camera" — along with the rear end.[15]

In recent years, the iconography of sexual fetishism and sadomasochism has increasingly infiltrated popular culture. Gucci's advertising campaign for Fall/Winter 1997, shot by Mario Testino, turned us all into "voyeurs, squinting at grainy surveillance footage," argues journalist Barbara Lippert, describing one image of a man's chest with "a red stiletto planted right between the nipples." Gucci's stilettos (which sold out everywhere) she calls "push-up bras

OPPOSITE The meaning of high heels is ambiguous. As this campaign by French shoemaker Séducta suggests, the high heel can be viewed as empowering rather than necessarily debilitating. **ABOVE, LEFT & RIGHT** Fetishistic iconography goes mainstream. The striking image of Sergio Rossi's red pump endows the shoe with a personality and life of its own, while Franco Fieramosca's grey stiletto borrows the bondage straps of the fetish shoe.

OVERLEAF Manolo Blahnik's pump demonstrates the power of shoes to challenge and even disturb. His clever design resembles a zebra's hoof with its stripy coat, square toe, and blood-red lining.

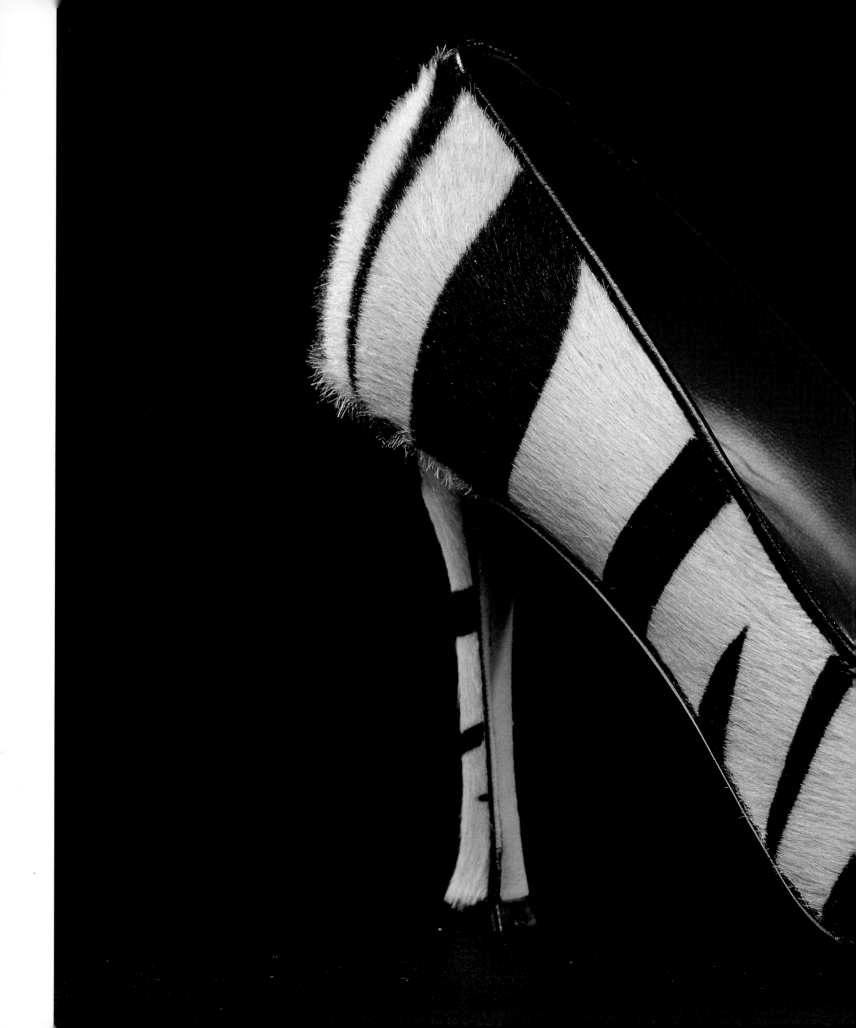

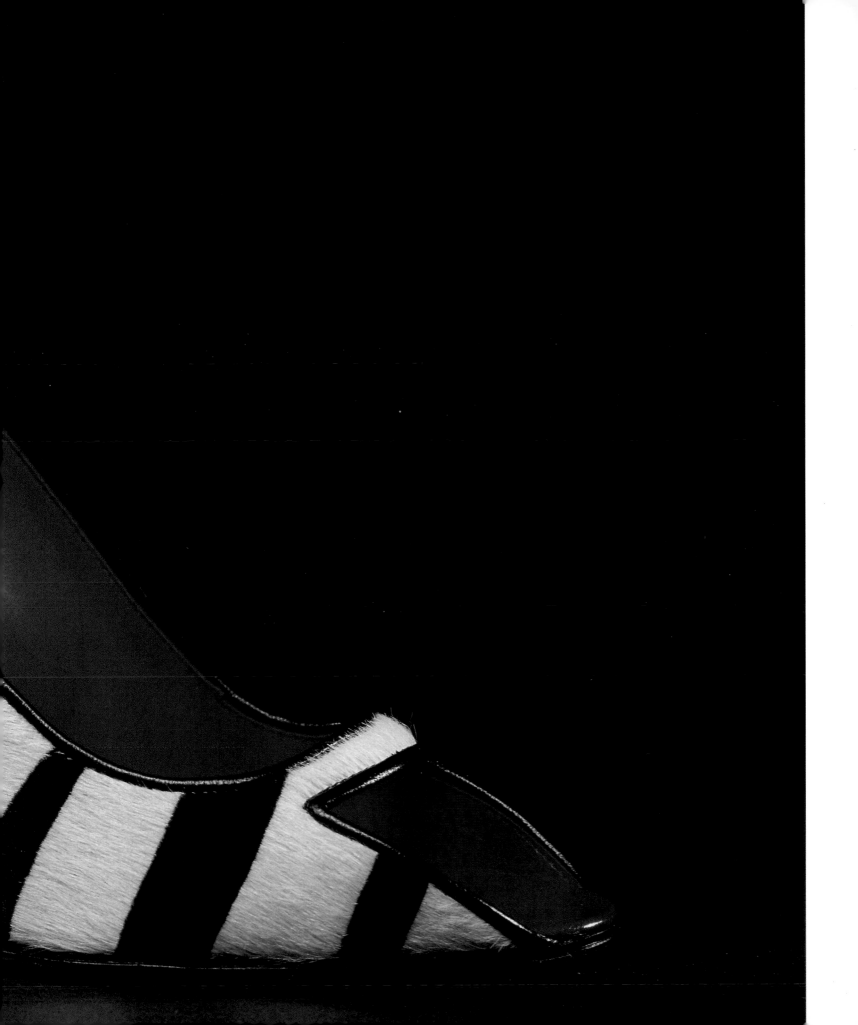

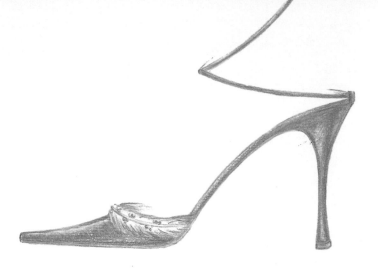

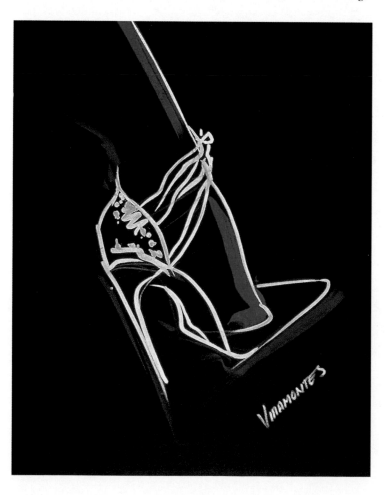

ABOVE & BELOW Designer illustrations emphasize the spindly proportions of their shoes. Sandra Choi's dainty rendition of Jimmy Choo's pink stiletto looks impossibly delicate. Viramontes's sketch of a Valentino shoe is all sharp angles and vertical planes.

for the legs and peds … harsh, cruel, phallic, yet hyper-girlie-girl." Lippert disapproves of the new trends in fashion and advertising, which she sees as "the same old 'woman as bitch' thing, dolled up in new rubber clothing." And she sarcastically quotes Simon Doonan, creative director of Barney's, who says that "In the eighties spiky high heels were cheesy and associated with … a louche … hedonistic lifestyle." By the nineties, he insists, the style had acquired different connotations. "It's for women who want to move the goalposts on their image," says Doonan. "Or teeter along on them," sneers Lippert.[16]

Yet fetishistic images may hold great appeal for some younger women, for whom high-heeled shoes — and stilettos, in particular — now carry connotations of rebellion against the established conventions of "nice" femininity. It could even be argued that by ironically appropriating the sartorial insignia of "bad girls," these young women have rejected thousands of years of patriarchal morality. Thus, according to one recent feminist analysis of the trend, the stiletto heel symbolizes "*liberation* rather than subordination." Instead of being the instrument of a passive, conventionally feminine enslavement, the high heel has been reinterpreted as the symbol of a rebellious, assertive, modern woman.[17]

Freudian theories may "account for the thrill some

RIGHT Walking, even standing, in high heels contorts the body, as shown on the catwalk by a model in Vivienne Westwood stilettos.
BELOW RIGHT High heels are perceived as being the most formal, the most fashionable, and the most prestigious of shoe styles, embodied by Rodolphe Menudier's velvet sandal.

men get out of the shoes women wear," but, according to Holly Brubach, they fail to explain "the thrill *women* get." As she puts it, "No woman with a normal, healthy shoe drive would content herself with a closetful of phallic symbols."[18] Certainly it seems that the erotic appeal of high heels is different than for men. In her book *Woman, Sex and Pornography*, feminist Beatrice Faust argues that high heels "are not visual stimuli for men; they are also tactile stimuli for women … Walking in high heels makes the buttocks undulate about twice as much as walking in flat heels with correspondingly greater sensation transmitted to the vulva."[19]

High heels can also convey an auditory eroticism. "Ever since I was very young, I have been obsessed with spike heels," says shoe designer Christian Louboutin. "The allegorical interpretation that Almodovar gives in his film *High Heels*, of the sound of footsteps which the heroine associates with the memory of her mother, seems to me to convey marvelously the infinite resonances of the sensory range. And it is true that, if sight remains the most evident of the five senses, the subtlety of hearing (and also the sense of smell) authorize interpretations whose sophistication exceeds the obvious."[20]

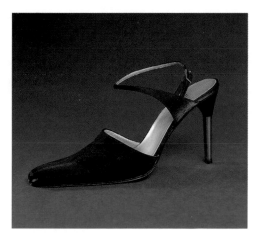

Beyond sensation, there is perception. Research indicates that high heels are perceived not only as the most "feminine and sexy" type of shoe, but also as the most formal, the most fashionable, and the most prestigious — all other reasons why women might like them.[21] Cartoonist Mimi Pond advises, "Look mean — this is part and parcel of the high-heel message."[22]

Height is not the only significant stylistic feature of the heel, however.

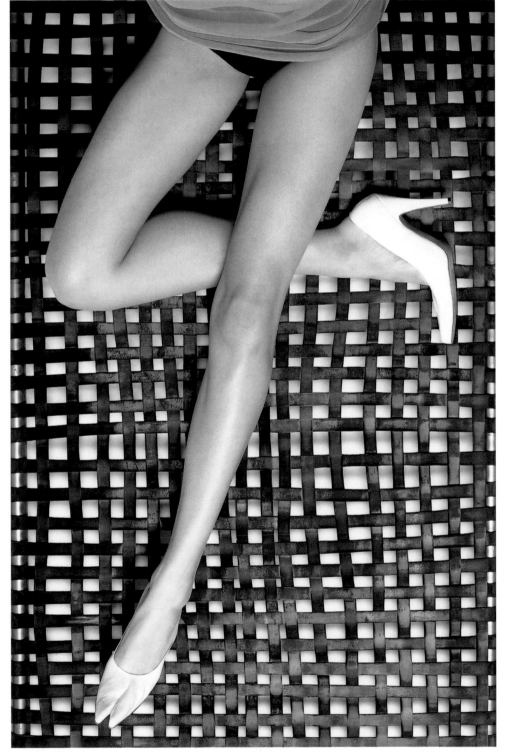

OPPOSITE American artist Vanessa Beecroft poses a model in silver high-heeled boots that elongate her legs, emphasizing the pathway to the genitals.

LEFT The toe of a shoe can also be sexy. The cloven toe on Jeremy Scott's shoes evokes carnal and satanic imagery.

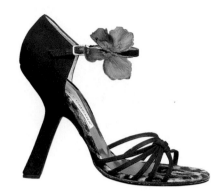

ABOVE A feat of enginering – Dolce & Gabbana join a long line of shoe designers who have pushed the definition of high heels by experimenting with heel shape.

BELOW Christian Louboutin's black pump with low-rise Louis heel affords a glimpse of his trademark red sole.

OPPOSITE A heel does not need to be especially high to be sexy, so long as it is narrow and delicate.

Width and shape are also important. As one fashion journalist put it, heels may be "slivered to the slimmest shapes to make us all look as dainty and delicate underfoot as a Cinderella."[23] Conversely, as pornographers imply, heels may be as thick as a penis. Some shoe designers, such as André Perugia and Roger Vivier, have been known for their innovative heel shapes. No study of the high heel can ignore Vivier's comma heel, for example, or Perugia's corkscrew heel. Then there is the Louis heel, the Sabrina (also known as the kitten heel), the ferrule heel, the stacked ball, the pyramid, and the *talon choc* — every one of which has acquired layers of associations.

The Sabrina heel, for example, is "one of the most influential heels of the twentieth century." According to Manolo Blahnik, "It typifies a certain elegance evocative of Audrey Hepburn." Women who want the femininity associated with the narrow heel, as well as the ease of a relatively low heel, may compromise by choosing a Sabrina heel. Alternatively, it is possible to make a high heel even higher by pairing it with a platform sole — but we will return to that subject later.

Some women, of course, long ago decided that "comfort is their main concern." Moreover, in the United States, in particular, "comfortable shoes are a part of casual dressing."[24] Obviously, not all high-heeled shoes are uncomfortable. (In fact, there is a growing business in comfortable medium-heeled pumps.) But the general consensus is that flats are the most comfortable

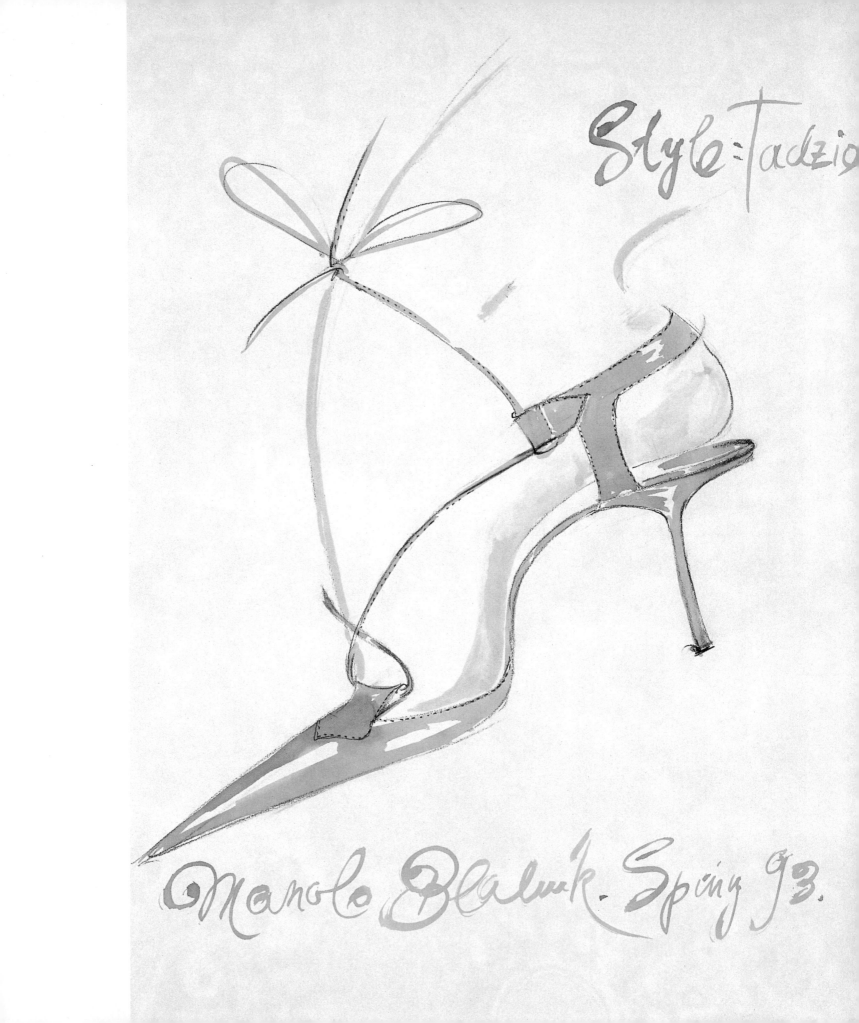

Style=Tadzio

Manolo Blahnik. Spring 93.

kind of shoes. Therefore, high heels implicitly convey the idea that comfort is not the only consideration, that under certain circumstances glamour happens to be more important. Conversely, when flat or medium heels are fashionable or generally worn by women, high heels look excessive. At the office, for example, very high heels may look inappropriate.

Certainly, one must stress the importance of fashion trends when assessing the significance of high heels. "Shoe fashions have accelerated so quickly that what is wrong today is what is right next season," maintains *Vogue*'s Katherine Betts. "Maybe everyone is wearing flats, so the stiletto looks wrong. But it could just be that it's so wrong it's right."[25]

OPPOSITE High heels may go in and out of fashion but, as Mario Testino's image for Gucci signals, they will always be worn by women aware of their sheer sexual power.

BELOW Roger Vivier, renowned for his innovations in shoe design, created these high-heeled pumps for Christian Dior in the 1950s.

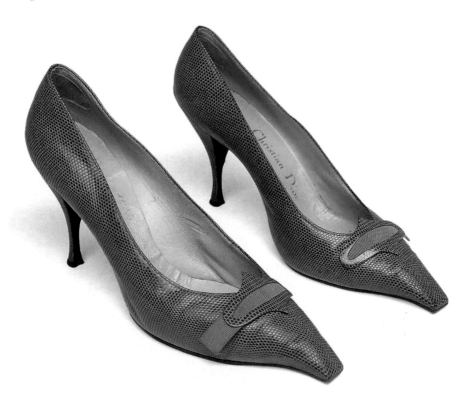

RIGHT George Logan's brooding nurse would not have quite the same impact if she were wearing sensible flats or Mary Janes. Her massive red heels are an essential part of the fetish uniform that symbolizes her position of authority.

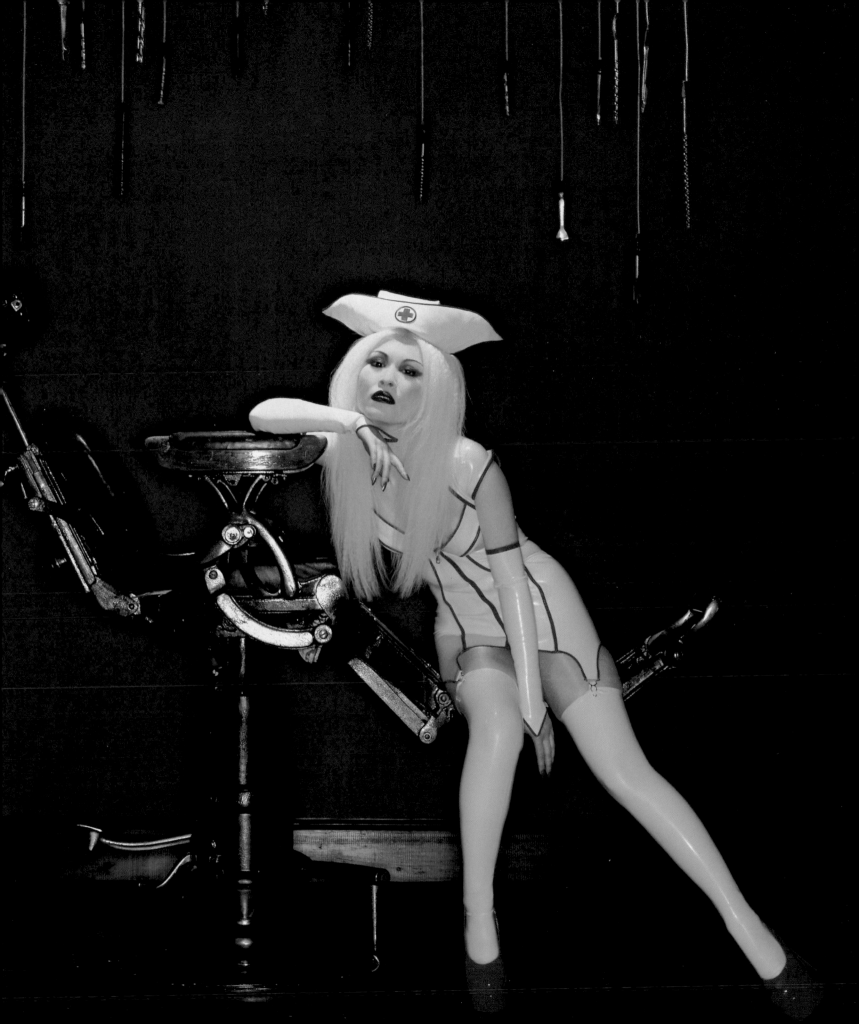

RIGHT & OPPOSITE In his campaign shot for Anna Molinari, Jurgen Teller distorts the familiar image of the girl dressing up in mother's heels. The disheveled hair, little red coat, and red seamed stockings appear eerily provocative above the baby-blue shoes. The Miu Miu label, meanwhile, combines the ribbon trim and shiny surface of a little girl's party shoe with the grown-up proportions of her mother's high heels.

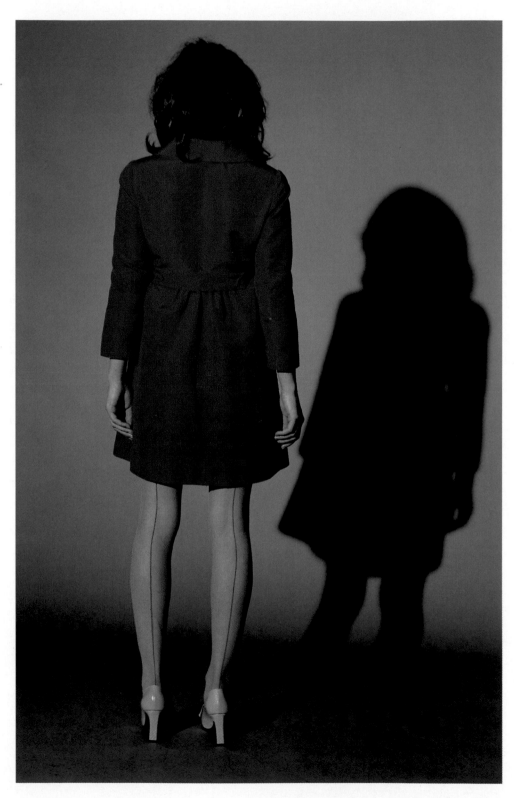

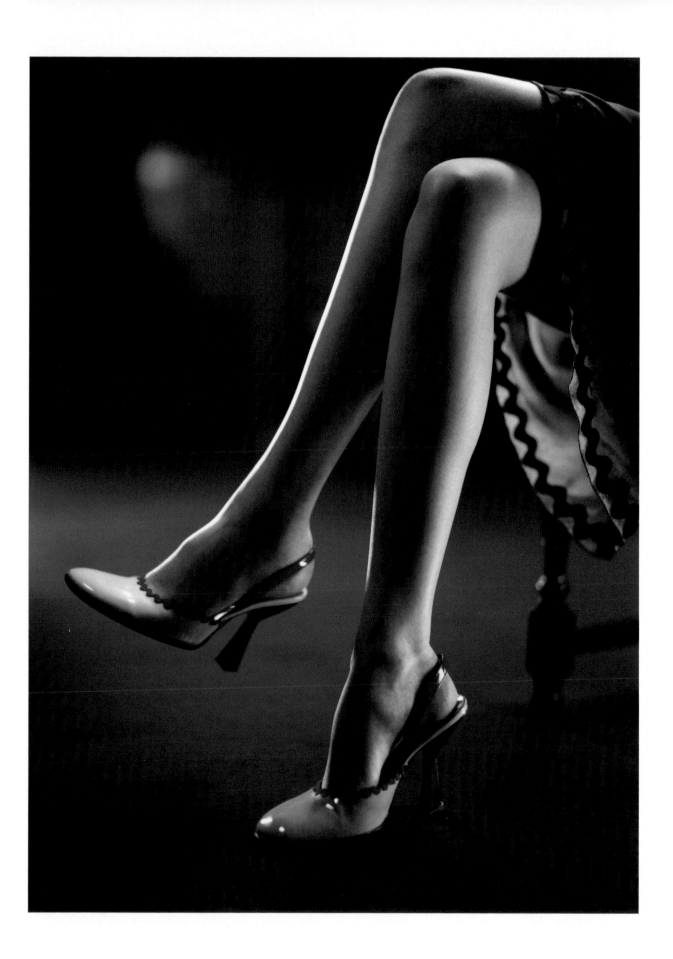

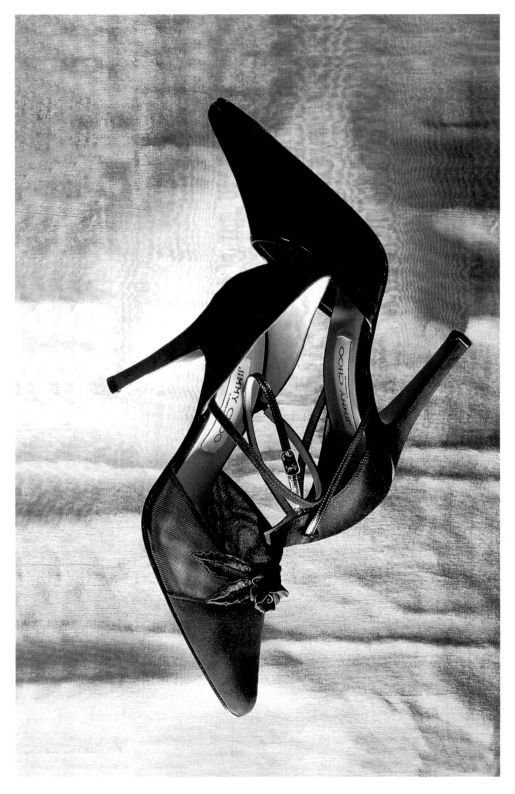

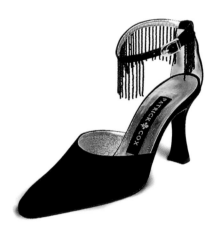

OPPOSITE When it comes to high heels, glamour is a more important consideration than comfort. Here, the stereotypical high-heel "type" — sexy, self-assured, and clad in clingy jersey and side-split skirt — wears Patrick Cox's shiny black pumps.

LEFT & ABOVE The high heel for evening has become a classic category of its own, typically relying on rich colors, luxury materials, and decoration for effect. Examples include Jimmy Choo's satin pumps in purple and midnight blue, and Patrick Cox's black suede sandals with beaded ankle strap.

RIGHT Gucci's sandal appropriates the snaffle of the ubiquitous

men's loafer in a high heel that looks anything but submissive.

OPPOSITE Rainbow colors, snakeskin texture, and a tiny

Mary Jane strap combine to make these high-heeled pumps

by Free lance both playful and sexy.

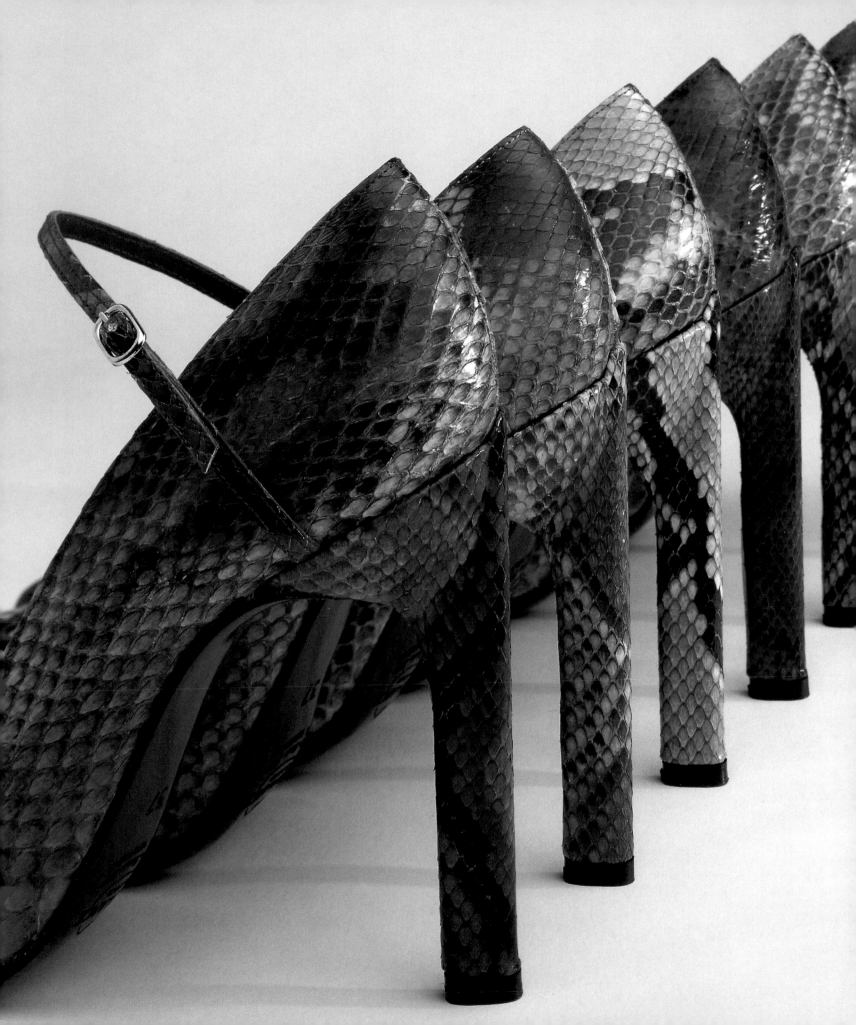

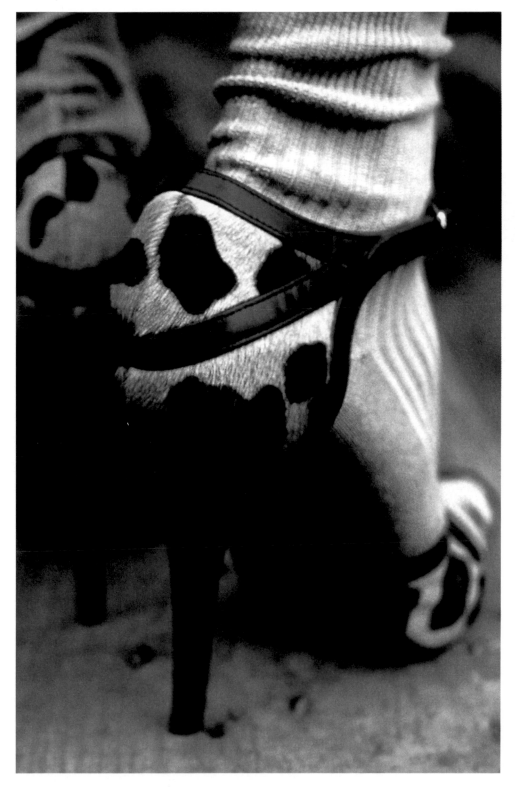

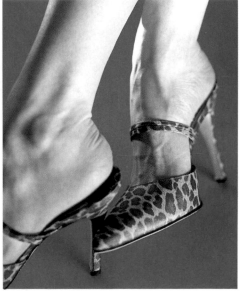

OPPOSITE The image of a woman in high heels walking down the street at night is implicitly erotic. This one was photographed by Seb Janik for a Charles Jourdan campaign.

LEFT & ABOVE Context is everything when it comes to fashion. Leopard-print heels are worn here in two very different ways: revealing bare, polished skin for overt sex appeal, and with a pair of ribbed socks for the Lolita effect.

BELOW Away from the dictates of catwalk fashion for either high or flat shoes, heel heights reach more intermediate levels for the everyday lives of most women. Pumps like these by Stéphane Kélian, photographed by Patrick Trautwein, retain the pointed toe and ankle strap of overtly sexy styles, but with a lower heel.

OPPOSITE As fashion continues along the current minimal, monochrome lines, shoes have become a mark of individuality. Increasingly shoes are used to add character to clothing and to define the mood of the wearer. The pink suede high-heeled shoes are by Free lance. Photograph by Robert Allen.

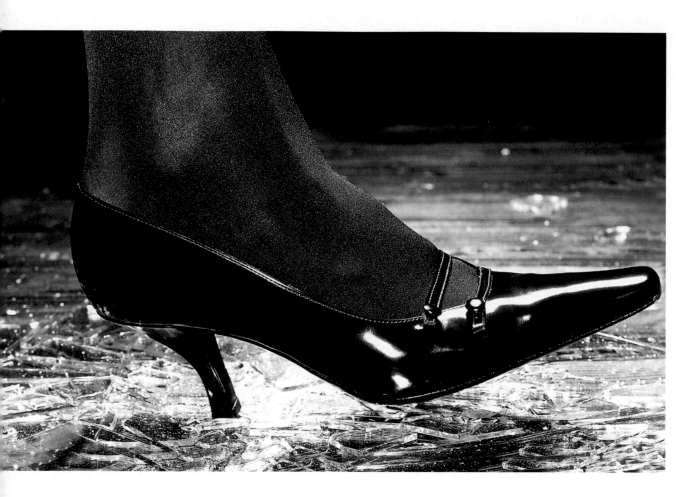

ABOVE The kitten, or Sabrina, is one of the most manageable variants of the stiletto. Its scaled-down proportion makes it easier to walk in, but its small spiky point retains much of the allure and symbolic power of its taller cousin.

OPPOSITE Even before she moves, a woman in high heels is transformed. The arch of her foot is curved, and her calf muscles tighten to appear shaplier. Her legs look longer, her pelvis is tilted, causing the lower back to arch and the buttocks protrude.

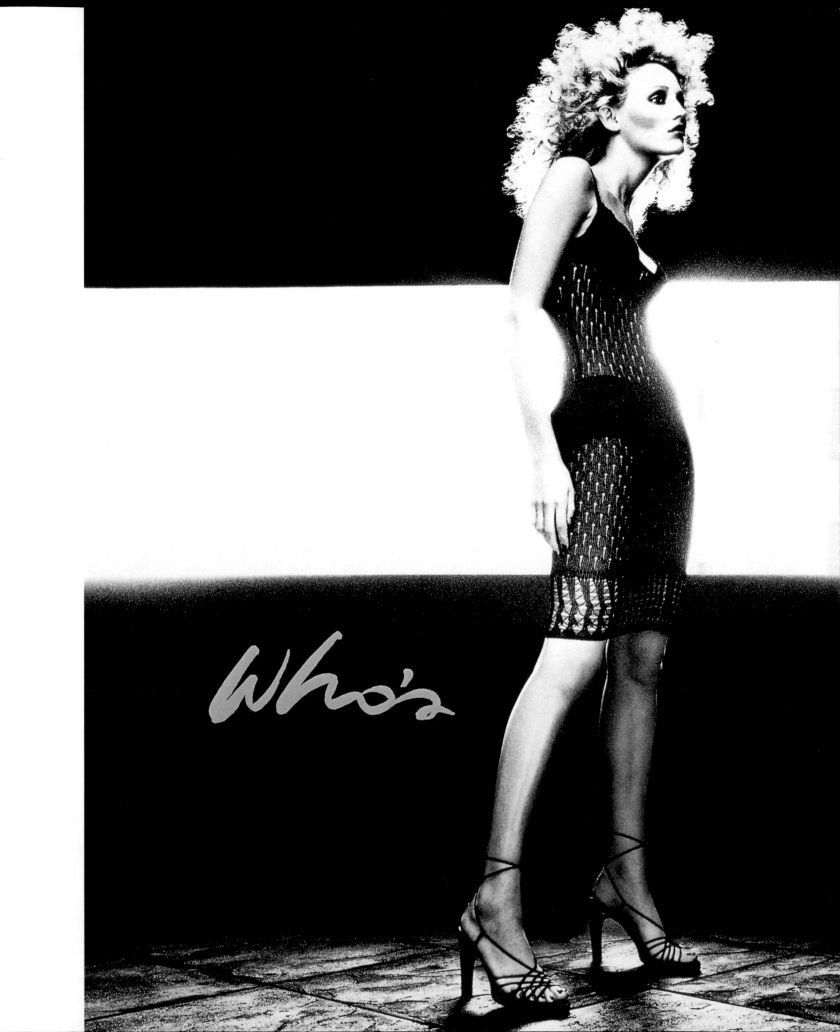

chapter two Sex

sex & shoes

"You have a nice suit, you're all put together, and then you look down and all of a sudden the feet are just screaming sex!"[1]

Quoted in The Wall Street Journal

ABOVE Male and female styling intersect in this fetish shoe, which combines masculine detailing and a feminine heel.

OPPOSITE Our perception of a particular shoe style is influenced by what parts of the foot it reveals. Cesare Paciotti's stiletto teasingly reveals both the arch of the foot and the "rump" of the heel.

High heels are not the only controversial design element in footwear. *The Wall Street Journal* once published an article on a shocking fashion in women's shoes: "The classic, closed-toe pump has developed a low-cut look in the so-called throat line, which means the shoe shows more of the cracks between the toes." The shoe industry calls this "cleavage," and many people find it "a sexy kind of look." Others, however, think the style screams sex and is thoroughly unprofessional.[2]

The concept of "toe cleavage" indicates that the entire foot is potentially perceived in terms of sex and gender. The slingback was also once regarded as very risqué, because it exposed the back of the foot. Since parts of the foot are frequently associated with parts of the (female) body, this rear exposure seemed, to many people, almost obscene. Indeed, slingbacks were once popularly known as "fuck-me shoes."

Research indicates that people tend to categorize shoes into one of several cognitive clusters: 1) "feminine and sexy;" 2) "masculine;" 3) "asexual or dowdy;" and 4) "young and casual." Thus, in one study, the respondents, who ranged in age from eighteen to seventy, regarded styles such as high-heeled pumps, strappy sandals, and women's high boots as being "feminine and sexy." Shoes in the masculine category included both work and leisure styles, such as loafers, oxfords, jogging shoes, and cowboy boots. The category of "asexual" shoes included women's shoes, such as nurses' shoes and career pumps, which were perceived as "unsexy, conservative, comfortable, and appropriate for work." The "young and casual" cluster included thongs (flip flops), clogs,

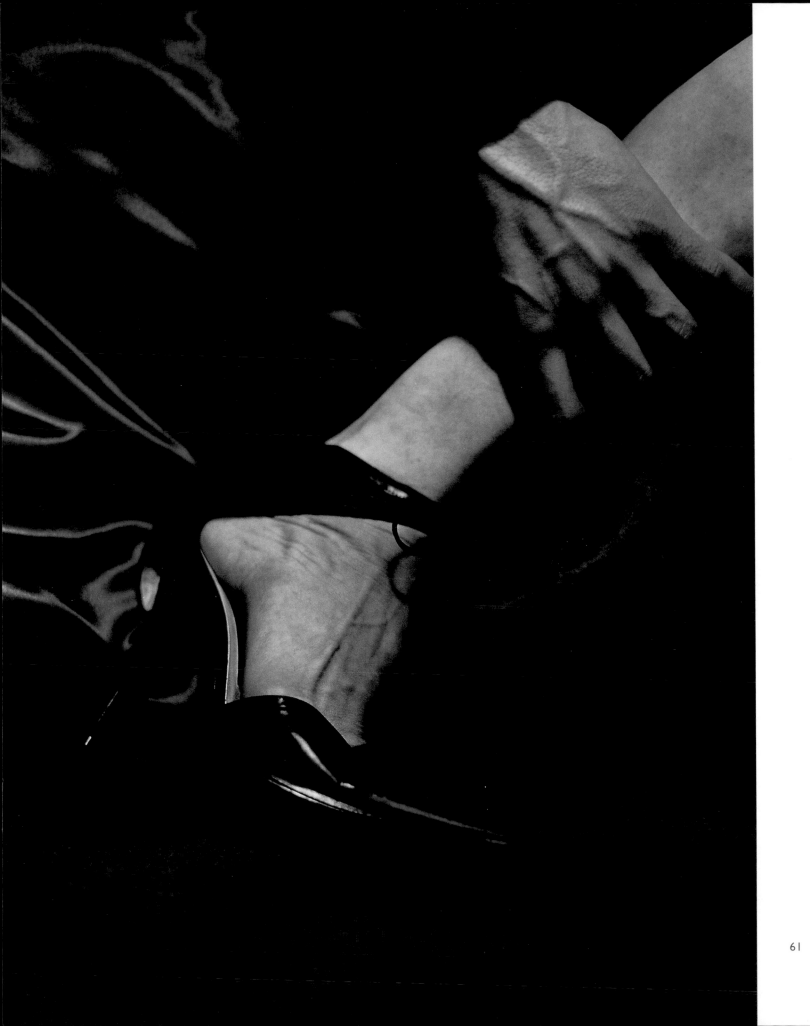

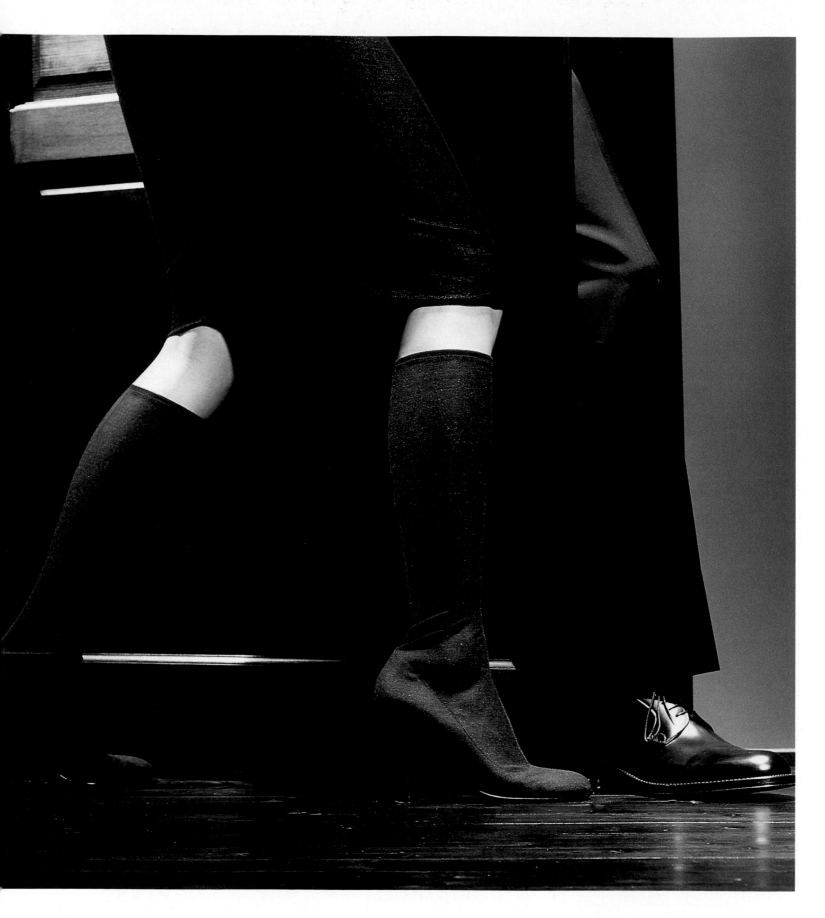

topsiders, and desert boots.[3]

In the popular imagination, it seems that "feminine" shoes must be sexy and uncomfortable. By contrast, "masculine" shoes are supposed to be comfortable and practical. On the "masculine" side are shoes that men wear, such as Oxfords and loafers, which, of course, women have also appropriated, along with athletic shoes and various kinds of boots which were formerly regarded as masculine. On the "feminine" side, we find shoe styles worn almost exclusively by women, such as pumps, slingbacks, and mules. Consider the following advertising texts from the 1980s.

"We can safely assume that the majority of women's pumps were designed by men who had domineering mothers and unhappy childhoods," declared a clever advertisement for Naturalizer shoes. The makers of the Soft Shoes Collection, which boasted extra padding and extra flexible soles, described Naturalizers as "Shoes that don't cramp your style." This advertisement implies that women have long been oppressed by male designers. Fortunately, they can now buy shoes "designed especially for women. By people who are especially fond of them."

An advertisement for Easy Spirit dress shoes took a somewhat different approach: "Looks like a pump, feels like a sneaker ... The first walking heels! ... anti-shock walking pumps ... Now, even in slender, whistlebait pumps, you can walk for miles — and your feet won't feel a thing." Although the reference to

OPPOSITE No one could mistake which of these shoes is worn by a man and which by a woman. The stretch boots with high heels are by Sergio Rossi. Photograph by Miles Aldridge.

ABOVE LEFT Bella Freud's optical take on the Oxford.

ABOVE This 1930s black pump incorporates both masculine and feminine elements in a style that has become something of a classic with its low-rise heel, sharp lines, and T-bar strap.

BELOW Once regarded as the sole preserve of men, no-nonsene flats have been appropriated by women.

RIGHT & BELOW This dainty bejewled mule by Manolo Blahnik has its origins in the elegant high-heeled footwear favored by seventeenth- and eighteenth-century dandies.

OPPOSITE Versace's shiny buckled shoes take a milk bath.

"whistlebait" would probably not be used today, this text acknowledges that women themselves have harbored contradictory desires — to be sexy but at the same time also be comfortable.

But pumps were originally worn by men as well as women. In the eighteenth-century poem "Monsieur A-la-Mode," the protagonist is described as wearing "A pair of smart pumps made up of grained leather; / So thin he can't venture to tread on a feather; / His buckles like diamonds must glitter and shine, / Should they cost fifty pounds they wou'd not be too fine."[4] In those days many men believed that fashion was more important than comfort. Today the pump has almost disappeared from the male wardrobe, and only a few dandies even own low-heeled patent dance pumps. Indeed, pumps are widely regarded as *the* feminine dress shoe. High-heeled pointed-toe styles are perceived as being the most glamorous, especially for evening, but there are also more practical ("asexual") pumps with sensible heels and rounded toes for wearing to the office.

Actually, pumps can have almost any kind of heel. The pointed-toe pump with metal spike heels has come in and out of fashion several times

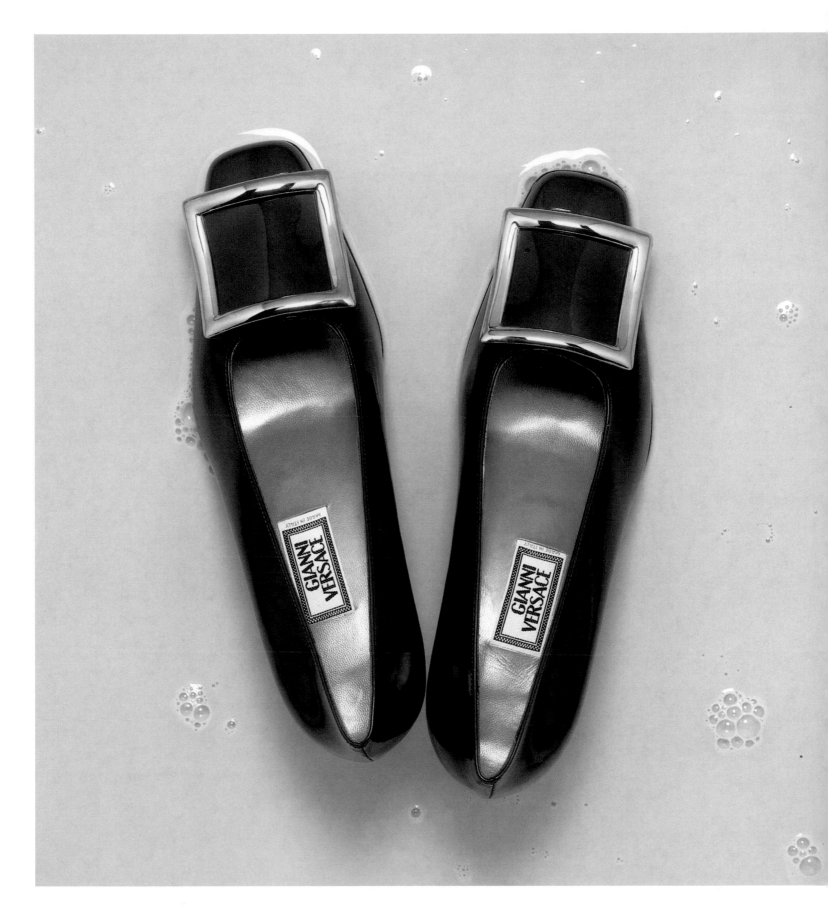

ABOVE A beautifully crafted slipper by Pollini shows how the bow, once a decorative device on men's shoes, has been almost exclusively appropriated by women. Only the man's evening pump is still occasionally adorned with a bow.

BELOW Ferragamo's "Princess" mule, created for the film retelling of the Cinderella story, *Ever After*, is the lost slipper that transforms the downtrodden servant girl into a princess.

in recent years. The medium-high straight heel has enjoyed a more continuous popularity. Trend reporters say that chunky flared heels are temporarily out of fashion, as are square toes. However, because fashion today changes so rapidly, and because so many "style tribes" coexist, a style that is out with the majority is almost certain to be "in" with some people. Pumps can also have different kinds of vamps and backs. A low vamp that reveals toe "cleavage" is still frowned on in the corporate world, as we have seen. The slingback, however, is increasingly acceptable, even in a work environment.

Although the basic definition of the pump says that it has no fastenings, in fact many pumps do have straps. Perhaps most famous is the Mary Jane, a

low-heeled pump with a strap across the instep, which periodically reappears, whenever the little-girl look is popular. In 1994, for example, Peter Fox caused a sensation with his "Toddler" shoe, a look that Courtney Love described as "kinderwhore." More recently, vampish high-heeled ankle-strap pumps have made a comeback, and, to a lesser extent, so have sophisticated shoes featuring strap T-bars.

Men have not entirely abandoned high heels. Think of Cuban heels, or cowboy boots. Nevertheless, over the past two centuries the overwhelming historical trend has been toward flat and low-heeled shoes for men. Ornamentation also has largely been eliminated from the male wardrobe.

RIGHT & BELOW Sergio Rossi's buckled red patent pump and Andrea Pfister's feathered fantasy mule both draw on masculine influences to create very feminine shoes.

Back in the sixteenth century, fashionable men and women wore shoes "stitched with silk and embroidered with gold and silver all over the foot with gew-gaws innumerable."[5] Now you would be hard-pressed to find any decorative men's shoes, with perhaps the exception of embroidered slippers.

"Unfortunately, today there are no more dandies," says Manolo Blahnik. "Men think only about comfort and economic success, not about following a code of behavior."[6] As a result, almost all the sartorial attributes of a leisured aristocracy — from delicate silks to embroidered high-heeled shoes — were abandoned by men, and left to women. Only very rarely have men reasserted a claim to some item of fashion after it had been deemed "effeminate." (That men have begun wearing earrings again is exceptional in the history of fashion, and is frequently justified by the fact that not only women but also pirates wore earrings.) It is precisely because high heels signify femininity that they almost invariably play a role in the transformation from he-male to she-male. As Rupaul put it: "How tall am I? Honey, with hair, heels, and attitude I'm through the damned roof."[7]

Mules were originally simple, flat, backless slippers. By the eighteenth century they had evolved into backless shoes on high heels. Today mules, which are also known as "slides," are believed to be among the most seductive of all shoes, because they leave the foot half undressed. Mules can easily be kicked off or dangled seductively from the foot. Indeed, one reason mules are so attractive is

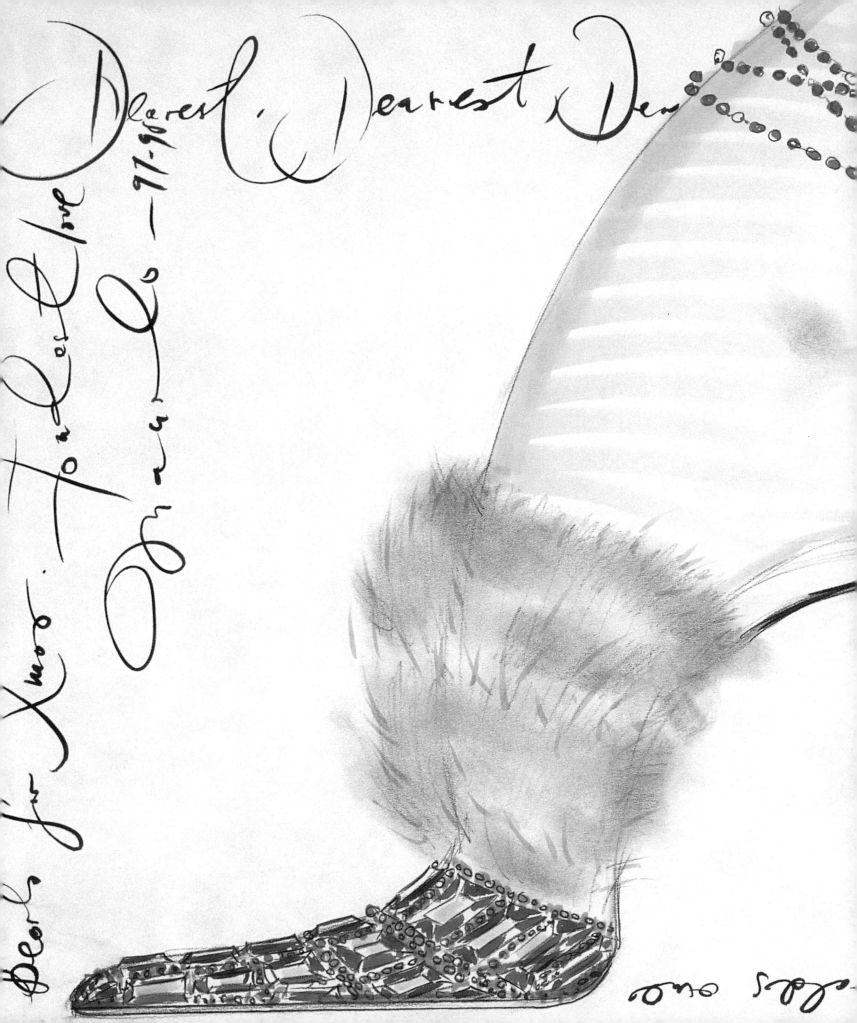

Dearest, Dearest, Dea

Pearls for Xmas. Fondest Love
Manolo. — 91-90

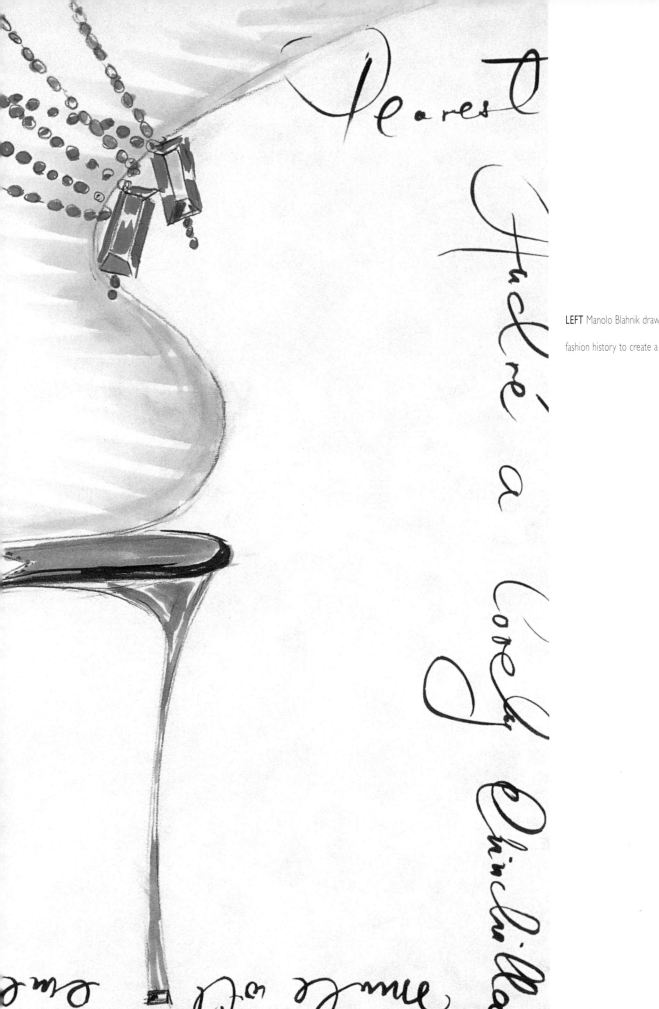

LEFT Manolo Blahnik draws on the rich decorative heritage of fashion history to create a delightfully decadent mule.

OPPOSITE & THIS PAGE From Bella Freud's witty red butterfly

mules to seductive marabou-trimmed slides, and fun and frivolous

Candie's, mules have a lot of personality.

precisely because they are insecurely attached to the wearer's feet. Who can forget the eighteenth-century image of a woman in a swing with her mule flying through the air? According to Manolo Blahnik, the mule is "as good today as it was for Madame de Pompadour slipping from her bed."[8]

"Thanks to Hollywood, the mule was carved out to reveal the toes and trimmed with marabou feathers," writes another admirer of the style. "The result: glamour and sex married into one unforgettable image of Marilyn Monroe descending the staircase in *The Seven-Year Itch* wearing her high-heeled, marabou-trimmed slides."[9] This quintessential sex kitten image was revived in the 1970s, when a kind of shoe known as Candie's swept America. Young women loved these sexy but inexpensive mules, and when the company regrouped in the 1990s, Candie's received a rapturous welcome — especially since the new Candie's were created by hip fashion designers such as Anna Sui and Vivienne Tam.

Traditionally masculine shoes carry very different connotations — of status and/or comfort and practicality. Thus, the authors of *A Century of Shoes* chose to illustrate the chapters on loafers and brogues with images such as a pair of (men's) loafers by Church's and a pair of (men's) Oxfords by Lobb of St James's. The descriptions of these styles also emphasize their functionalism. We are told, for example, that Native

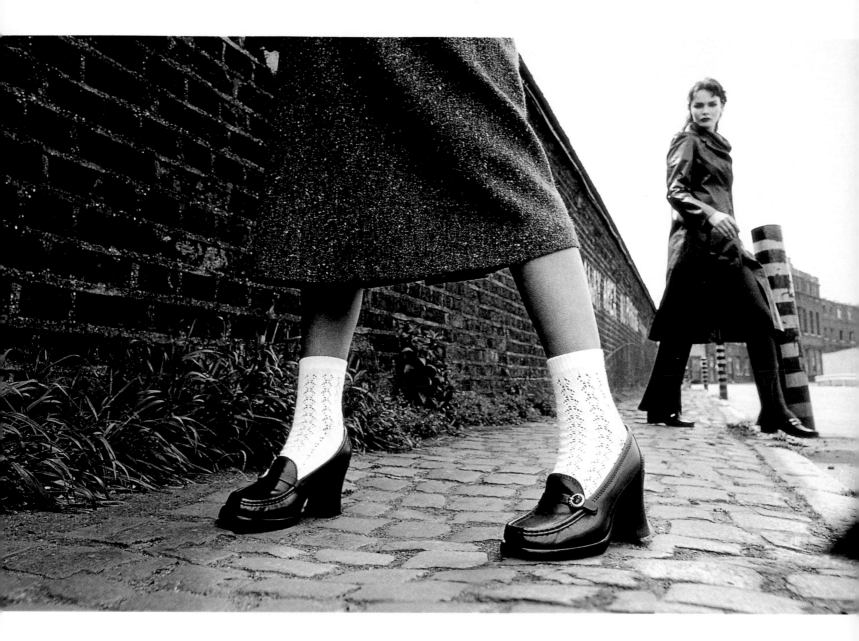

ABOVE Patrick Cox contributed to the revival of the loafer in the 1990s with his Wannabe line. Both men's and women's styles have identical front detailing; only the heel height, which ranges from flat to very high, distinguishes the women's range.

OPPOSITE Bespoke shoemaker Lobb of St. James's has long been renowned for its men's shoes, but the same engineering skills are brought to bear on women's styles.

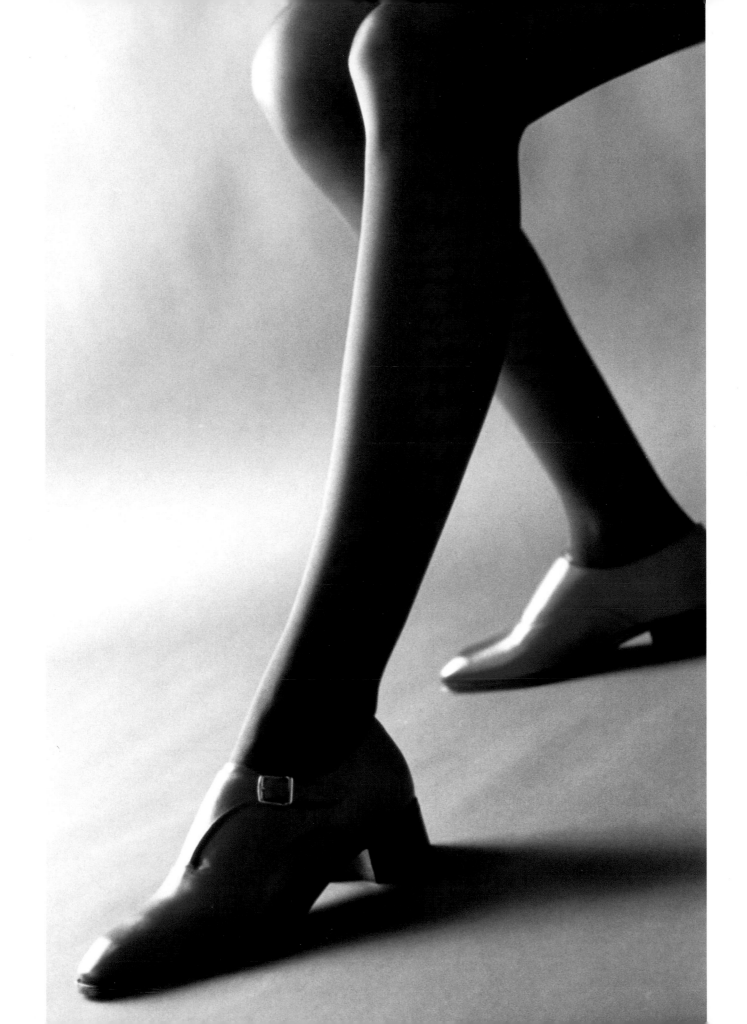

ABOVE A lace-up by Sigerson Morrison shows the distinctive top stitching and lacing of the Oxford. More "tailored" than the loafer, the Oxford is perceived as a masculine or "unisex" style.

ABOVE RIGHT The classic pump, interpreted by artist Tanya Ling in pastel blue with feminine detailing such as the tiny T-bar strap.

OVERLEAF Men usually conform to a narrow range of acceptable footwear colors and textures, but women frequently wear mannish shoes in brilliant colors and fabrics, such as Tom Ford's loafer in turquoise snakeskin and Christian Louboutin's orange felt flats.

Americans originally made moccasins from a piece of hide wrapped around the foot. From this style developed the loafer, "essentially a two-piece moccasin [with] a hard sole."[10] We also learn that the word "loafer" may have come from the German *Landlaufer*, meaning wanderer or vagabond.

A certain social significance is implicitly conveyed through this historic association with Native Americans and vagabonds. Shoe advertisements also characterize loafers and moccasins as comfortable and "casually classic." Oxfords tend to be perceived as a more "tailored," less casual type of shoe. Yet here, too, there is an emphasis on practicality. As a Macy's advertisement once put it: "Lace up if you place an emphasis on ... comfort, quality and classic good looks."[11]

Manolo Blahnik says, "Flat shoes used to be associated with active or mannish women, like Greta Garbo. But today feminine women also have the freedom to wear mannish shoes. Women today have an incredible choice of different kinds of shoes." Robert Clergerie, for example, debuted his shoe line

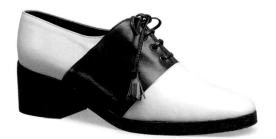

LEFT The driving shoe by J. P. Tod's is based on the moccasin, or loafer, and has become an icon of casual chic. Tod's keep the designs for men and women largely the same every season, but bring them out in new colors and textures. This women's range for summer is feminized with the use of pastels.

BELOW Masculine-style shoes tend to defy fashion trends, retaining a timeless quality. Here, three classic takes on masculine styling with Annie Hall appeal: Silvia Fiorentina's two-tone spectator shoe from the early 1970s, Sigerson Morrison's black patent lace-up, and Bottega Veneta's spotted calf-skin Oxford.

in 1981 with his lace-up Oxfords, "a man's shoe made for a woman, that has since become the accessory equivalent of the little black dress: indispensable to a wardrobe."[12] Clergerie got his start when he quit his job at Charles Jourdan and bought a bankrupt men's-shoe factory in Romans called Fenestrier. "Everyone said I was crazy," he recalled. "I had bought the worst company in Romans! But I wanted to be independent and realize my own designs." After he resuscitated Fenestrier, he decided to launch his own line of women's shoes. "Women are more progressive, adaptable, than men," he explains. "Men are so conservative; they buy the same shoe for ten years. With women's shoes you can change, grow — and sell more shoes!"[13]

According to Clergerie, "The influence of the masculine style is determined mainly by the fashion of the moment." It was essentially accidental that his own factory had previously made men's shoes. Much more relevant, he argues, is the fact that "the modern way of life is favorable to this kind of shoe."[14]

Today, when fashion rules seem made to be broken, a host of classic "masculine" styles have been recreated as high-fashion shoes for both men and women. J. P. Tod's driving shoes, for example, are made in more than 100 colors, and have become one of the most stylish unisex shoes in the world. With the revival of Gucci under Tom Ford, the famous Gucci loafer has been reborn. The shoe designer Patrick Cox is best known for the Wannabe, a classic unisex loafer which became an international bestseller from the moment it

OPPOSITE Ballet shoes in black with knee-high lacings by Free lance give a definite edge to an otherwise demure shoe style.

ABOVE Franco Fieramosca's streamlined shoe is inspired by the ballet slipper, which is considered one of the most feminine of flats. His ankle boot is equally minimalist.

TOP With its elastic sides and supple sole, Junya Watanabe's quirky treatment of the dance shoe is for Comme des Garçons.

TOP RIGHT Charles Jourdan's navy ballet flat from the 1960s adds a Mary Jane strap and mirrored heel.

arrived on the scene in 1995. Naturally, Cox also designs feminine shoes, like his shiny pink "Blondie" mule and leopard metallic sandal. He says, "I love all types of shoes, from sneakers to stilettos." Nevertheless, his fame rests on the unisex Wannabe, which has been called "the Dr. Marten of the Nineties."[15]

Without high heels to add sex appeal, flat shoes focus on other visual strategies. Many of the most stylish flats now come in a rainbow of colors, and in every material from leather to linen, and from satin to suede. A feminine, glamorous look is conveyed by colors like pearlized pink. The one flat which everyone regards as feminine is the so-called ballet slipper, based on the dance shoe that developed in the mid-nineteenth century. You can get the real article at dance stores, but the flimsy sole makes it impractical for streetwear. As a result, most women who like the slipper's soft, flat construction and demure appearance buy designer versions.

"A sexy, feminine shoe is defined by the shape of the toe and the heel, and by the pattern of the last," says Franco Fieramosca, a native of Italy, who worked with Bally, Ferragamo, and Cole-Haan before launching his own collection of women's shoes in 1994. "You don't need ornamentation, only a certain delicacy and refinement of details and materials. Even women who love heels also like to wear flats sometimes, and if done beautifully, flats can be very sophisticated and elegant."[16]

In particular, Fieramosca cites the importance of the ballet slipper. "It is not necessarily casual. A ballet slipper in pale pink suede looks refined and ladylike. When I designed my ballerinas, I was inspired by the image of

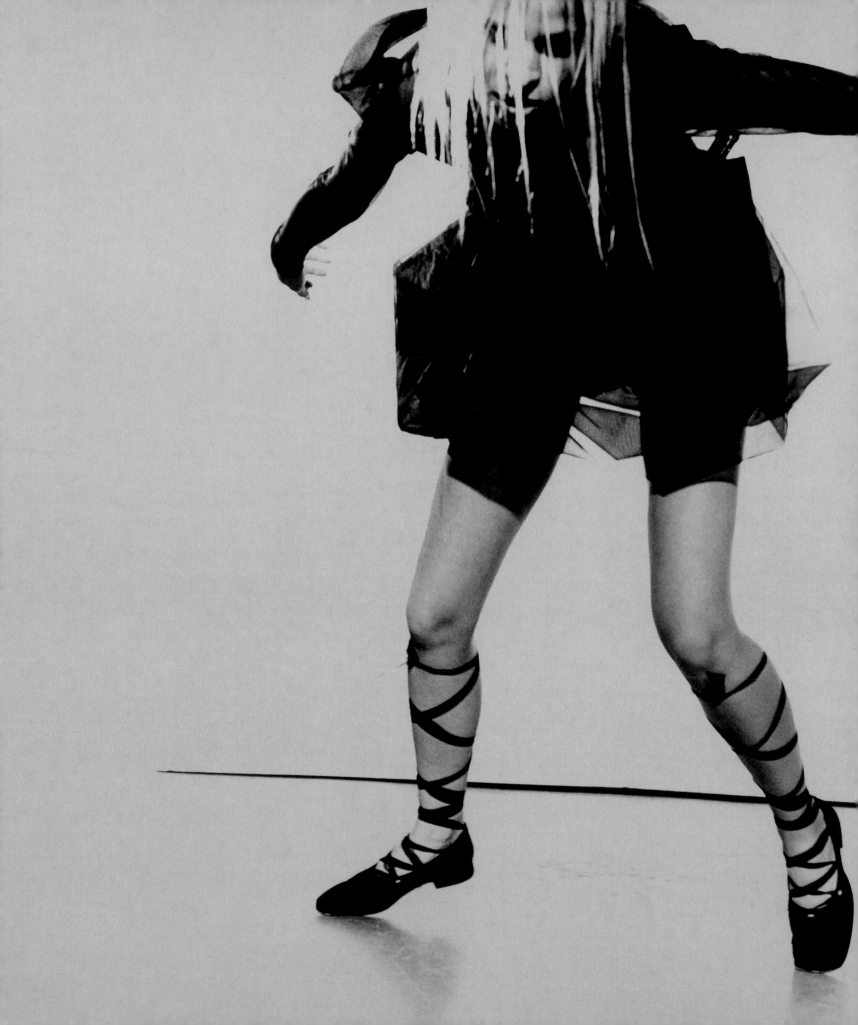

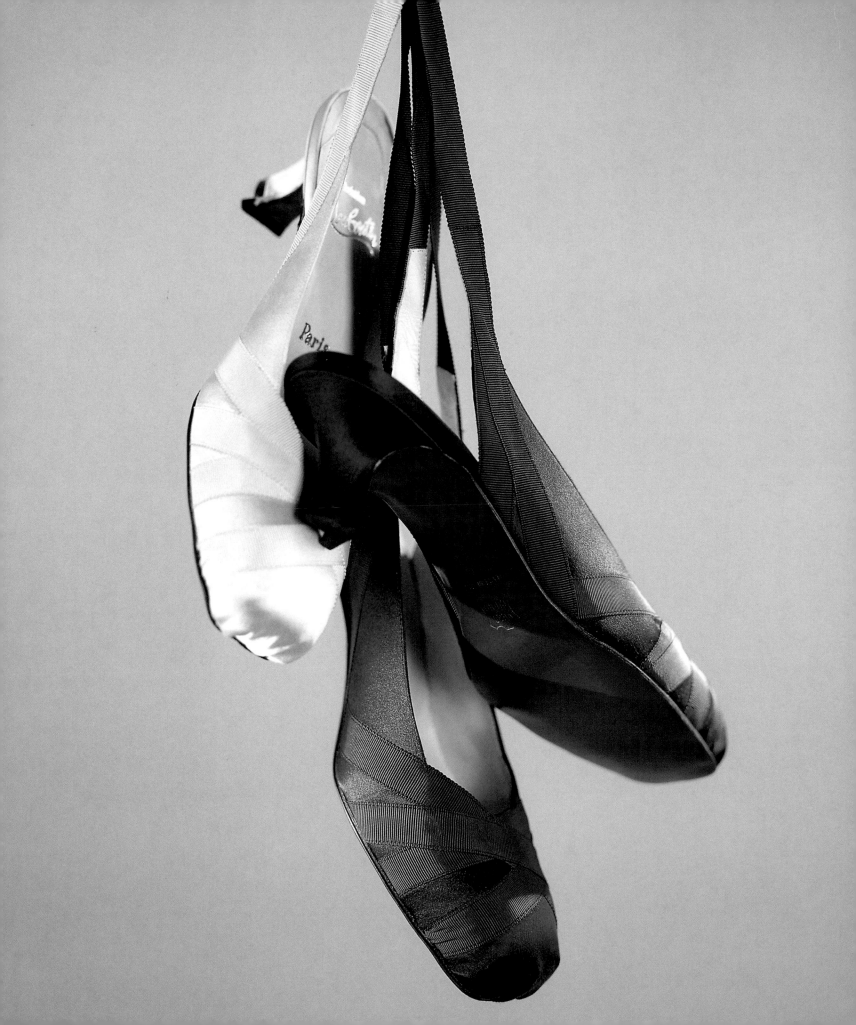

OPPOSITE Christian Louboutin's balletic evening shoes feature the blocked toes and ribbon ties of dancers' point shoes.

Lady Diana getting into a jet. She was wearing tight gabardine pants and a blazer, and you might have thought that masculine shoes would be appropriate for those clothes, but her ballerinas looked so phenomenal! They were so delicate, those ballerinas. I try to make shoes which are delicate, feminine, and sophisticated."

Other designers also focus on the creation of feminine shoes. The young French designer Rodolphe Menudier, for example, is known for his strappy, ultra-fem shoes, which carry names like "Salomé." Pumps seem too classic for Menudier, who creates styles such as "Barbie," a wedge with a bow on the front. Todd Oldham also created a shoe called "Barbie." Indeed, the entire issue of shoe names is worthy of attention. Christian Louboutin named a pair of Mules "Sea, Sex and Sun." And after the police reported that a pair of his shoes was connected with the unsolved murders of three women, he decided to create a shoe called "Murderess." Back in the 1980s, shoe artist Thea Cadabra-Rooke did wonderful fantasy shoes, like the patent leather "Maid Shoe," which had high heels shaped like sexy female legs, while the front of each shoe featured a tiny, frilly maid's apron.

Variety in footwear is the wave of the future. As an advertisement for Nine West put it in 1996: "We all need strappy, sexy, patent sandals. Slinky, stretchy, comfy slings. Hip, lively loafers. Open toes, with plenty of sole. Sassy, shiny Mary Janes. We all need shoes."

TOP & ABOVE The most feminine of mules, in baby blue with sculpted edging by Jimmy Choo, and in black velvet studded with diamantes by Christian Louboutin.

OVERLEAF Maurice Scheltens's photograph for Michel Perry uses shoes to confuse our expectations of male and female behavior.

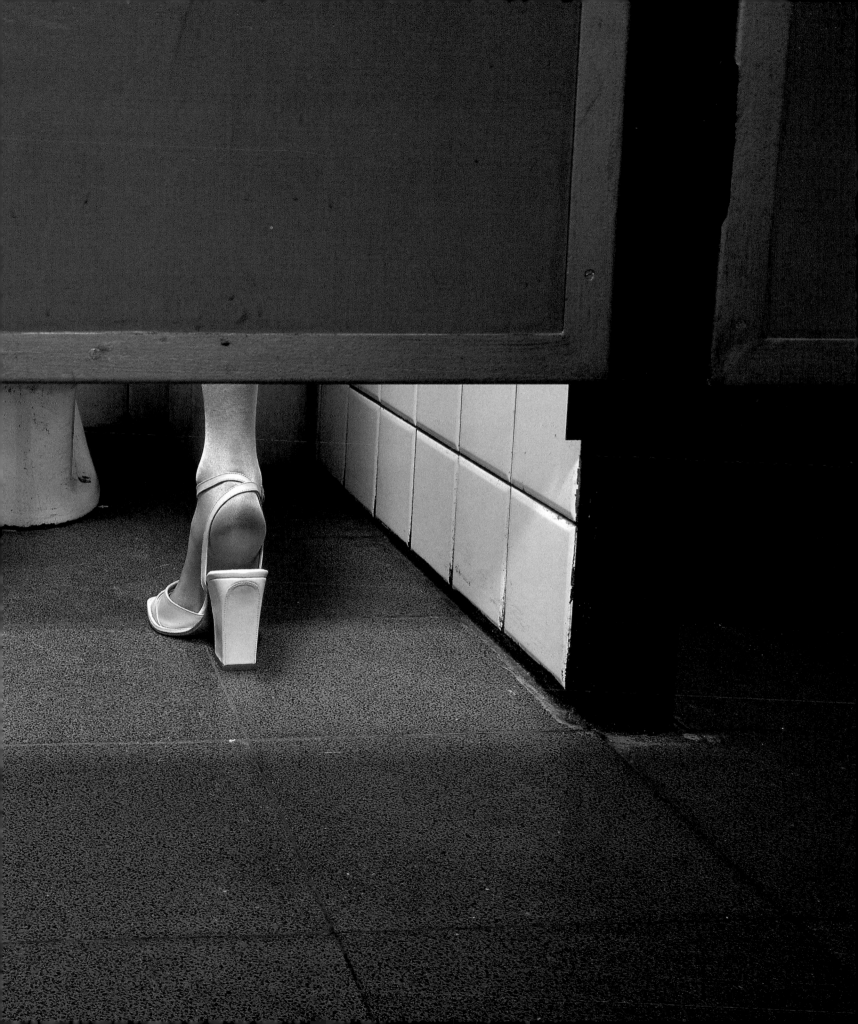

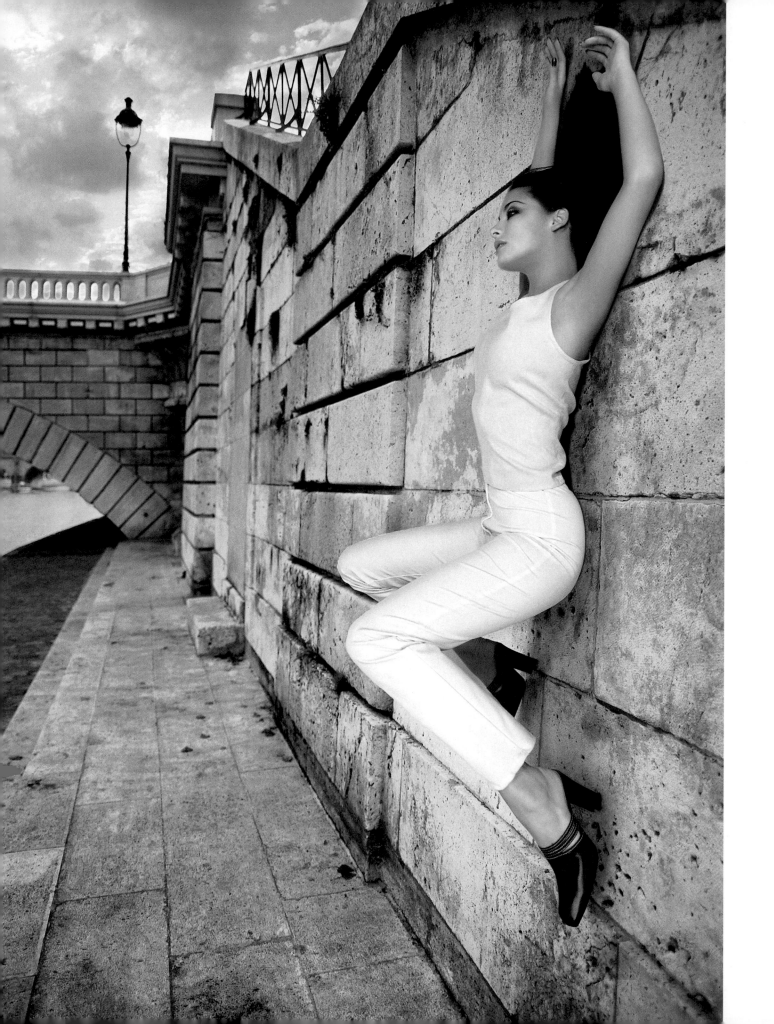

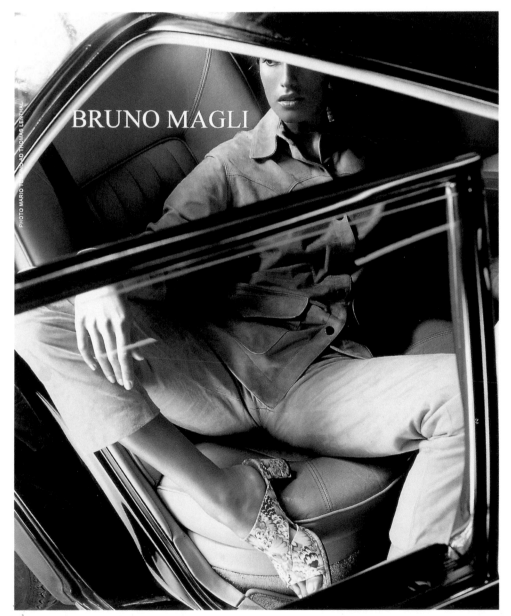

BRUNO MAGLI

PHOTO MARIO TESTINO AD THOMAS LENTHAL

OPPOSITE & LEFT Charles Jourdan's sleek crimson leather mules with their thick heels and streamlined style give an immediate sense of authority to the wearer. Meanwhile, Bruno Magli's vividly patterned slides say, "I'm a girl at heart."

RIGHT Sergio Rossi reworks the spectator shoe.

OPPOSITE Flat shoes mean mobility. Some women choose to wear only sensible flats, feeling that they provide more secure footing both physically and psychologically.

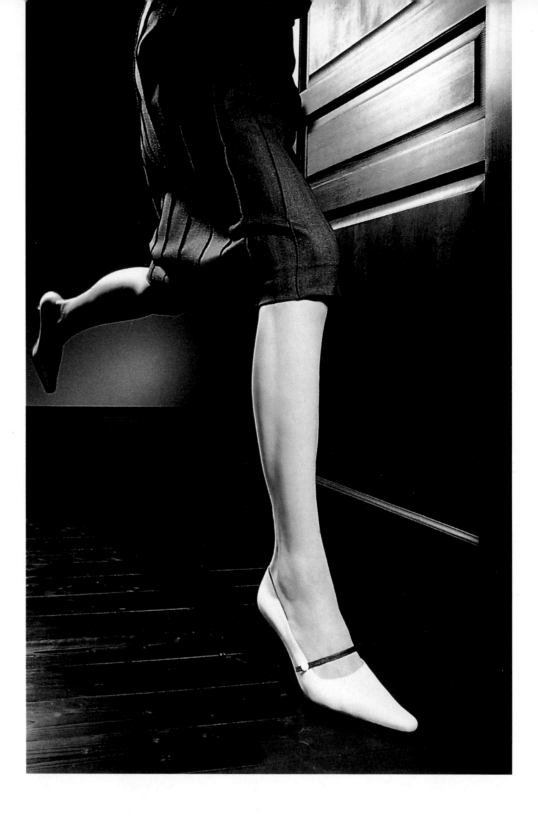

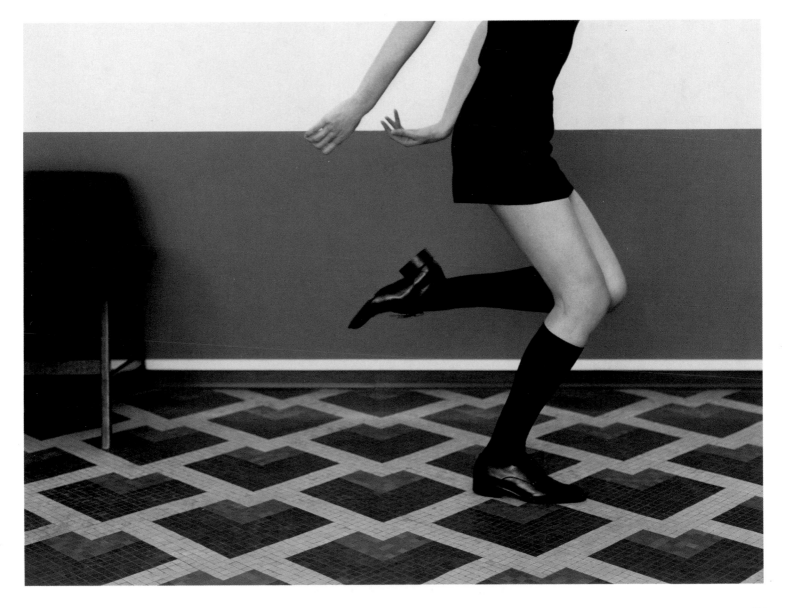

Like Being Barefoot

like being barefoot

"The wonderful thing about flat sandals is that you have the feeling of being barefoot. It's pure liberation."[1]

Christian Louboutin

ABOVE Stéphane Kélian's leather slides embroidered with gold thread are the exotic way to go barefoot.

OPPOSITE Kareem Iliya's illustration captures the light-as-a-feather freedom of the summer sandal.

Sandals have always been among the sexiest of shoe styles, because they leave the foot nearly naked. The Biblical heroine Judith wore sandals when she went to seduce (and assassinate) the enemy chieftain Holofernes. According to the Book of Judith, Holofernes admired her clothing and jewelry, but it was "her sandals that ravished his eyes." They may have been the last thing he saw before she cut off his head.

Cultures as radically different as ancient Rome and puritan New England agreed that respectable women must cover their feet. Within the Christian tradition the naked foot was regarded as impure and shameful. Saint Jerome advised women to wear shoes which would cover the entire foot and thus "subdue the carnal inclinations lurking in men's eyes." Saint Clement of Alexandria commanded women not to bare their toes in public, and condemned "the mischievous device of sandals that evokes temptations."[2]

At its most basic, the sandal consists of nothing more than a sole tied onto the foot. You can add a heel or elaborate on the straps, but essentially you are talking about "the irreducible minimum." Indeed, in 1939, the editors of *Vogue* fretted that sandals were simply too revealing to be worn on city streets, as they had "neither toes nor backs, just heels and straps."[3] Yet different styles of sandals expose the foot in very different ways, resulting in very different kinds of symbolism. Christian Louboutin describes how flat sandals give the liberating feeling of being barefoot. But, according to *The New York Times*, a pair of Chanel platform sandals evokes fantasies of bondage.

What is so "sexy, perverse, and delicious" about a pair of platform sandals

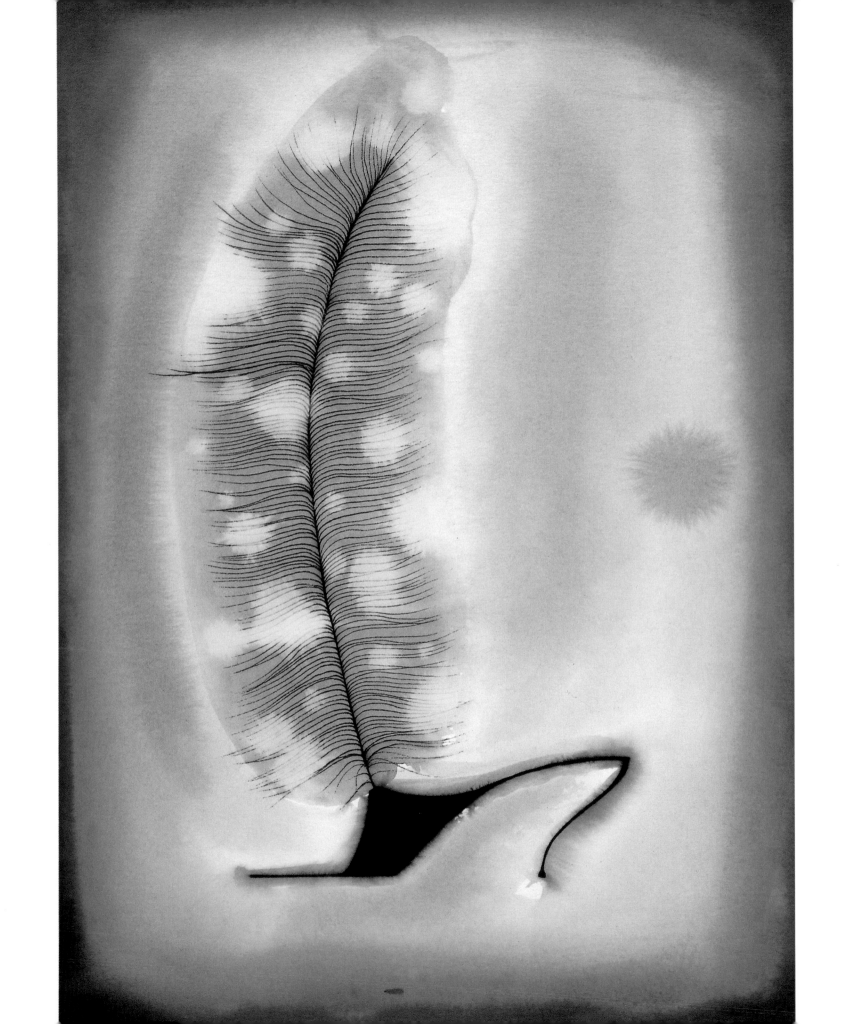

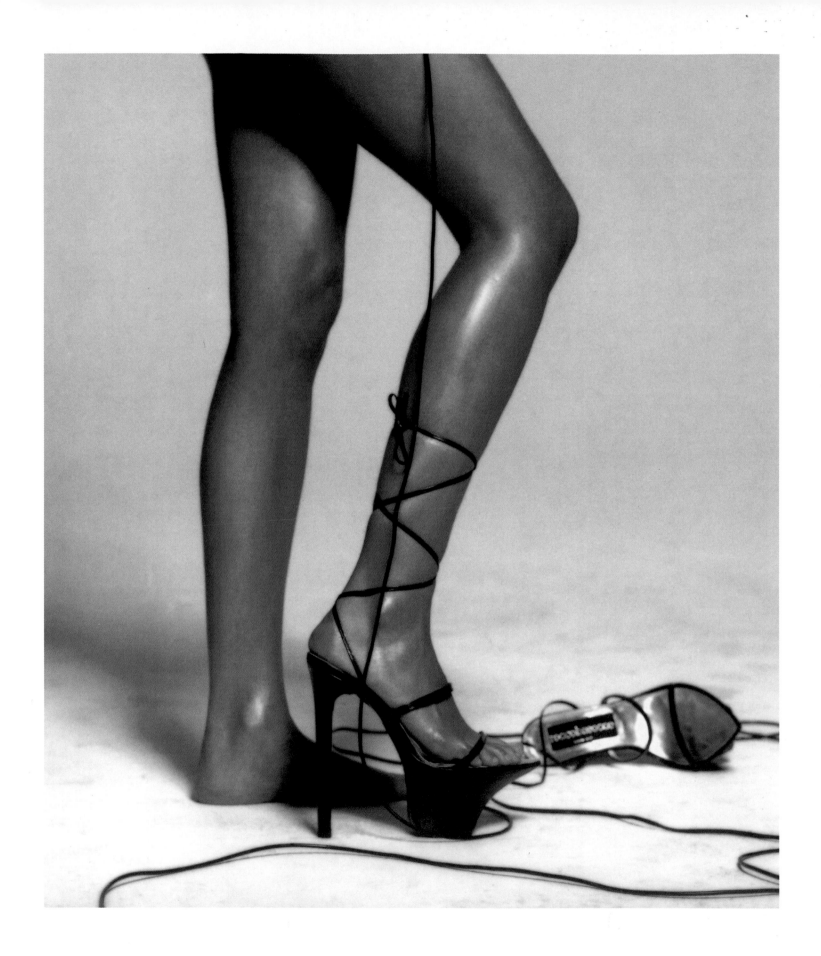

OPPOSITE One of the world's oldest footwear designs, a sole

with leather thongs attached to wrap around the foot and leg,

is reworked here in extreme form by Rocco Barocco.

with ankle straps? An elegant ankle harness presents the foot "as a beautiful slave," thus implying "untold erotic practices," says fashion historian Anne Hollander.[4] The fetishist hero of Geoff Nicholson's novel agrees: "I'm a great fan of the ankle strap, and even more so of the double ankle strap. I'm absolutely sure this must have something to do with bondage."[5] All of these straps, of course, also emphasize the contrast between flesh and leather, and, like shoe cleavage or backless shoes, they draw attention to the presence of the naked foot within the shoe.

ABOVE & BELOW The combination of high heel and barely-there straps makes the stiletto sandal an especially sexy type of shoe, revealing the maximum amount of bare flesh, as here in Richard Tyler's beaded gold sandal and Sergio Rossi's slick black thong.

In her autobiography, Shelley Winters tells how she and Marilyn Monroe used to steal shoes from the film studio. Once she took a pair of high-heeled sandals with lattice-work at the toe and an ankle strap that tied in a bow. "They really were the sexiest shoes I've ever seen," she recalled, and happily described them as "fuck-me shoes."[6] Genevieve Antoine Dariaux would not have approved. In her book *Elegance*, she argued that open-toed shoes "are perhaps comfortable, but certainly unaesthetic, dangerous, and even unsanitary." Ankle straps she dismissed as "unflattering" and "cheap looking," while "too high heels … are extremely vulgar."[7]

There is still a great deal of hostility expressed toward platforms. Paris *Vogue* recently featured an article asking readers whether they were "for or against" platform shoes. Apparently there had been many letters, especially from younger readers, complaining that *Vogue* was (unjustly) ignoring the current fashion for platforms. Untrue, replied the author. She maintained

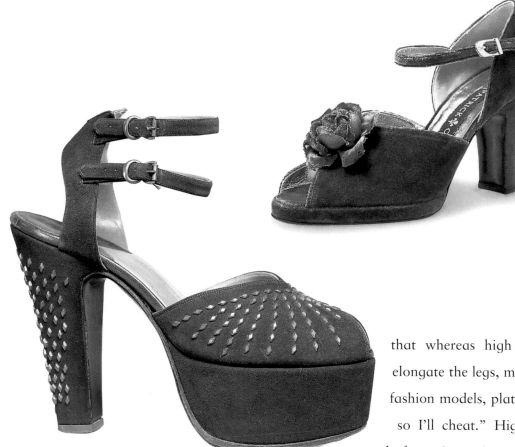

ABOVE Chunky soles work particularly well with sandals, the heavy base balanced by the open vamp — either in the subtle form of Patrick Cox's purple suede retro model or in Halstern's substantial platform with ankle straps, dating from 1947.

OPPOSITE Platforms are an acquired taste, loved by some women for the elevated status they bring, despised by others for their association with the "decade that taste forgot." Salvatore Ferragamo's platform dates from 1938-9 but its stacked sole would make it coveted by many 1970s disco divas.

that whereas high heels are elegant and sexy, and elongate the legs, making ordinary women look like top fashion models, platforms just seem to say, "I am short, so I'll cheat." High heels give a sexy gait, whereas platforms just raise you up, at the cost of weighing down your steps. Of course, there are some attractive platforms, admitted the author, citing a pair of Orientalist platform sandals by Christian Louboutin: "*C'est magnifique.*" But if platforms were too extreme and awkward, she warned, they would rarely be shown in *Vogue*.[8]

Obviously, platform soles can be paired with any kind of shoe or boot, but they are particularly popular today on sandals. This is probably because the open structure of the sandal lightens what might otherwise appear to be the overly heavy look of a massive platform. "Secretly I pray platforms will return in a big way," writes Ann Magnuson longingly. "I always liked being tall, but my poor dogs can't take prolonged hours in high heels anymore. I need something orthopedic yet stylish …"[9] Manolo Blahnik, however, can find nothing good to say about them, insisting, "I absolutely hate platforms. They remind me of the hideous 1970s glam-rock style. You should elongate the leg — whereas platform shoes give you these huge surgical things on your feet!"[10]

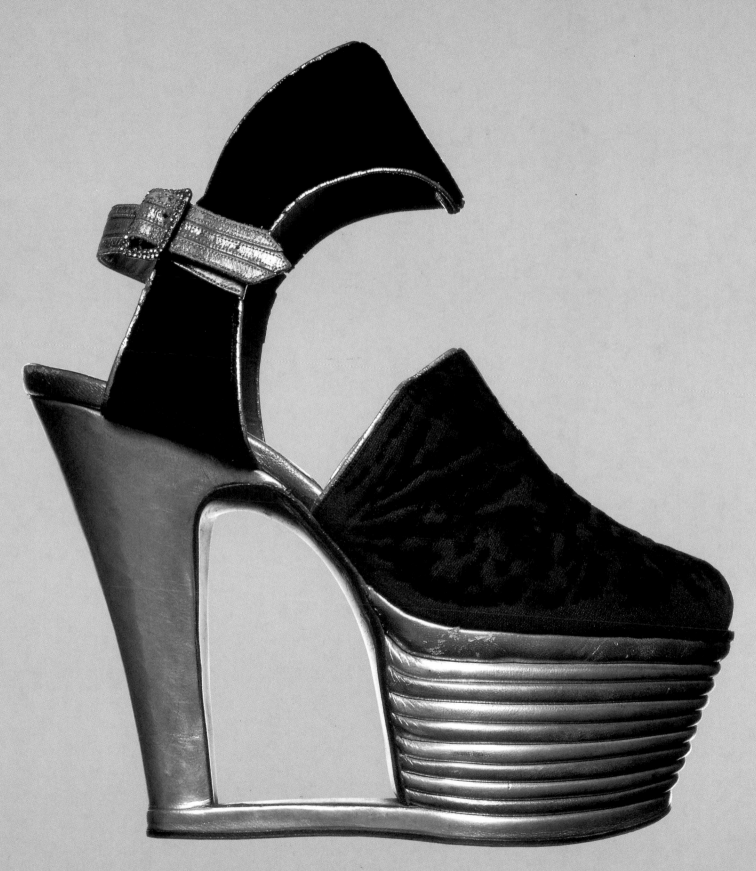

LEFT The antithesis of the dainty, strappy, barely-there sandal is Sergio Rossi's hefty yellow patent slide with rubber tread.

BELOW A chunky heel is balanced by a fine sole, a simple plaited strap for the toe, and one over the arch in this Séducta design.

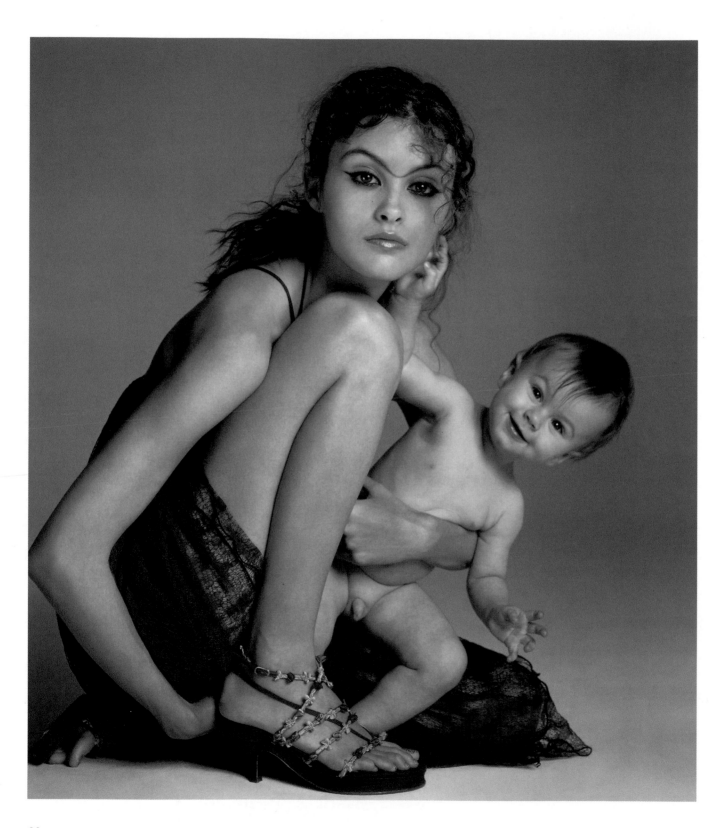

OPPOSITE Richard Avedon's photograph for Romeo Gigli emphasizes beauty and youth, qualities echoed in the rosebud sandal on its tiny platform.

BELOW Sandals are inextricably bound up with the prospect of summer vacation. Feet are scrubbed and polished and toenails painted in anticipation of exposure in the perfect pair of sandals.

Robert Clergerie

ABOVE Laid-back luxury. Gucci combines minimal form with status icon in this modern matt-black Capri sandal.

If there is a continuum between fine fashion and fun fashion, obviously platform sandals belong in the fun category. They tend to appeal more to young people, and are often made in inexpensive materials, such as wood or cork. Platforms are also irrevocably associated with the 1970s, which is often described as "the decade that taste forgot." Certainly, youth fashions of the early 1970s tended toward excess. Style journalist Peter York once called it the "Big Leggy" look — as men and women alike donned trousers with wide flared hems and shoes with towering platform soles and clunky big heels.[11]

It was all very glam rock, but even at the time, it was a retro style, evoking the platform sandals that Carmen Miranda had worn in the 1940s. Indeed, probably the most spectacular platform sandals of the twentieth century were those designed by Salvatore Ferragamo in the late 1930s. Some of these, which were probably intended for theatrical clients, deliberately recalled the *chopines* worn in the sixteenth century by Venetian courtesans.

More than 1,000 years earlier Roman courtesans sometimes had the soles of their sandals engraved so that their footprints read "Follow me."[12] Something of the same erotic allure is conveyed by the red soles which are so conspicuous a feature of all the shoes designed by Christian Louboutin. According to Louboutin, the red soles were inspired by the chance visit of an extremely attractive young couple to his Paris shop.

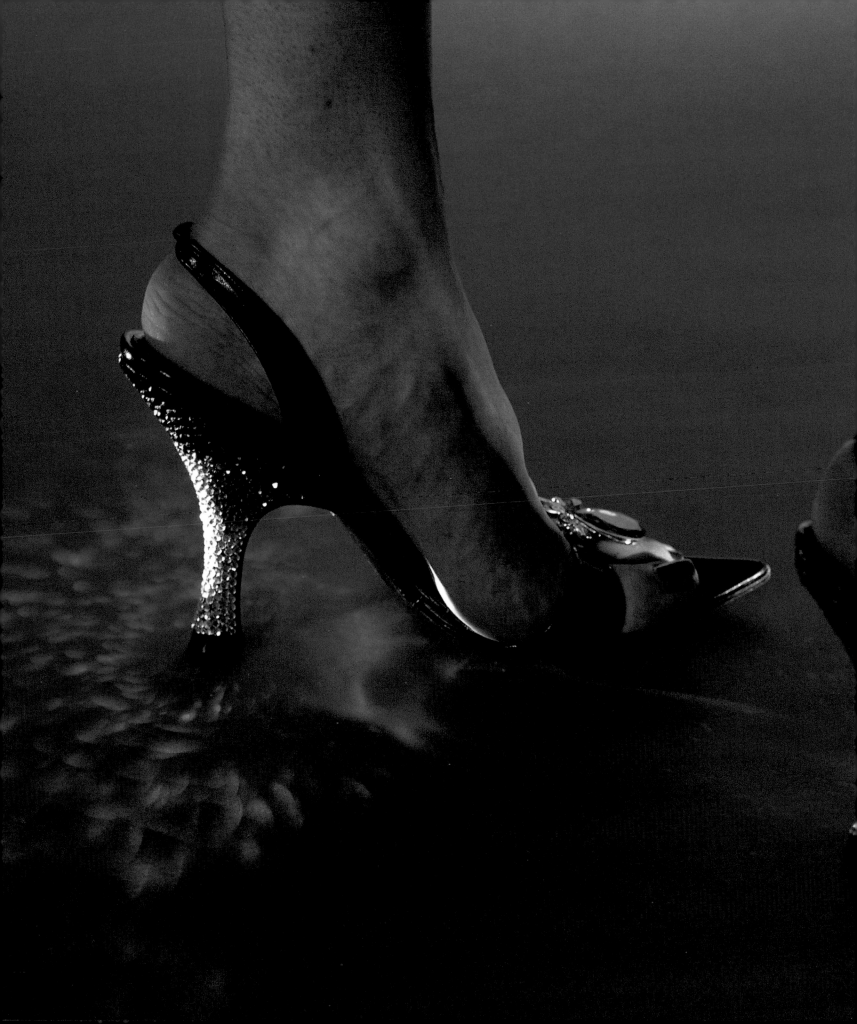

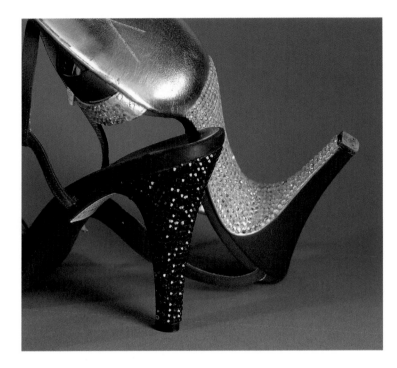

OPPOSITE Nothing draws attention to the foot like a generous

smattering of rhinestones, to be worn at night for maximum

effect. These showy slingbacks are by Vivienne Westwood.

ABOVE A heel encrusted with red rhinestones graces Halston's

satin sandal from 1979, while Valentino goes one step further by

cladding the sole with diamantés.

RIGHT Sandals provide a showcase for toenails, the colors of which can convey messages about mood, personality, and style predilections. Vermilion red symbolizes passion.

BELOW Emma Hope's dainty slide captures the magic of warm summer days with their iridescent flowers and butterflies.

The man picked up a shoe and examined it carefully, but when he turned it over to look at the sole, he appeared to be disappointed and put the shoe back down again rather hastily. A few minutes later, he and his girlfriend left without purchasing anything.

"Did you notice how he looked at the sole of the shoe?" Louboutin asked his assistant. "I wish we could have put something there that would have attracted him."

"How about my telephone number?" she joked.

Louboutin could not forget the incident, and not long after he suddenly thought of painting the soles of his shoes red. There was, of course, a precedent for this fancy in the seventeenth- and eighteenth-century fashion for red heels. Louboutin's experiment with red soles seemed successful, so the next season he tried green soles.[13]

Although these also looked pretty, they lacked the same strong appeal, because red is a peculiarly powerful color in both visual and symbolic terms. It is the color of fire, blood, passion, and revolution. We speak of the scarlet woman and the red-light district. Stop signs are red, and shoes

RIGHT Sergio Rossi's supple leather footbed and fine straps make
an elegant statement on the intrinsic simplicity of the sandal.

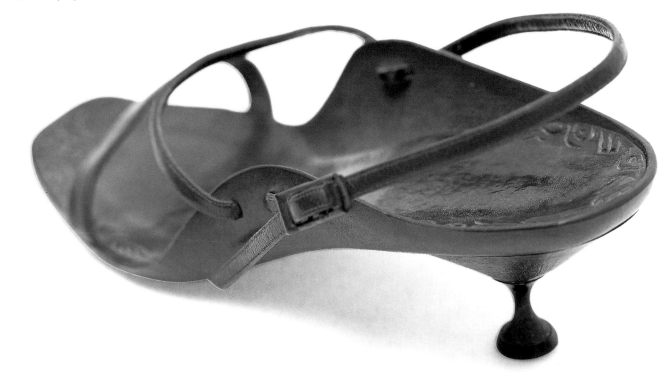

with red soles certainly grab attention. Indeed, red shoes in general are said to exert a powerful attraction on many men. Louboutin's red soles also recall the shoes with diamond-encrusted soles which were worn on stage by the famous nineteenth-century courtesan Cora Pearl. As an observer recalled, "In one last extravagant gambol, she threw herself flat on her back and flung her legs up in the air to show the soles of her shoes that were one mass of diamonds."[14]

Cora Pearl also appeared on stage as Cupid in Offenbach's operetta *Orpheus in the Underworld*. Although she played a Greco-Roman deity, she did not wear sandals, because they were not in fashion during the 1860s. (Instead she wore boots.) Indeed, although sandals are one of the most ancient types of footwear — first appearing in the Mediterranean world around 3000 BC — sandals were seldom worn in Europe after the fall of the Roman Empire. The only exception was during the Directoire period in France (1795–99), when

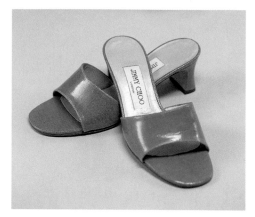

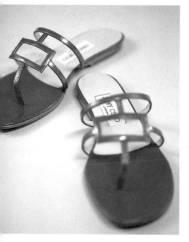

ABOVE Fashions of the 1950s that have never gone out of style: the summer slide and the Capri sandal.

OPPOSITE Liberating the foot, Robert Clergerie reduces the shoe to its bare minimum for maximum effect.

sandals were temporarily revived as part of the neoclassical style.

Sandals next became fashionable in the 1920s, concurrent with the rise of the Riviera as a vacation scene. Although less conspicuous during the Depression and World War II, sandals came back into fashion in the 1950s, and never again fell out of style. The reappearance of sandals in the twentieth century thus marked a milestone in the history of footwear. In more general cultural terms, sandals were one aspect of the movement toward women's social and sexual liberation. Their significance parallels women's new freedom to wear trousers, short skirts, and revealing swimwear.

Certain kinds of sandals have also been explicitly associated with a bohemian way of life. Thus, early-twentieth-century socialists and dress reformers, such as Edward Carpenter, habitually wore sandals, which had "the liberatory effect of emancipating feet from shoes ... One begins to own one's body at last."[15] Later, beatniks and hippies also favored sandals; and during the 1960s and 1970s, when they were first introduced from Germany to the United States, Birkenstocks, in particular, acquired the reputation of being a "crunchy granola" shoe, appropriate for hippies, hikers, and lesbians.

Although once regarded as ugly and orthopedic-looking, the Birkenstock has now become the prototype for a host of deliberately frumpy high-fashion sandals by designers such as Prada and Gofreddo Fantini. "The footbed is completely modern," says Patrick Cox. "It's slip on, slip off. It's very nineties and all about comfort."[16] The footbed sandal can be identified by its deep bed of suede-covered cork and wide spatula shape, which follows the form of the

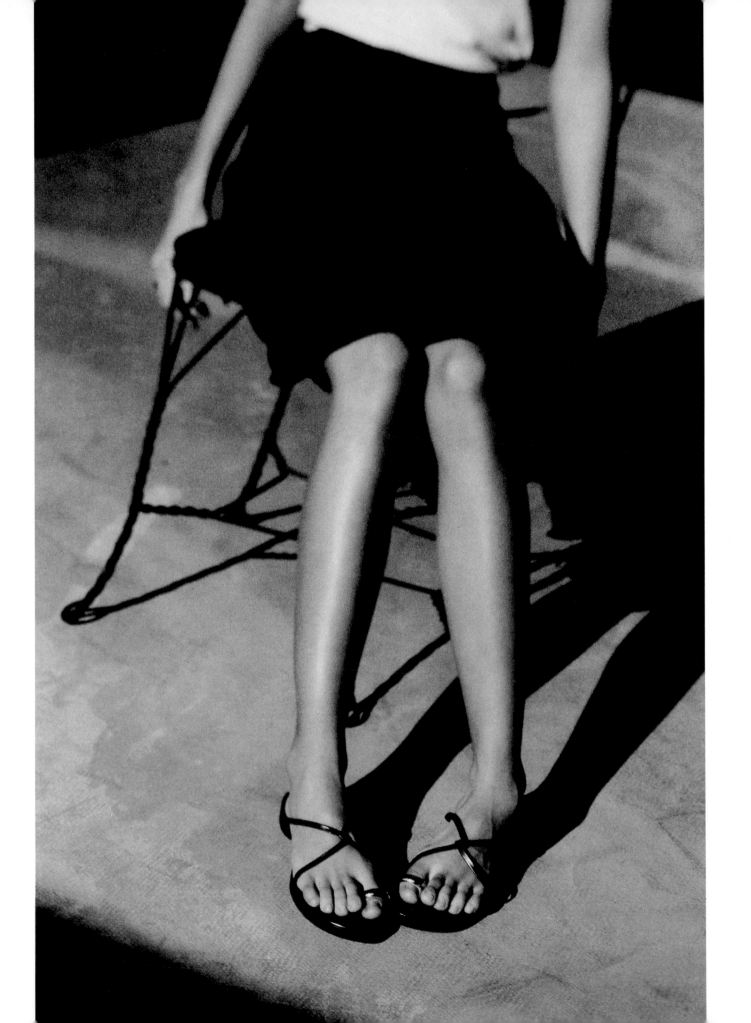

OPPOSITE Emulating the barefoot feel with grass and daisies underfoot, Red or Dead's platform thongs.

RIGHT The re-emergence of sandals in the twentieth century parallels the move toward women's liberation, including the freedom to wear revealing clothes.

BELOW RIGHT Manolo Blahnik's high-heel slide demands supreme foot confidence, the sole held on with tiny bikini ties.

foot. This shoe is about sole. If the shape is right for your foot, then the design of the upper is relatively unimportant. The flatbed can be a slide, a thong, or a slide with an ankle strap. The main characteristic is its extremely comfortable sole. Narsico Rodriguez had Birkenstocks make sandals for one of his fashion shows, and Chrome Hearts custom-makes a special Birkenstock buckle for $1,500. Jil Sander's plasticized leather sandals seem equally suited to posing at a cocktail party or hiking up a hillside.

Sports sandals have also emerged as an important style. Described as a cross between a rubber thong and a stripped-down running shoe, sports sandals were initially conceived in 1983 by white-water rafter Mark Thatcher as a non-slip, quick-drying alternative to athletic footwear. They consist of a tough rubber sole, securely held on the foot by a web of comfortable, durable straps. The best-selling brand, Teva, comes in a variety of styles and colors. First adopted by college students and hikers, it now appeals to consumers who like the combination of high-tech functionalism and a back-to-nature aura.[17]

"Are You Shy About Baring Your Feet?" asked a full-page advertisement in *The New York Times*. Many people suffer from unsightly feet, suggested the text, and it is necessary to take care of one's feet before exposing them. According to William Rossi, however, the real reasons for shyness derive from an "instinctual feeling about the foot's erotic character and the sense of nudity when the foot is bared."[18] There is certainly a great deal of historical and anthropological evidence to support Rossi's contention. The great shoe designer Perugia once said that "almost every woman is not only conscious

RIGHT Sandals for evening. Jimmy Choo's bright blue stiletto pulls out all the stops for maximum sex appeal with its shiny satin strap and ultra-thin heel. Sigerson Morrison's dark purple velvet slide is more subtle in its appeal, drawing on the glamour of the movie-star mule but tempering it with regal color and deluxe fabric.

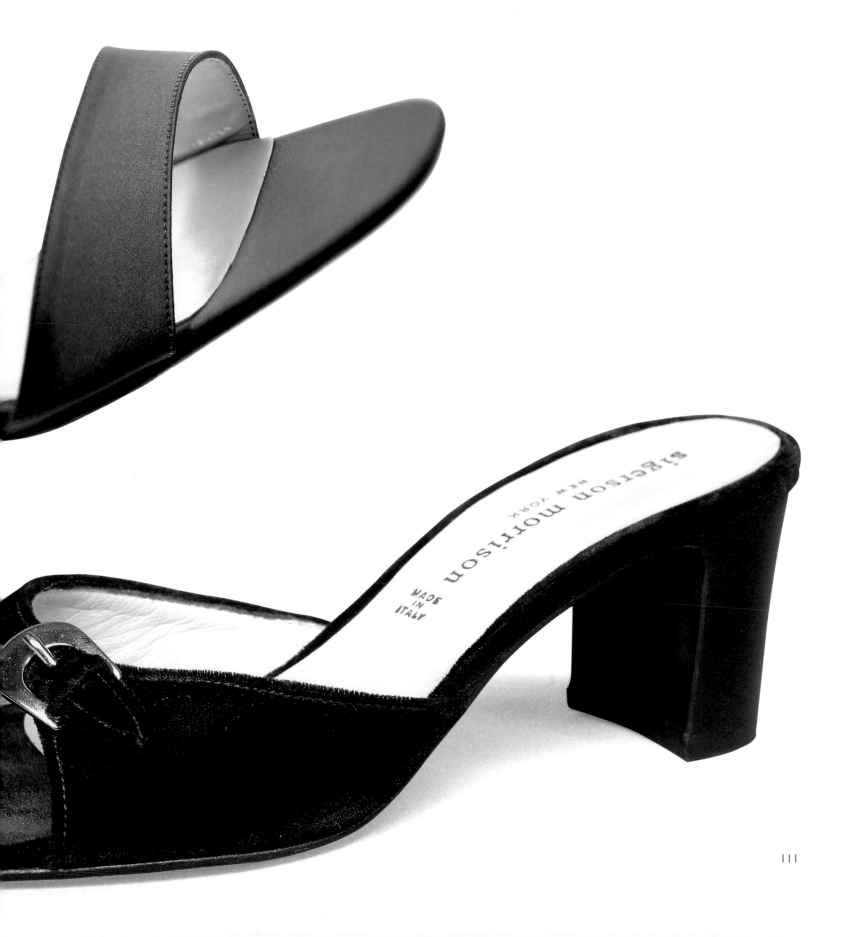

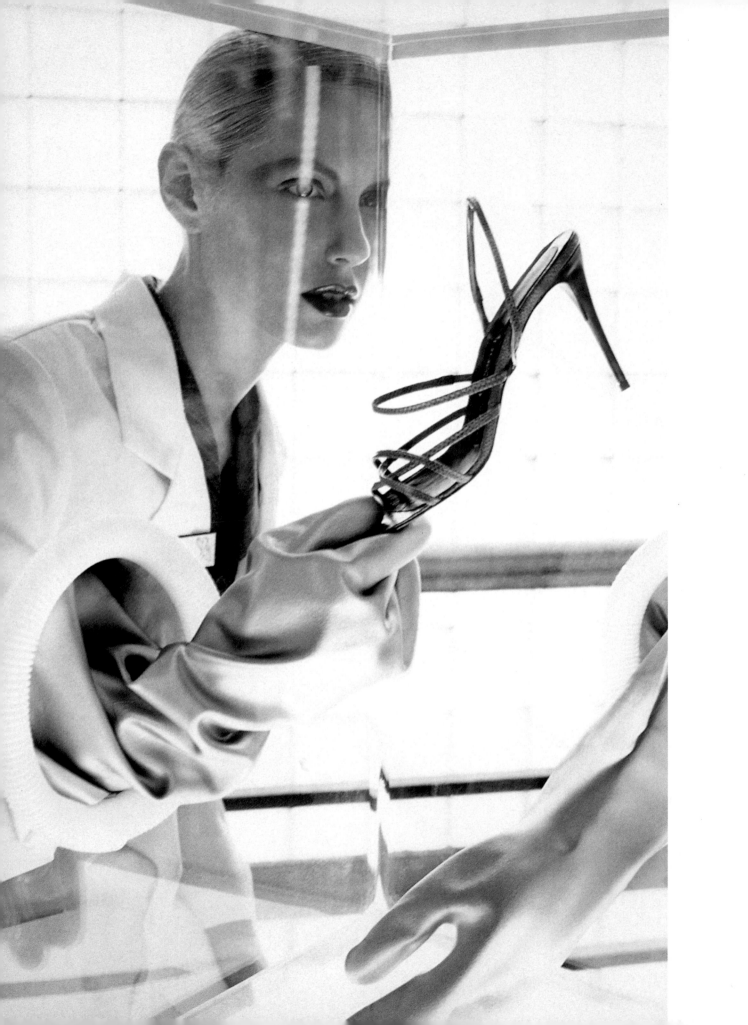

OPPOSITE An image of Donna Karan's slender, strappy high-heeled sandal for the store Neiman Marcus emphasizes the fantasy element of such shoe styles.

of her feet, but sex conscious about them."[19] And yet we may still wonder why naked *feet* are more sexual than, say, naked elbows.

Dr. V. S. Ramachandran may have uncovered the reason why feet are sexy. In his astonishing book *Phantoms in the Brain: Probing the Mysteries of the Human Mind*, he explores the way different parts of the body surface are mapped onto the surface of the human brain. The map — called the Penfield homunculus — was drawn from information which came from real human brains. Ramachandran recounts a dramatic story:

"During the 1940s and 1950s the brilliant Canadian neurosurgeon Wilder Penfield performed extensive brain surgeries on patients under local anesthetic (there are no pain receptors in the brain, even though it is a mass of nerve tissue). Often, much of the brain was exposed during the operation and Penfield seized this opportunity to do experiments that had never been tried before. He stimulated specific regions of the patients' brains with an electrode and simply asked them what they felt. All kinds of sensations, images, and even memories were elicited by the electrode, and the areas of the brain that were responsible could be mapped."[20]

Penfield discovered that sensations from different parts of the body were mapped in an interesting way on the surface of the brain. Certain body parts that are particularly important (such as the lips or fingers) take up disproportionately large areas. The area of the brain surface corresponding to the lips, for example, takes up as much space as that involved with the entire trunk of the body. "For the most part, the map is orderly, though upside down." (The

ABOVE LEFT At the other end of the spectrum to the barely-there stiletto, Joan & David's solid, sensible sandal.

ABOVE The slenderest of soles and the simplest of straps are all there is to this retro-inspired slide by Jimmy Choo.

OPPOSITE An arched foot and an extended ankle look sexy in this photograph by Frank Rispoli.

ABOVE A feathery sandal highlights lacquered toenails. Looking down at one's own painted nails creates a sense of visual pleasure for the wearer of the summer sandal.

foot is at the top, the arms at the bottom.) "However, upon closer examination, you will see that the map is not entirely continuous. The face is not near the neck, where it should be, but is below the hand. *The genitals, instead of being between the thighs, are located below the foot.*"

One day a female neurologist at Beth Israel Hospital telephoned Dr. Ramachandran and told him that she was studying phantom limbs, which are a common phenomenon among those who have lost parts of their body. She herself had been in an accident and lost her left leg below the knee. "I'm calling to thank you," she said, "because your article made me understand what is going on. Something really strange happened to me after the amputation that didn't make sense. Every time I have sex I experience these strange sensations in my phantom foot. I didn't dare tell anybody because it's so weird. But when I saw your diagrams, that in the brain the foot is next to the genitals, it became instantly clear to me."

Then a male engineer called with a similar story, except in his case, he said, "I actually experience my orgasm in my [phantom] foot. And therefore it's much bigger than it used to be because it's no longer just confined to my genitals." As Dr. Ramachandran observed, apparently "it's not just the tactile sensation that transferred to his phantom but the erotic sensations of sexual pleasure as well." And he added: "A colleague suggested that I title this book, *The Man Who Mistook his Foot for a Penis.*"

Dr. Ramachandran's research indicates that the electro-chemical signals

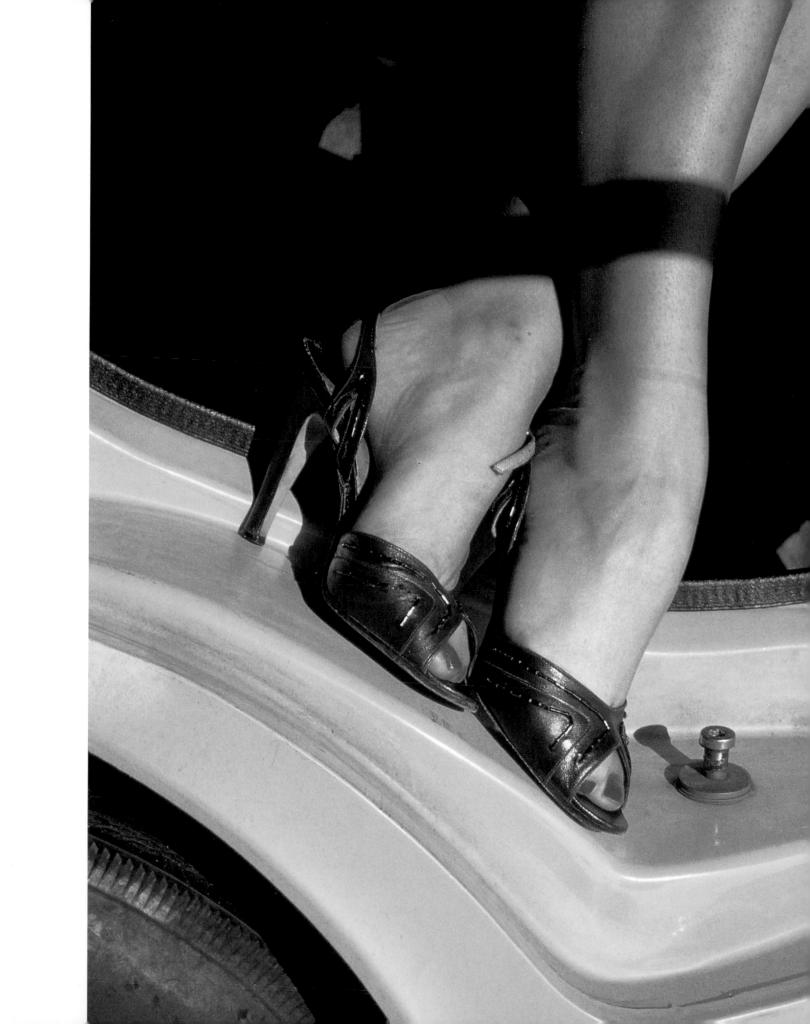

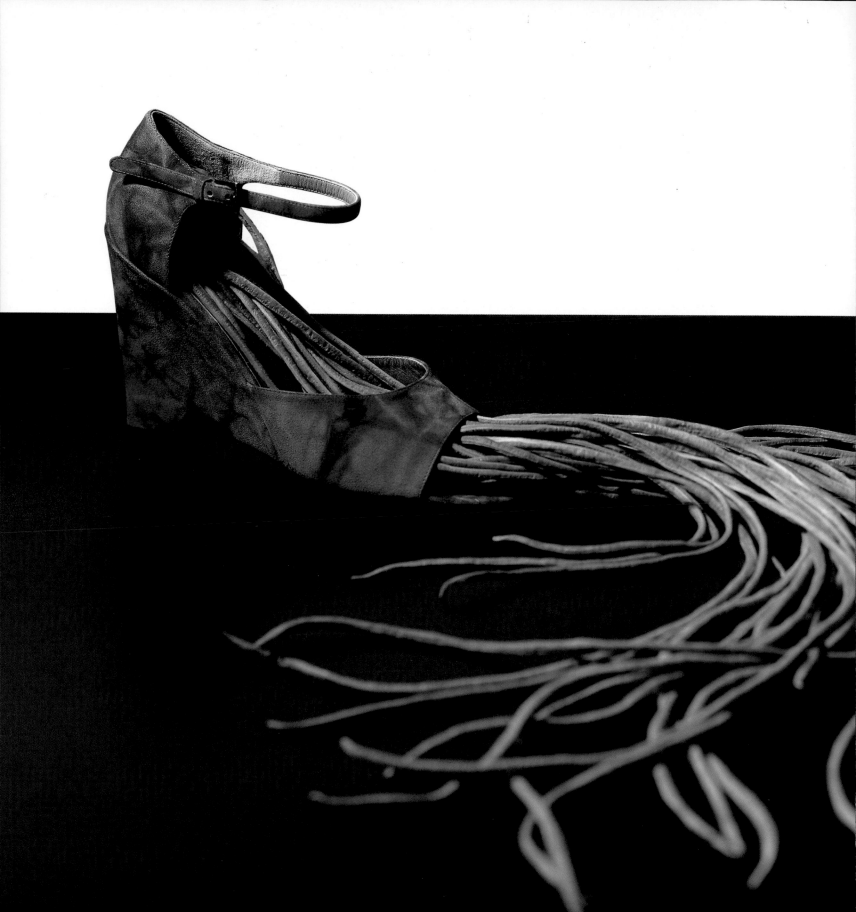

OPPOSITE This surreal image of a Prada shoe by Cornelie Tollens

reminds us that feet are extremely sensitive to tactile sensations.

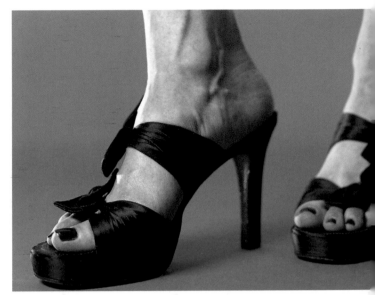

ABOVE Christian Louboutin does the platform sandal with style, recalling the glamour of 1930s Hollywood. He uses black satin bows to dress the naked foot, and his trademark red soles to draw the attention of the onlooker.

that the mind interprets as sensations can spill over from one brain-surface region to the other. The receptor areas for feet and genitals are immediately adjacent to each other. The people who lost their legs experienced a remapping phenomenon, which is "what you'd expect if input from the genital area were to invade the territory vacated by the foot." But it is possible, even likely, that many of us have "a bit of cross-wiring," which would explain why we perceive fondling and caressing of the feet as sexually pleasurable, and why we involuntarily curl our toes in response to sexual pleasure.

I would argue that many people have thought sandals are sexy precisely because the foot itself is sexually arousing. And not only for men like Saint Jerome, who *see* a woman's naked foot, but also for women, who *experience* erotic sensations in their own feet. Finally, it is worth remembering that women also see their own feet. To look down and notice painted toenails peeping out of sandals is one of summer's small but very real pleasures. As *Vogue* once put it: "Shining Color — at your Feet." The accompanying picture showed nine feet in sandals: "Sexy, isn't it! All this dark, iridescent allure! As you can see … nail color is really stepping lively at night now."[21]

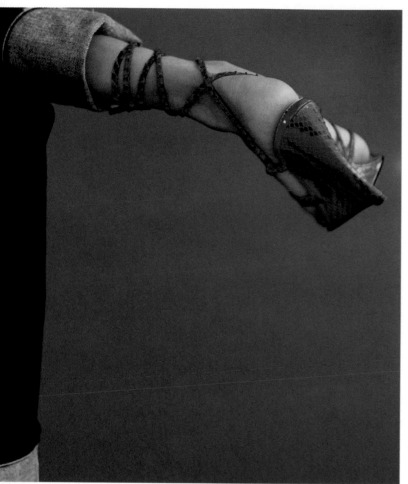

LEFT The pink snakeskin ankle straps of this stiletto sandal by Free lance symbolize erotic bondage.

OPPOSITE Todd Oldham's barbed-wire sandal, photographed by Max Cardelli, emphasizes the vulnerability of the exposed foot, the prickly straps wrapping around smooth skin.

RIGHT Prada's design takes up the bondage theme, with ivy trailing up the heel to wrap around the ankles and toes.

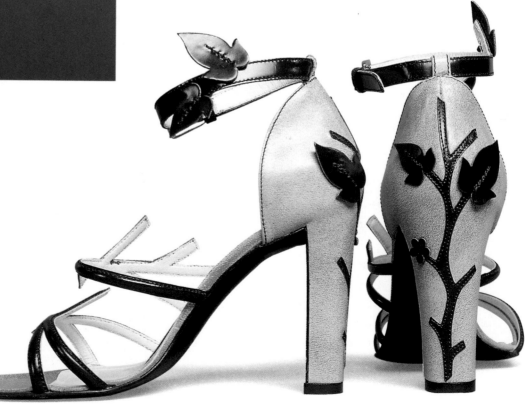

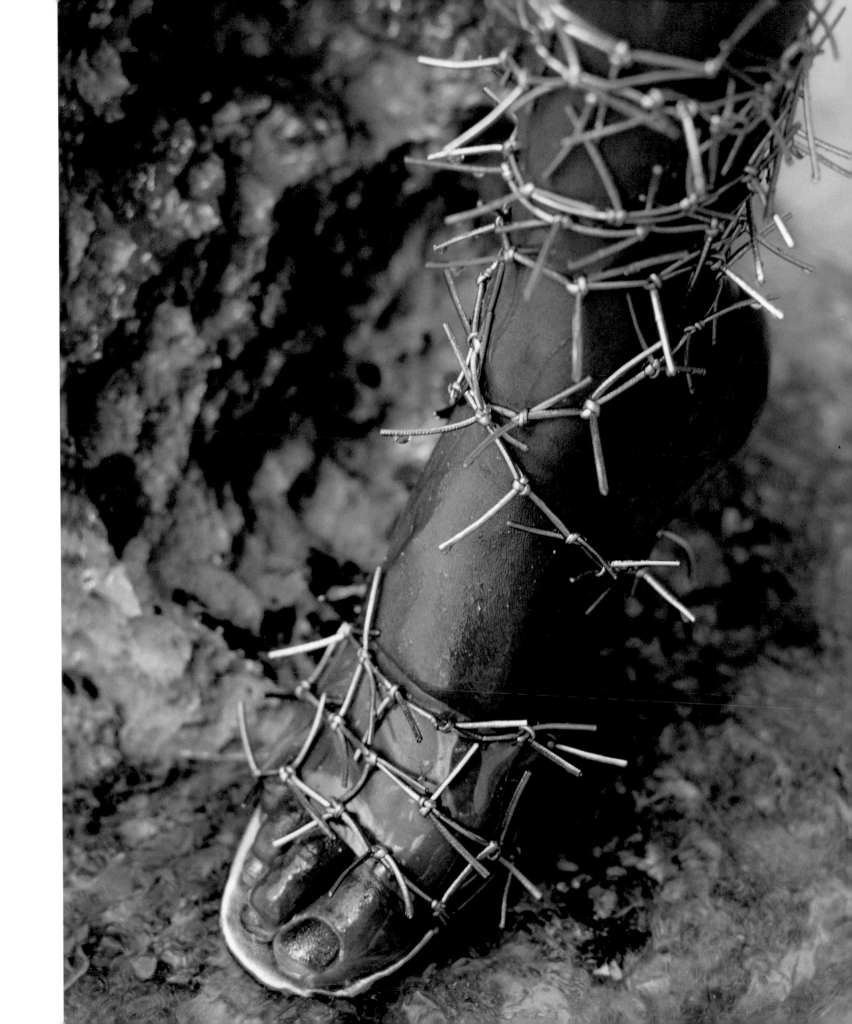

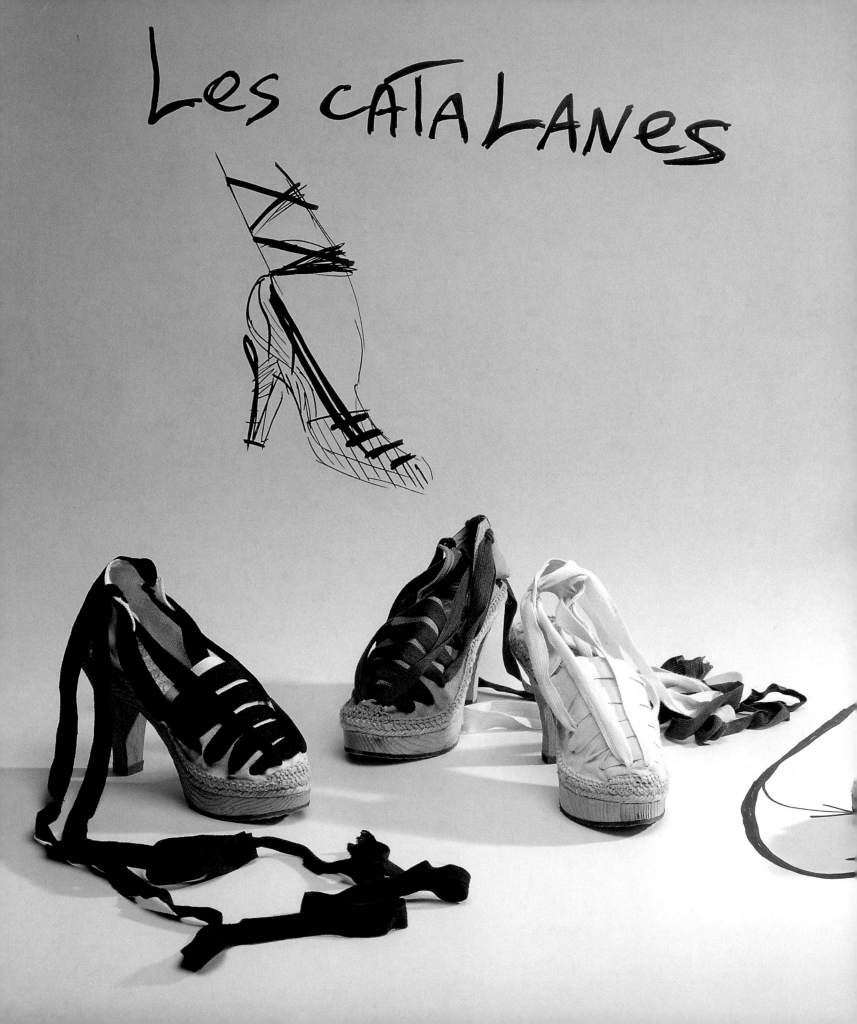

Les cataLanes

plateForme sAblée.
RubAns de saTin pour
le soir.

LEFT Christian Louboutin draws on global influences for his shoe designs. Here the traditional footwear of Catalan serves as inspiration for a line of chic lace-up sandals.

ABOVE & RIGHT Just as an abundance of straps and ties creates a particular visual message, so likewise does an absence of secure fastening. Gina's diamanté-encrusted flat and Todd Oldham's high-heeled 'Barbie' slide look almost impossible to wear.

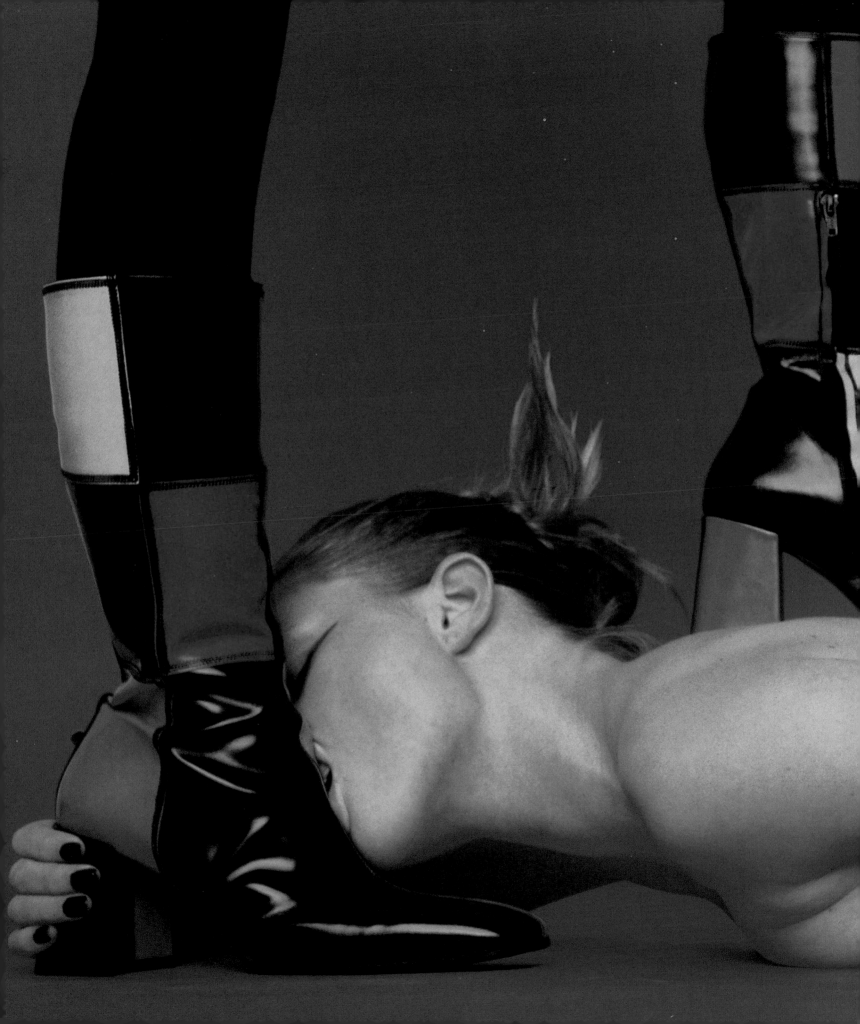

Booted Amazons

booted amazons

"Fashion designers have crossed Emma Peel with Betty Page to come up with ... boots that would look smashing with a rubber mac and a horsewhip."[1]

Ann Magnuson

ABOVE Fashion illustrator Liselotte Watkins gives her modern-day Calamity Jane a pair of high-heeled mid-calf boots.

OPPOSITE With a knife-edge heel and rich red velvet, Gucci's boots walk a fine line between bold dressing and trashy taste, the essence of postmodern style. Photographed by Mario Testino.

"I have nothing against boots ... and I'm well aware that a whole category of fetishist worships them. But they fail to work for me simply because they enclose and therefore hide the foot," writes Geoff Nicholson.[2] Ah, but what about the legs, Geoff? Boots convey a very different message than other kinds of shoes, because they not only cover the foot, they also have a "leg" that rises, at the very least to the ankle, often climbing to the calf, the knee or even halfway up the thigh. Legs are not only the organs of locomotion, they are also the pathway to the genitals, as well as constituting an erogenous zone of their own.

"These boots are made for walking," says the song. "All over someone," adds Mimi Pond. "No matter if they are stiletto or flat-heeled, black or pink, knee-high or demi-ankle, boots instill you with a certain Power."[3] What, though, is the source of this power? As with most symbolism, the boots-power nexus derives largely from the history of this type of footwear.

Boots have long been associated with horseback riding. "Put on thy boots, we'll ride all night," wrote Shakespeare. Hence also the expressions "booted and spurred" and "boots and saddles."[4] This connection with horseback riding inevitably resulted in military connotations, since for millennia cavalrymen were most formidable warriors. In feudal societies, like early modern Europe, the man on horseback was also the aristocrat, the knight, literally the *chevalier*. Thus, the boot implicitly symbolized both power and high status.

Obviously, boots have also had utilitarian functions in everyday life. On rainy days or when the ground is covered with snow, boots provide protection from the elements. Moreover, historically, boots have not exclusively been worn

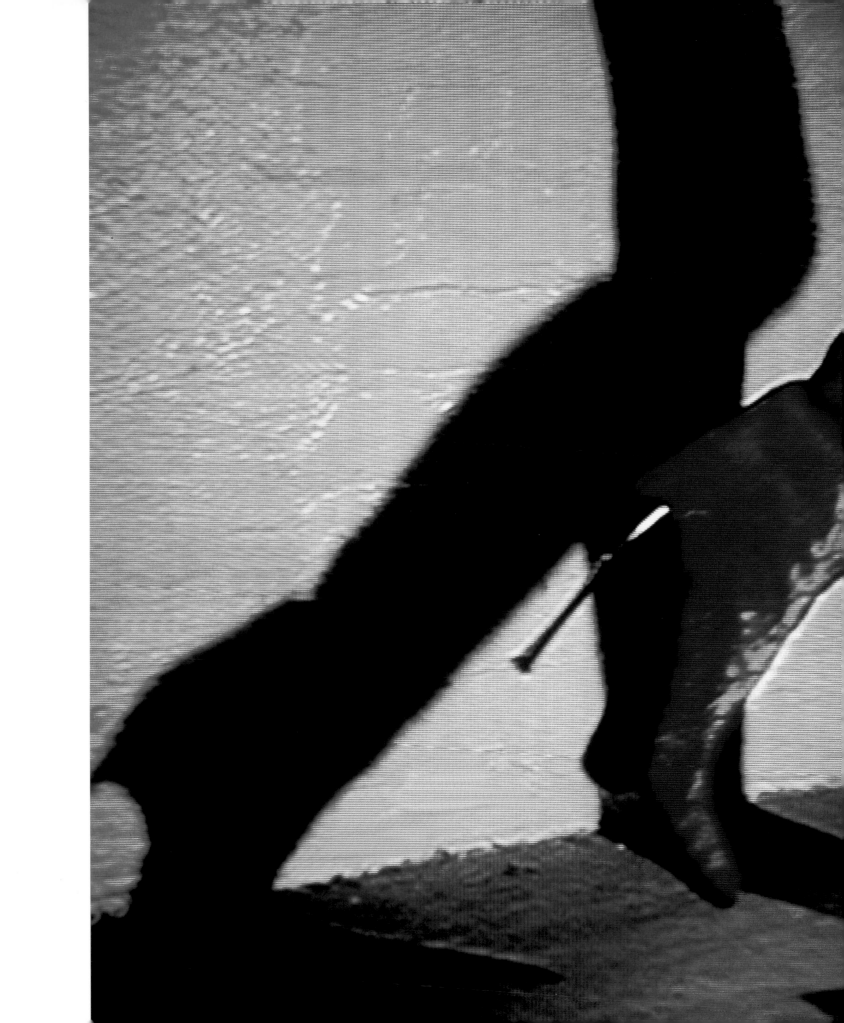

BRUNO MAGLI

OPPOSITE Thigh-high boots like these by Bruno Magli evoke images of swashbuckling pirates and muskateers.

by men. Throughout the nineteenth century many women wore ankle boots for walking and riding. Nevertheless, the predominant symbolism of boots has been masculine and militaristic.

"A soldier in shoes is only a soldier. But in boots he becomes a warrior," declared General Patton. The German leader Bismarck agreed: "The sight and sound of good Prussian boots on the march are a powerful military weapon by themselves."[5] By functioning as shin guards (or greaves), boots protect the legs, while also supporting the ankles, making it easier to march for long distances over rough terrain. Boots can also function as weapons. Indeed, used as a verb the very word to *boot* is synonymous with kicking. Merely by wearing boots, as opposed to lighter shoes, a man would become conscious of his greater strength.

Because of their historic association with soldiers, *jack-boots* (a certain type of heavy, over-the-knee boot) have become synonymous with bullying, oppressive militaristic tactics. There was also an instrument of torture called the boot, which was used in Scotland in the late Middle Ages. It consisted of a metal vice that fitted over the leg from the knee to the ankle, and was tightened with screws, eventually crushing the lower leg. "Shall I draw him on a Scotch pair of boots, Master, and make him tell all?"[6] Few people are aware of this antiquated use of the term, yet the dictionary reminds us of many other expressions which are still commonly used.

Because of their association with kicking, to *get the boot* or to be *booted out* means to be dismissed, fired, or roughly ejected. To *die with one's boots on*

ABOVE LEFT & BELOW Chanel's boots are an ultra-stylish rendering of French desert army gear, while Versace's have the polished sheen and strict cut of police boots.

OVERLEAF Photographer Miles Aldridge's sexually charged image of Sergio Rossi's high-heeled boots.

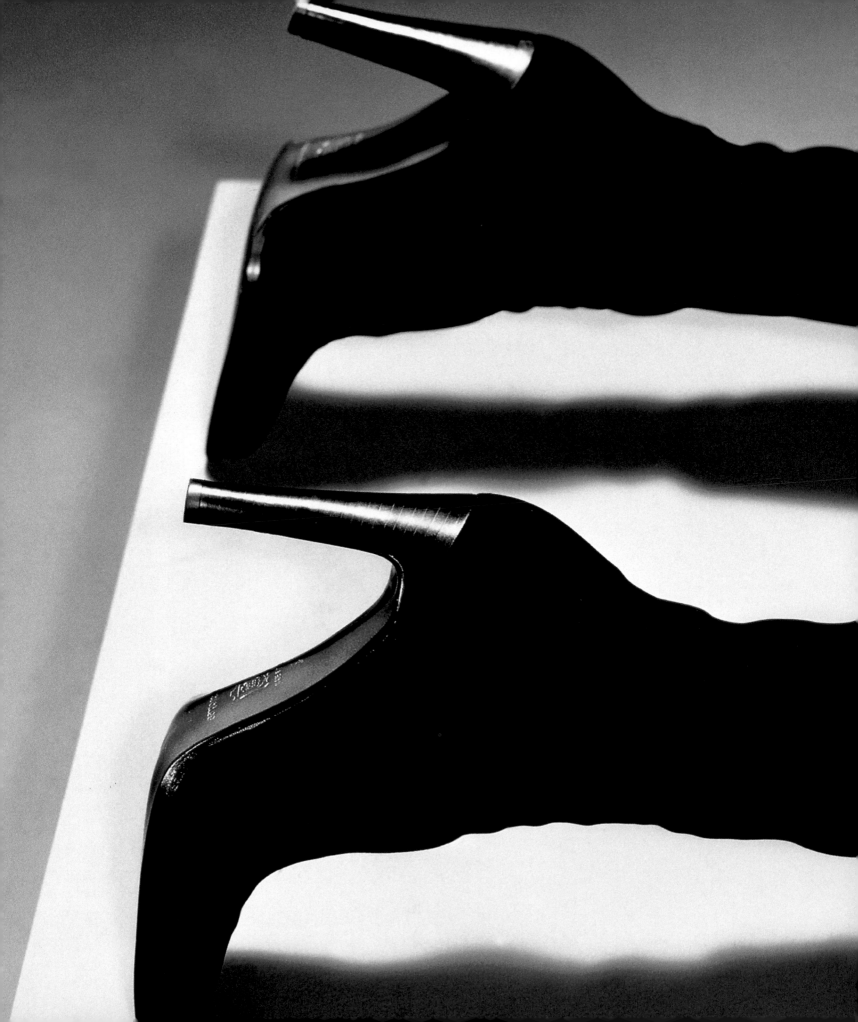

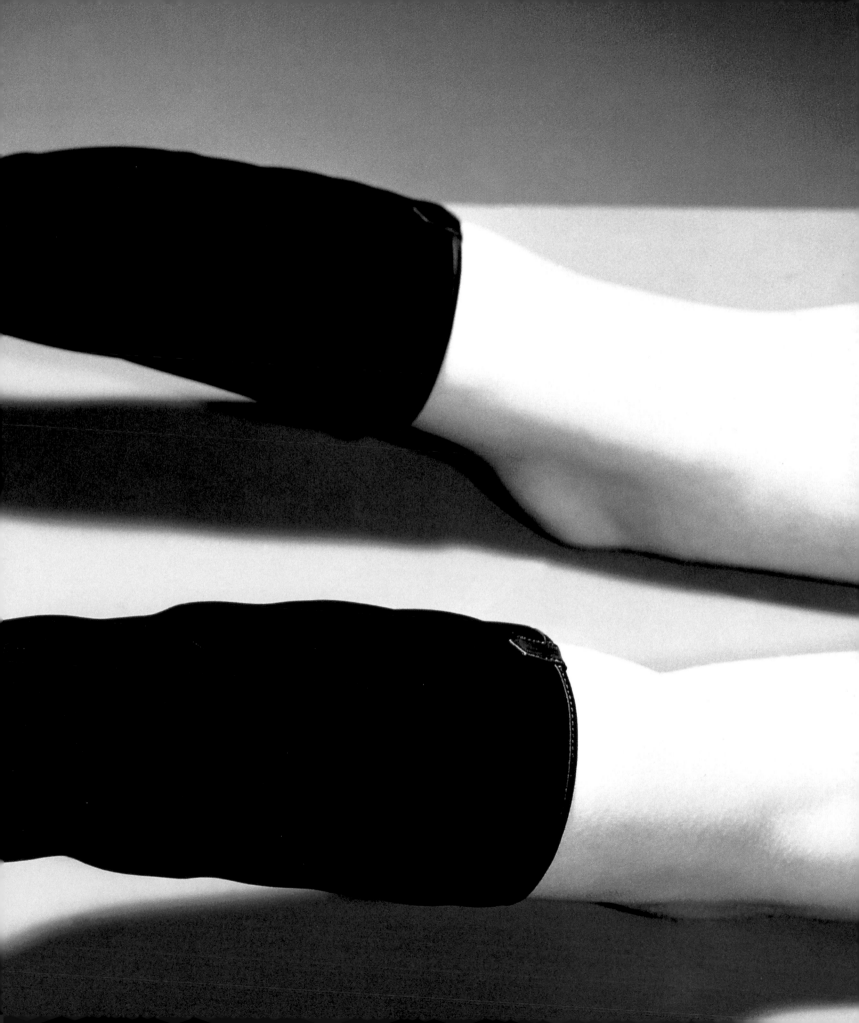

LEFT The riding boot is among the haughtiest of footwear styles

for women. This variation is by Stéphane Kélian.

means to die while actively engaged in work, and especially while in battle. *Booty* refers to loot, in particular the spoils of war, and *bootleg* refers to illegal liquor.[7] In essence, then, boots convey an image of potent masculinity. Yet it is precisely this aura of phallic power that makes women's boots so sexy.

Booted women have long been associated with Amazons, the *femmes conquérantes* of ancient mythology. The *Amazone* was a powerful erotic icon throughout the nineteenth century, celebrated in art and literature for her strength, courage, and grace. Beautiful and feminine, she nonetheless controlled the powerful animal beneath her. "She puts on some small boots furnished with silver spurs," observed one nineteenth-century author.[8] Today, too, the popular imagination acknowledges the fetishistic appeal of the "Riding Mistress," and prostitute cards in phone booths advertise "Horse Riding Fantasies."

Kinky boots, long the trademark of the professional dominatrix, first became fashionable in the 1960s as part of the sexual revolution. Kinky boots had high heels and covered the leg at least to the knee — and often to the thigh. They frequently laced or buttoned closed. Yves Saint Laurent was especially famous for designing thigh-high crocodile boots and Mary Quant grabbed attention for her knee-high corset-laced boots. The fetishist magazine *High Heels* asked in amazement: Was it "fashion or fetish?" A reader of *Bizarre Life* submitted two pictures of English fashion model Jean Shrimpton, along

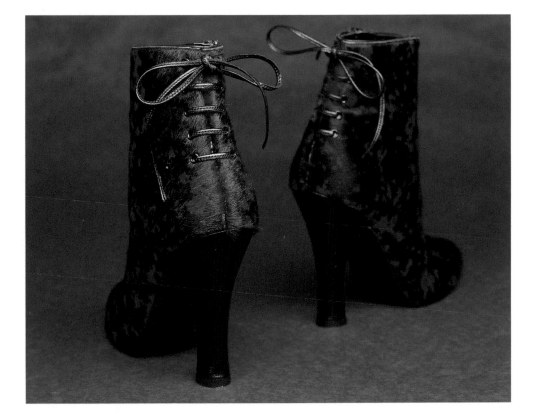

with a note: "I thought your readers might get a thrill out of seeing [these]. The 'Kinky' boots send shivers up my spine whenever I look at them, and I must admit that Jean's long, luxurious hair is thrilling, too."[10]

Bitches in Boots, another fetishist magazine, was aimed specifically at masochistic men who obtained sexual pleasure from being stepped on or stomped on by women in high-heeled boots. For these "bootmen," low shoes were far less exciting than high boots. As the sexual revolution continued to escalate throughout the 1970s, all sorts of sexual "perversions" became increasingly accepted. "Dig black stockings and boots?" asked a 1975 article in the popular journal *Sexology*, adding reassuringly, "There's a bit of fetishist in everyone."[11] Soon even mainstream fashion companies, such as Montgomery Ward, began selling the kind of high boots formerly worn by prostitutes specializing in sadomasochism.

TOP & ABOVE The back-lacing on Martine Sitbon's ankle boot for Stéphane Kélian and the leather strapping on Patrick Cox's knee-high version both allude to the fetish connection.

OVERLEAF Boots by Versus that erotically conceal and reveal.

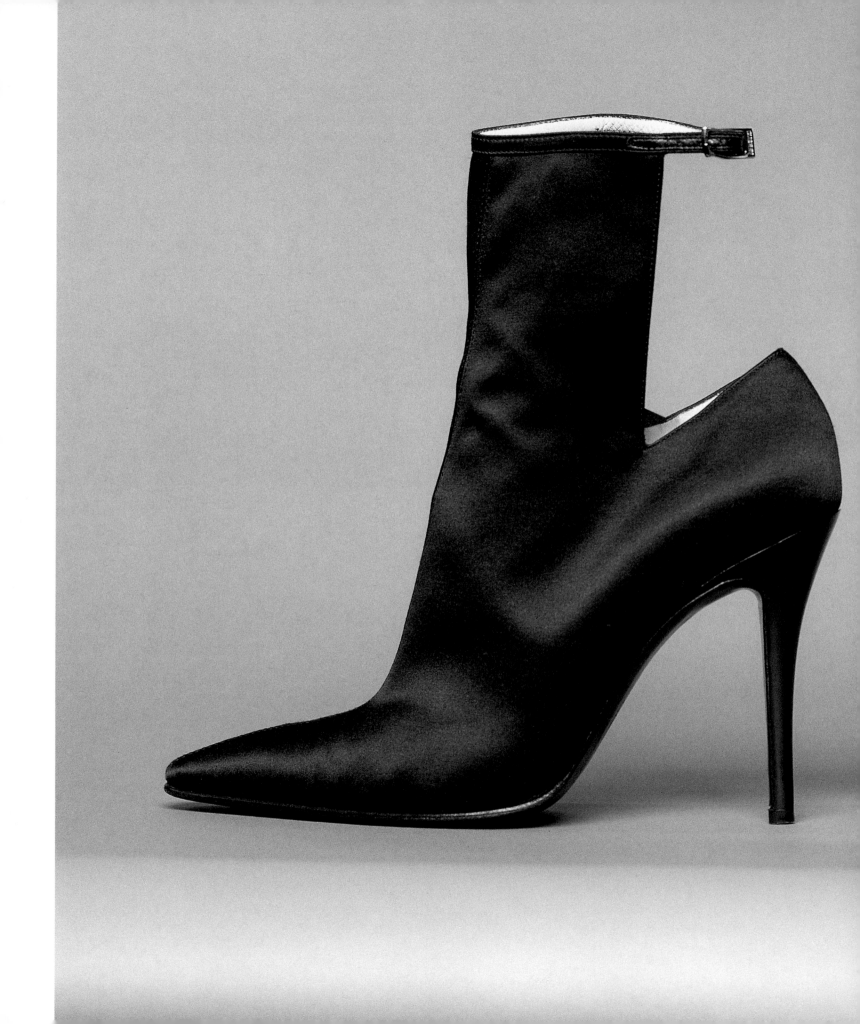

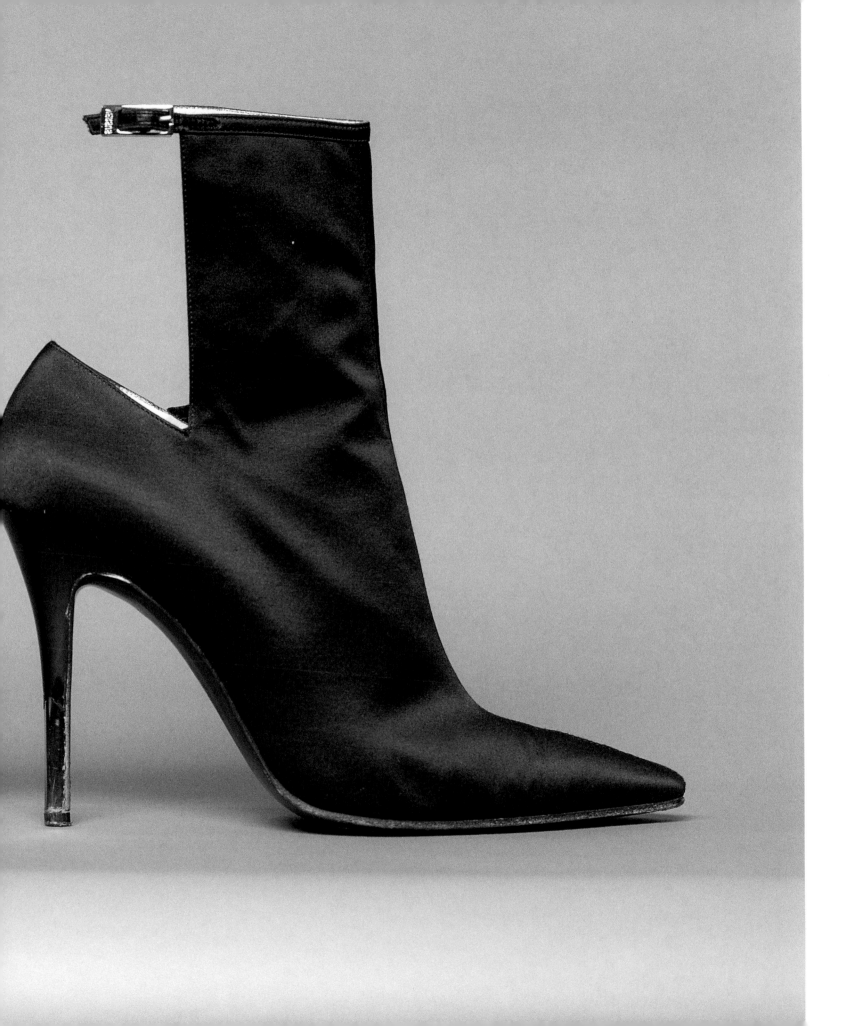

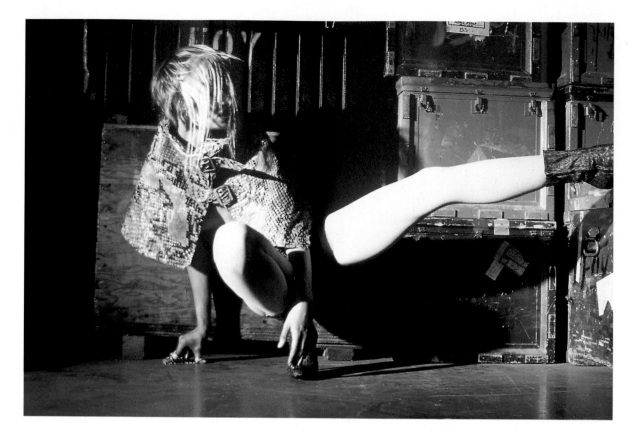

ABOVE, OPPOSITE & BELOW The material used for a boot often says as much as the cut and heel height. Free lance's stiletto ankle boot in snakeskin-effect fabric suggests the wild nature of its wearer, as photographed by Chris Edwick. Jimmy Choo's faux-fur bootie almost invites one to reach out and stroke it, while the use of patent leather gives Pollini's Chelsea boot a hard, urban edge.

The novelty of this development becomes apparent if we look up the section on boots in an ordinary fashion book, such as *Elegance*, which was published in 1964. The author, Madame Genevieve Antoine Dariaux, was then *directrice* of Nina Ricci. Dariaux admitted that boots were "practical for walking … in the city during very cold or slushy weather." But she obviously felt that they were most appropriate for outdoor sports: "For years boots were hardly used for anything but fishing and horseback riding." While acknowledging that boots have recently become fashionable, she argues that few women have the kind of long, slender, shapely legs that look attractive in boots.

"A high-heeled boot is less likely to give you a masculine stride than a flat one," she admits, "but if it almost reaches to your knee you are apt to resemble a circus lion-tamer." (Notice this strange euphemism!) Ultimately, Dariaux concluded that, "except for outdoor women living in rigorous climates, boots are usually a superfluous accessory, more at home in a college girl's closet than in the wardrobe of an elegant woman. (And even the

BOOTED AMAZONS

BELOW The slender arched heel of Christian Louboutin's smart black ankle boot emphasizes the bulge of the heel and arch of the ankle, paralleling the derrière and lower back of the female body.

OPPOSITE Martin Margiela's tabi-toe boot is based on traditional Japanese socks, which were designed to be worn with sandals.

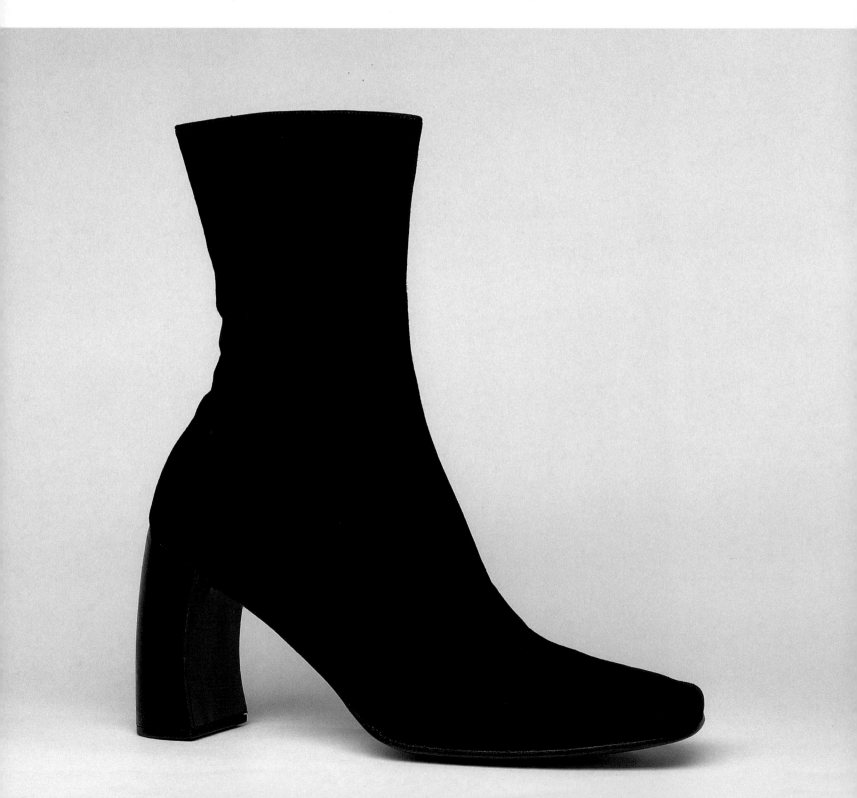

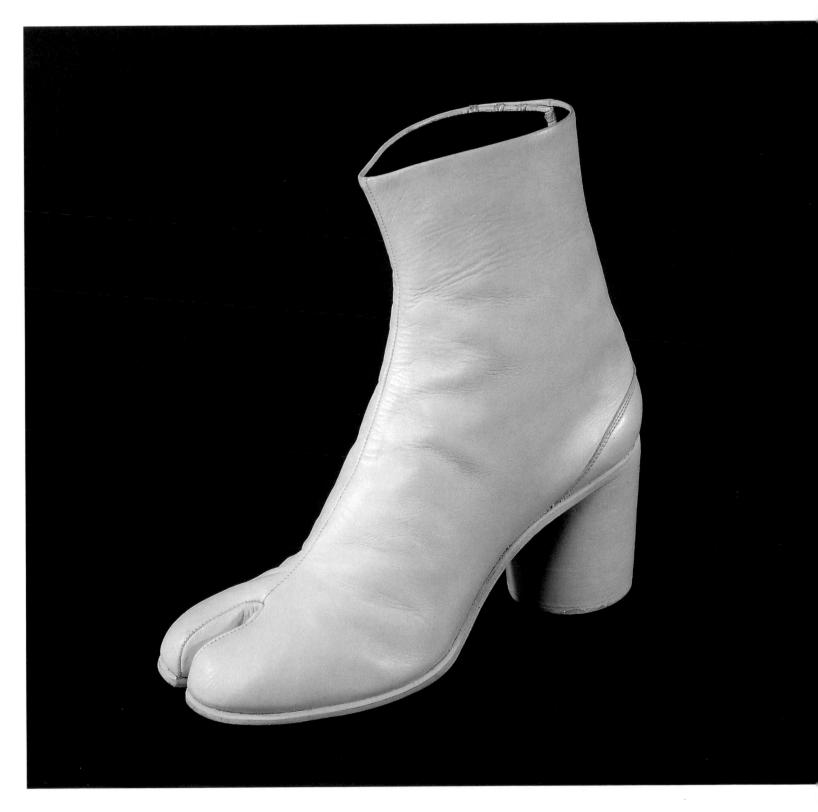

LEFT 1970s boot by Sergio Rossi. The platform boot has remained popular with some style tribes.

BELOW The Russian peasant look goes deluxe in Stéphane Kélian's brown suede boot topped with a thick shock of fur.

astounding success of Saint Laurent's Robin Hood thigh boots have not made me change my mind.)"[12]

Generally speaking, the higher a woman's boot, the sexier it is perceived to be — although the degree of eroticism varies also in relation to the height of the heel, and whether the boot is closely fitted to the leg, so as to reveal the shape of the calf. Nevertheless, even low boots still convey a message of sex and power. Ankle boots are a perennial fashion, and come in many forms, including the jodhpur boot, a traditional horsy style, and the granny boot, which is based on the Edwardian laced boot.

Contemporary fashion journalists declare that "The riding boot is the haughtiest footwear, and strides down every strada in a state of high polish."[13]

The high buttoned boots of the early twentieth century have essentially disappeared, the buttons having been replaced by laces, elastic, and zippers. Many other historic styles, however, are periodically revived. The elastic-sided Chelsea boot, for example, became fashionable for both men and women in the 1960s, and often reappears as a retro style. Clark's desert boot has also been revived. Perhaps most famous, however, are the low-heeled, white leather boots associated with André Courrèges. This style recurs periodically and still conveys a sense of streamlined modernity.

By contrast, the symbolism of thigh-high cuissarde boots is romantic and historicist. These boots were originally intended for men. "One of the charges brought against Joan of Arc in 1431 was that she had worn them."[14]

THIS PAGE Historic boot styles continue to be revived. Patrick Cox's fur-lined lace-up is an update of the warm yet elegant boots of the Belle Epoque. The square, mannish toe of the cowboy boot is reworked in Goffredo Fantini's oxblood ankle boot; while the neat proportions of the Chelsea, or Beatle, boot are apparent in Stéphane Kélian's bronze ankle boot. Bruno Magli's patent low-heeled boot recalls the Courrèges styles of the 1960s.

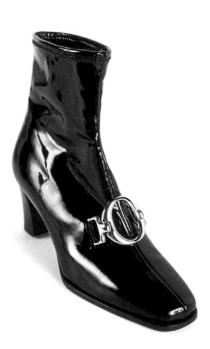

Much later they were a type of fetish footwear, and by the 1960s Roger Vivier was making them for dancers like Rudolf Nureyev and Zizi Jeanmaire. Brigitte Bardot wore black leather cuissarde boots, while posing on a Harley Davidson motorcycle. And we have already mentioned the thigh-high crocodile boots that Vivier designed for Yves Saint Laurent.

In the past, the only people who wore cowboy boots were cowboys. Over the past quarter of a century, however, cowboy boots have become incorporated into the fashion vocabulary — for both women and men. As a special subcategory of riding boots, cowboy boots obviously evoke the horsemen of the Wild West, so the symbolism of the boots is directly related to the symbolism of the cowboy. As one scholar puts it: "The cowboy is 'pure' symbol" — the rugged, free individual in a (largely mythic) preindustrial American past. Like a knight, he is also "the bearer of a moral code."[15]

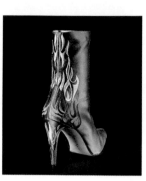

RIGHT & OPPOSITE Country and western meets rock and roll in Bernard Figueroa's grey satin boot licked by embroidered flames, and in Fiorucci's gold cowboy boot of 1974.

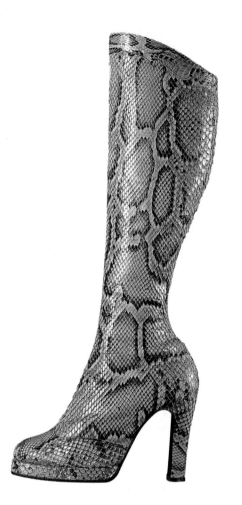

ABOVE The platform soles, high heels, and shiny snakeskin of this boot from 1977–8 embody the allure of the glam rocker.

Men and women who wear cowboy boots tend to identify with some element of the cowboy myth. Most obviously in the United States, people from the western or southwestern states sometimes wear cowboy boots. The boots first entered fashion via the country-and-western music scene, and remain a staple of the western wear industry. By the late 1970s, however, cowboy boots had appeared on the disco scene, and were worn by such unlikely urban cowboys as Andy Warhol, Catherine Deneuve, and Anwar Sadat. When John Travolta starred in a movie about urban cowboys, the popularity of cowboy boots rose again.

The cowboy has also long been a gay icon, because of his extreme masculinity. Because cowboys have such a macho image, their boots are permitted to be far more colorful and ornamental than the usual male footwear. They are also among the very few men's styles to have high heels. Women who wear cowboy boots today are more likely to do so either from a sense of geographical identity (Texas boots are most prestigious), or because a particular fashion designer, such as Alexander McQueen, has chosen to emphasize what might be called the Wild West look of "lust in the dust."

Biker boots are another quintessentially masculine style, symbolizing the existential outsider — this time mounted on a motorized substitute for the horse. Like the rest of the biker's clothing, his boots are clearly functional: made of heavy leather, they protect his ankles from the heat of the engine and the exhaust pipe, and their thick soles protect his feet, which not infrequently drag along the surface of the road. Yet biker boots also feature a strap and

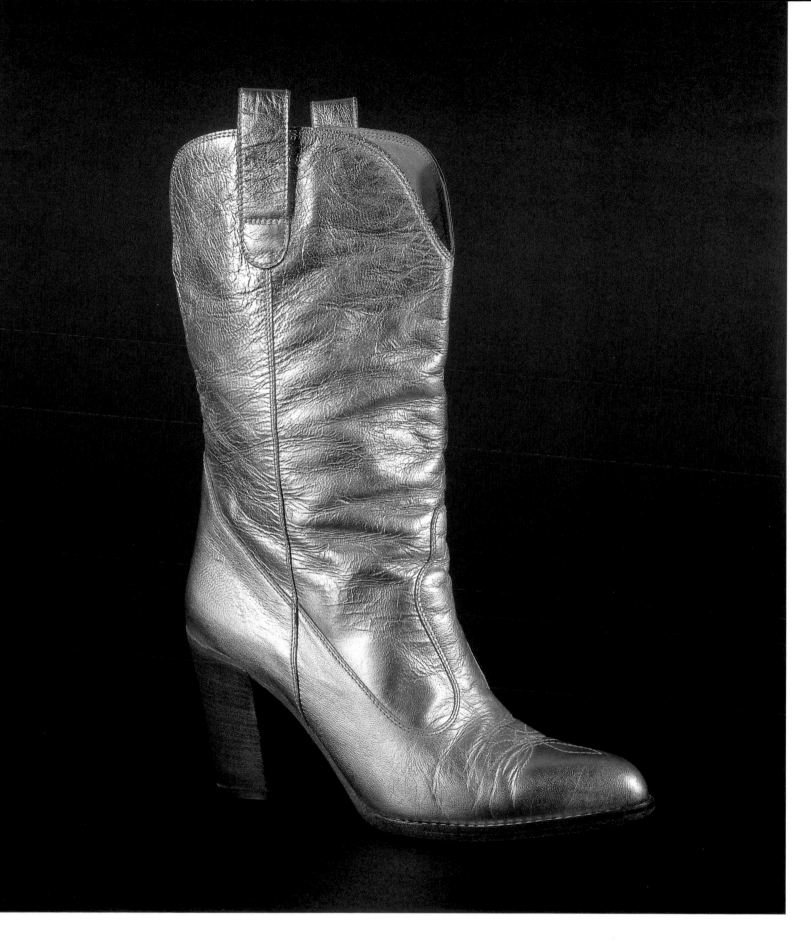

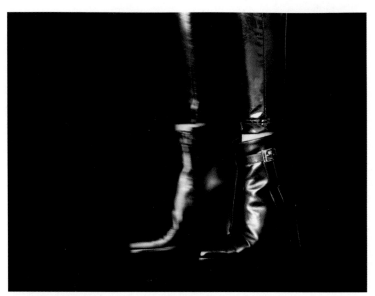

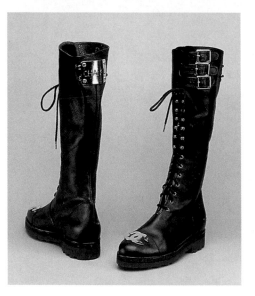

TOP & ABOVE The rebel boot is given high-heeled sex appeal by Séducta and made acceptable to high fashion followers through the addition of Chanel's distinctive gilt-edged logo.

buckle across the instep, a decoration that recalls the strap used to attach a spur.

Just as the biker himself is envisioned as being much more aggressive and rebellious than the cowboy, so also are his boots. Gay pornography that focuses on bikers stresses that the biker boot symbolizes a big penis and an ultra-masculine persona. The spread of "downtown" gay fashion has become a conduit for ultra-masculine styles, such as Chanel's triple-buckled leather combat boots, which resemble the boots worn by bikers and motorcycle cops.

Boots with buckles and straps draw on the prototype of motorcycle gear, but they also reference punk anti-fashion. Indeed, the rise of punk in the 1970s was the most influential street style since the hippie look of a decade before. Ted Polhemus, who is probably the world's most inveterate scholar of street styles, has unearthed fascinating 1977 advertisements for the shoemaker Bloggs of London. One advertisement promotes "The rebel boot ... made especially for anti-establishment heroines!" and other "riotous creations for punk sisters," including "Trouble Makers," which featured a "cult ankle chain and safety pin buckle — boots to dictate by." These were not exactly classic motorcycle boots, however, since they were made of patent leather in colors like Razor Red, Slash Yellow, and Bondage Black. Naturally, they had stiletto heels.[16]

The same principle of aggression is evident in Dr. Martens "bovver boots." Advertisements from the 1980s emphasize the key features, such as "heavy cleated commando soles" and "steel toe caps," which made these boots such

BELOW The modern appeal of the motorcycle boot lies in
its connotations of urban cool and social rebellion. That idea
is reworked here in boots by Patrick Cox.

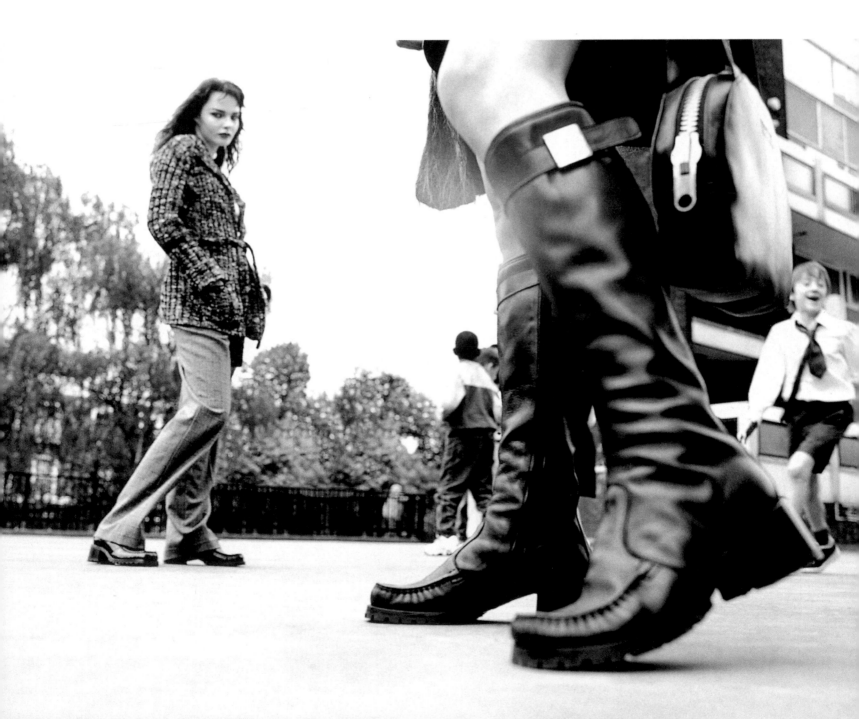

OPPOSITE The Dr. Marten, a fashion classic. It once held

the promise of endowing immediate street credibility on the

wearer but has now become ubiquitous.

formidable weapons for skinheads and neo-Nazis. Despite (or, rather, because of) their reputation, these boots rapidly became a cult fashion and were even featured in British *Vogue*. According to *Vogue: Modern Style* (published in 1988), the Doc Marten "symbolizes all that is tough and aggressive and modern and has given endless street credibility to many a fashion victim."[17] It is a classic, comparable to the Levi's 501, which itself has been advertised with the slogan: "Our models can beat up their models."

Traditionally, women's fashions have been interpreted primarily in terms of sex, while men's fashions have been viewed in terms of status and power. Yet the journalistic discourse on boots provides evidence that women's fashions have increasingly been perceived in terms of both sex and status, power and practicality. As *Cheap Chic* advises women: "Sink your money into a very good pair of boots ... Boots not only look good, they feel good. How far and how fast can you walk in a pair of high-heeled pumps?"[18]

BELOW Practical boots, like these by Goffredo Fantini, get the thumbs-up from fashion journalists for the power they confer by giving the wearer freedom of movement.

OPPOSITE One take on boots is the "caveman" look, here by

Free lance, which strikes at the primitive and the wild in all of us.

ABOVE LEFT Gucci's high-heeled boots appear completely

unadorned — no buckles, zips, or exterior decoration to distract

from their curvaceous silhouette.

ABOVE Azzedine Alaia's ankle boots are made of fake leopard

skin — perfect footwear for the *femme fatale*.

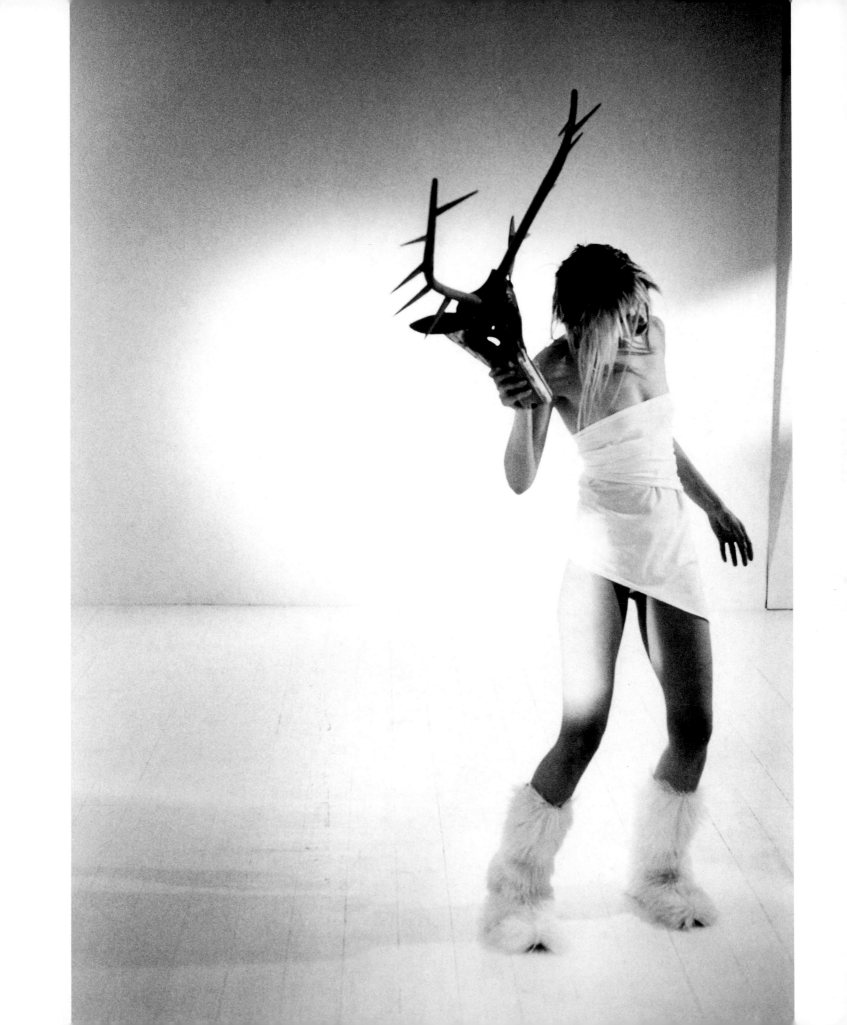

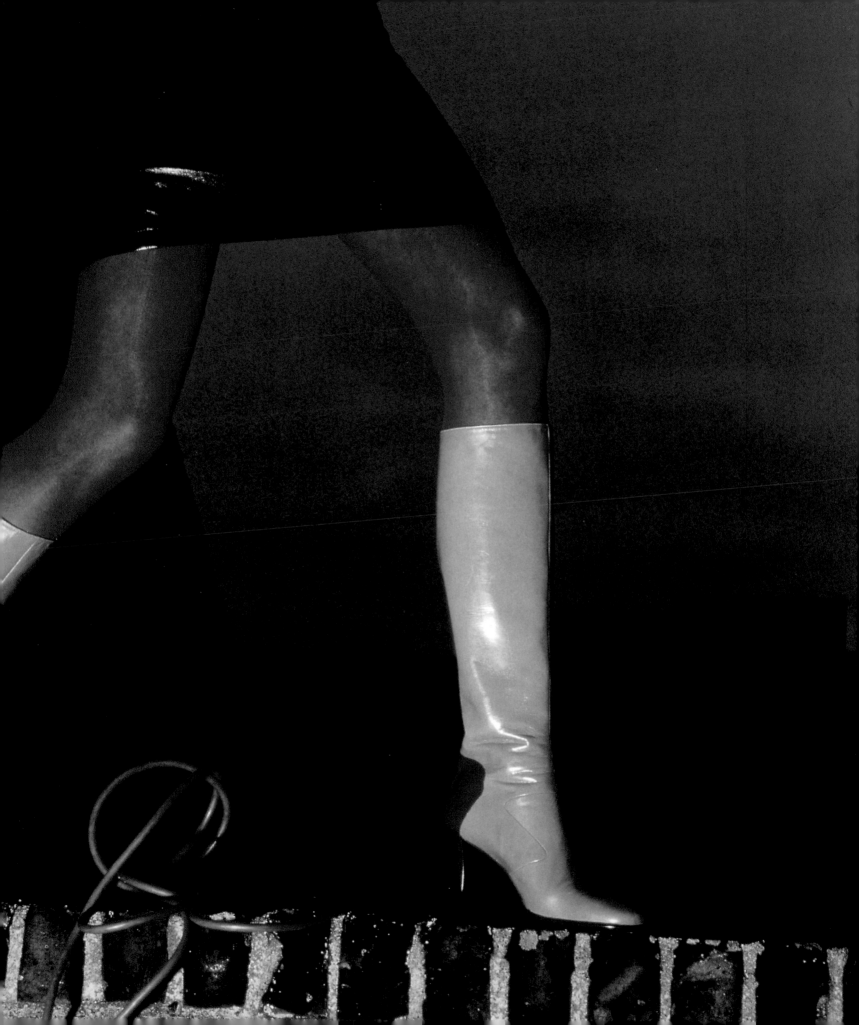

ABSOLUT BLAHNIK.

OPPOSITE The confident pose of Bruno Magli's rooftop prowler, photographed by Mario Testino, suggests that her boots make her sure-footed and rebellious. Their color gives her added dynamism. **LEFT** Helmut Newton photographs model Kristen MacMenamy on an airbed in a downtown city pond to create a tongue-in-cheek urban jungle-woman for Absolut Vodka's ad campaign. Swashbuckler boot by Manolo Blahnik.

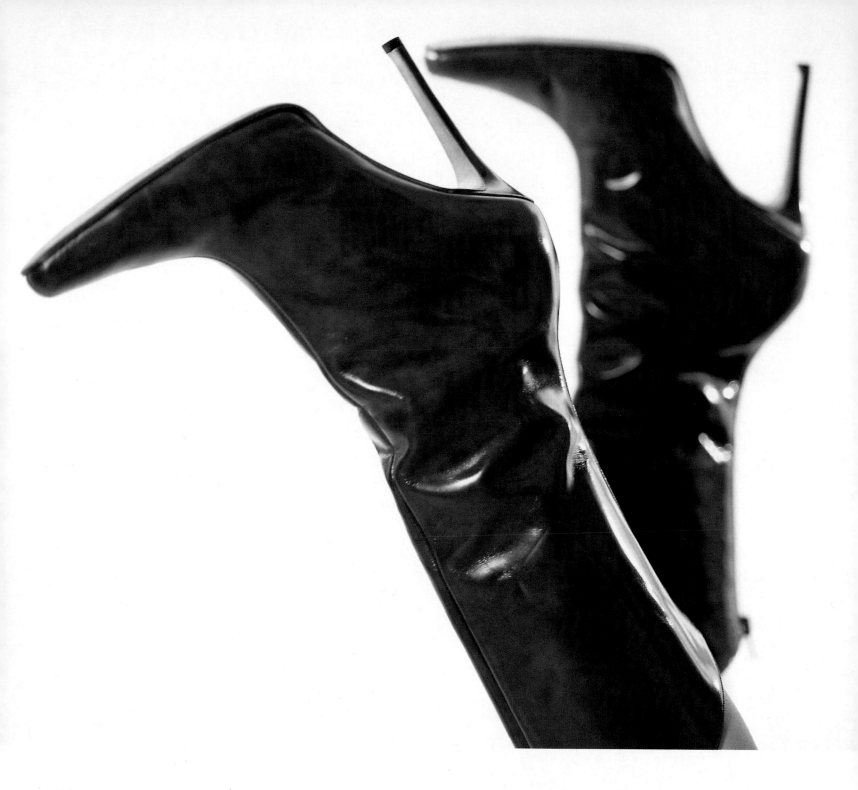

ABOVE With their pointy toes and spike heels, Roberto Cavalli's

patent tan boots look more like weapons than footwear.

LEFT A robotic leg highlights the inspiration for Red or Dead's ankle boot and implies its wearer is a futuristic über-woman: hard-edged, dangerous, and beyond the touch of human emotions.

BELOW Other boots in the realms of sexual fantasy are Cesare Paciotti's black "slingback," seductively suggesting the foot reigned in underneath, and Christian Louboutin's scarlet "Chinese" boot.

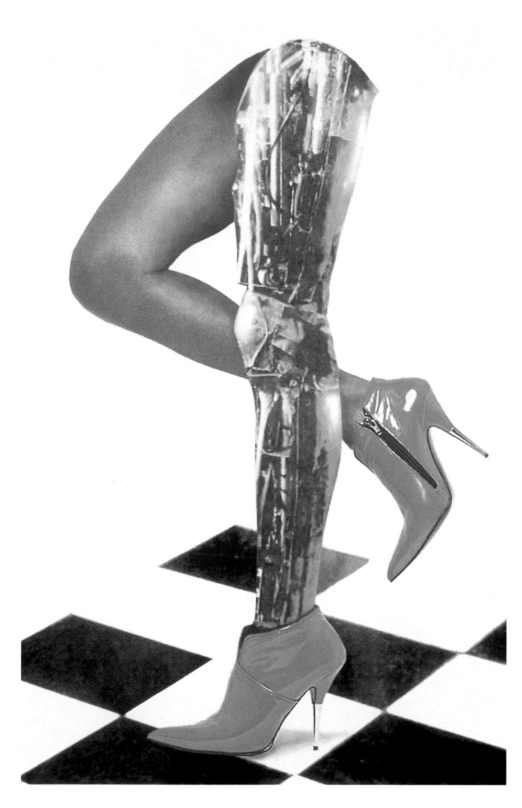

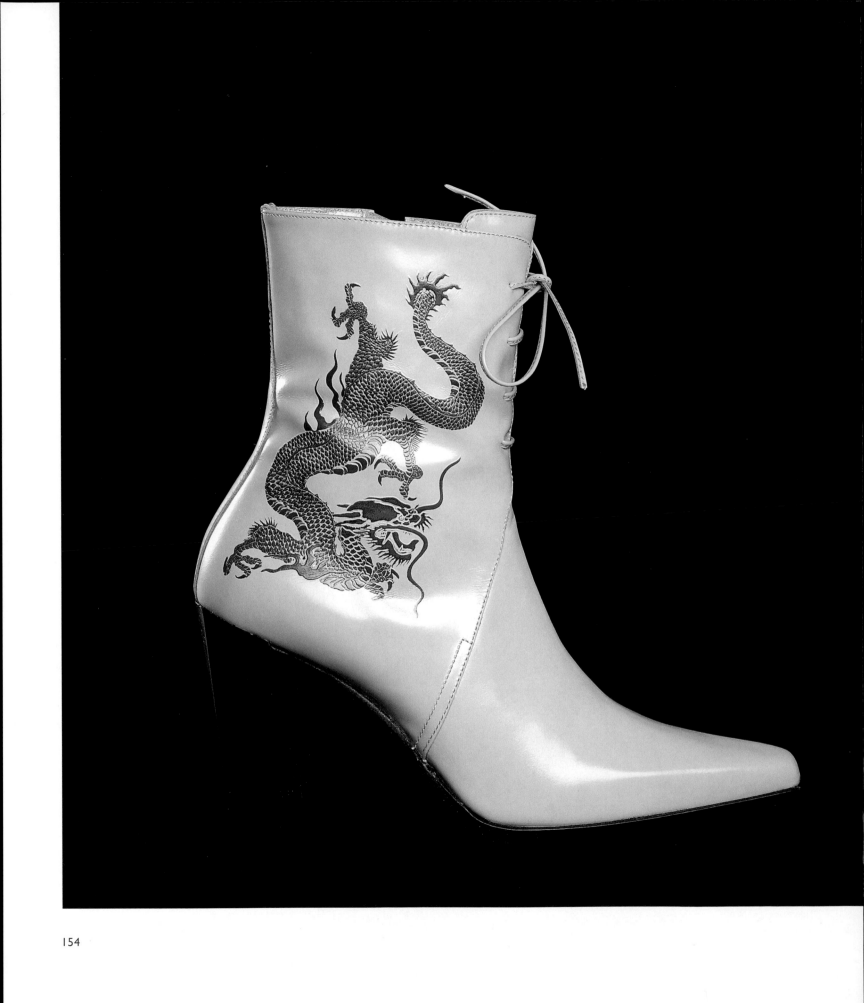

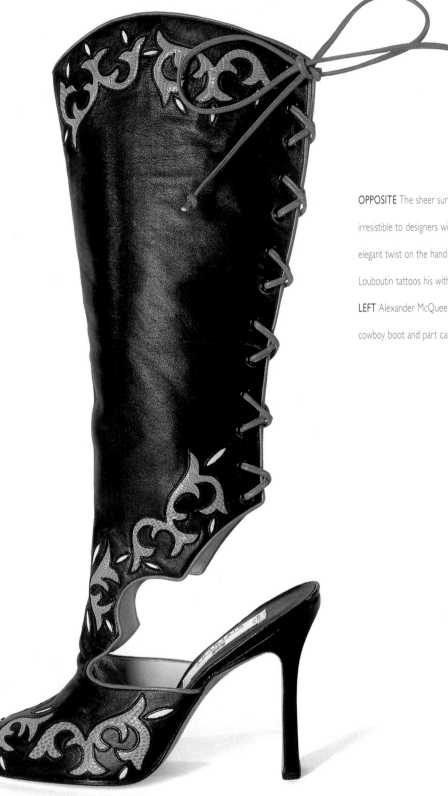

OPPOSITE The sheer surface area of boots makes them irresistible to designers with a penchant for decoration. In an elegant twist on the hand-tooled cowboy boot, Christian Louboutin tattoos his with a Chinese dragon.

LEFT Alexander McQueen's lace-up extravaganza is part cowboy boot and part cancan girl.

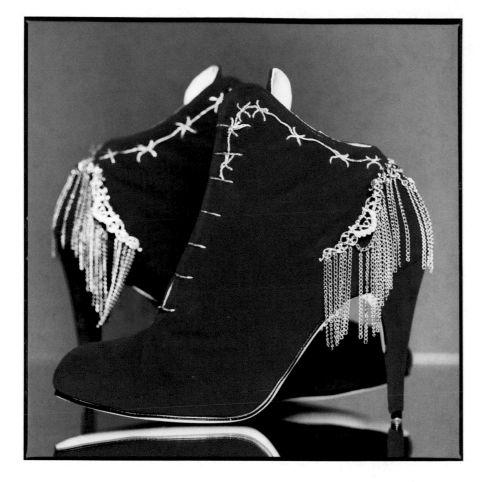

ABOVE Bella Freud's showgirl boots combine the heel of the sexy stiletto, the stirrup detailing of the cowboy boot, and the rich suede of the muskateer boot. The lack of conventional laces also gives them a very contemporary edge. Photo by Suresh Karadia.

RIGHT Boots may well be the perfect footwear for the modern urban woman. They are practical yet sexy, powerful yet playful, as heightened in Liselotte Watkins's whimsical depiction.

Sneaker Chic

sneaker chic

**"We're talking the coolest, hippest, most hard-to-find sneakers out there.
The kind that look good with those Helmut pants and that Prada bag."**[1]

Jennifer Jackson, Harper's Bazaar

ALL WE DID WAS GET RID OF THE LACES AND PIECES OF THE SHOE YOU WEREN'T USING ANYWA

ABOVE Dispensing with shoelaces has been one of the key

developments in sports shoe design.

OPPOSITE The epitome of sneaker chic, and of modern relaxed

dressing, masculine-style suiting with plain white tennis shoes.

The suit implies that the wearer is serious, intelligent, confident,

while the choice of footwear indicates that she is not bound by

the conventions of the corporate wardrobe.

Sports shoe manufacturers insist that they are interested only in function, not in fashion. They talk about stability, traction, and support. New technical improvements in fibers and soles. Precision engineering. Bidirectional waffles. That's all well and good, but sports shoes are no longer just for running or working out at the gym. Sneakers, or trainers, have become one of today's most fashionable items of clothing. But not just any sneakers are fashionable. The trick is knowing which kind is currently regarded as "the coolest."

Certain brands and styles have been taken up with wild enthusiasm, only to be replaced a few months later by another cult favorite. Just as clothing fashions become démodé as soon as they are worn by too many of the wrong people, so also is a cult sneaker doomed once it becomes ubiquitous. Very often the hippest sneakers are those that are hardest to find. Perhaps only a few of them were made. Or perhaps they were sold only abroad — as was the case with certain colors of UK brand New Balance sneakers, which then became incredibly fashionable in the United States. As fashion journalist Jennifer Jackson observed, "I've received more compliments (and money offers) on my cherry-red New Balances alone than on all my Prada, Gucci and Manolo Blahnik shoes put together."[2]

Why sneakers? Why now? Which sneakers are most fashionable? And which ones should I buy? I flew to London to discuss these questions with Richard Wharton, who is internationally famous as an expert on the cultural significance of sports shoes. The term people kept using was "sneaker guru." His official title is Buying Director of Office and Offspring, two British stores

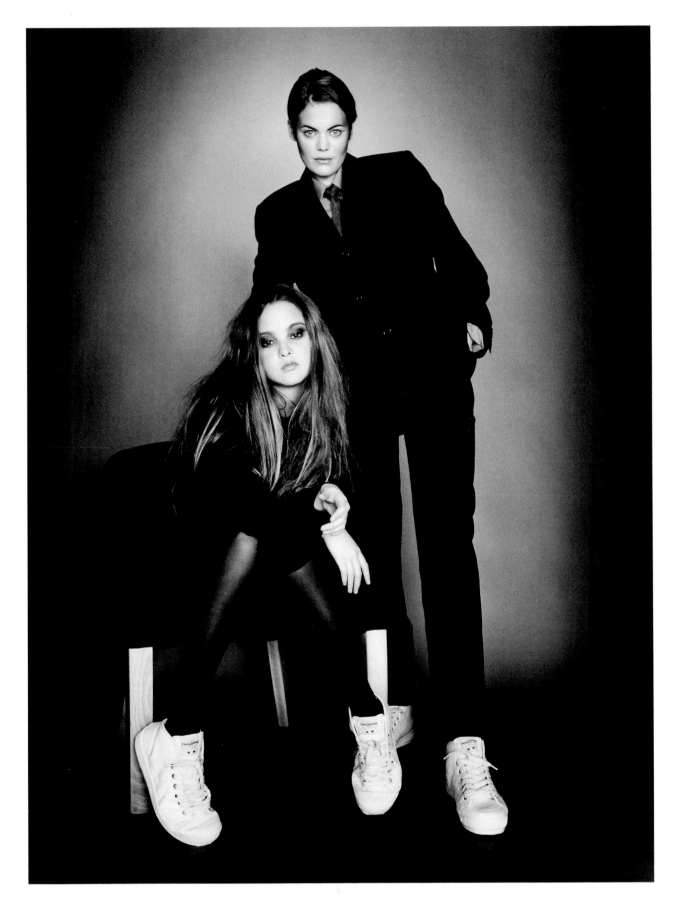

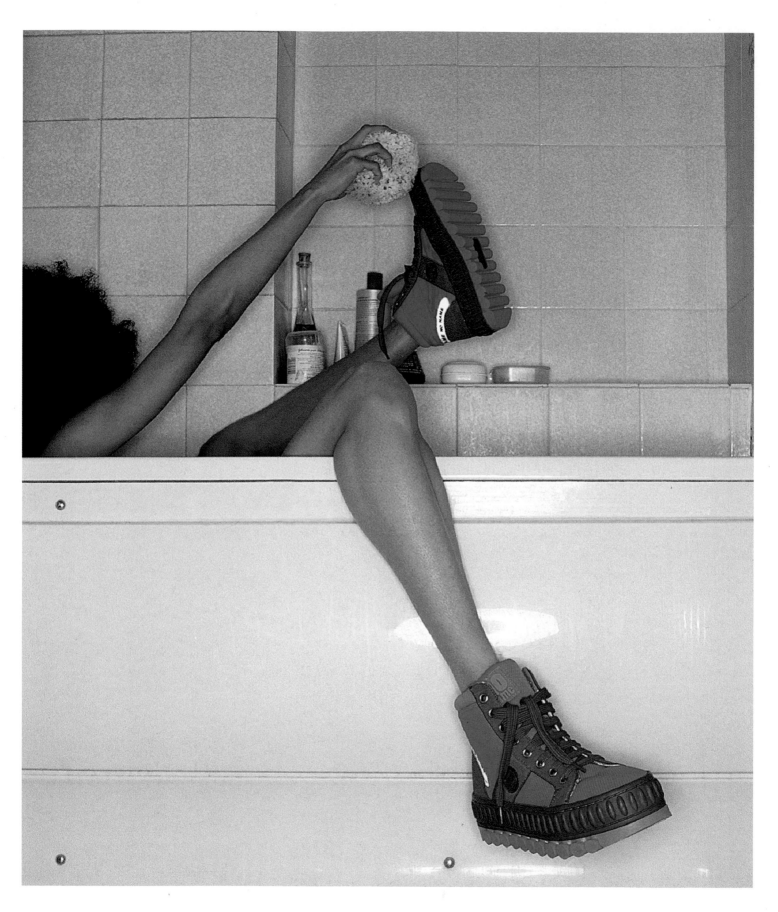

162

OPPOSITE For the new style tribes, the sneaker or trainer is indispensable. London's Soho Trendies "live and die in a pair of sneakers," a sentiment echoed in this image for No Name.

ABOVE The Royal trainer has no laces or other fastenings; rather, it slips on like a loafer. It is typically worn by young urban warriors with wild hair, piercings, and techno clothing. They are among the most street-aware of trainer aficionados.

specializing in footwear. People like Kate Moss and Alexander McQueen shop at his stores. So do an array of international connoisseurs, known in the business as "sneaker pimps."

I began by asking Wharton what types of people wear different kinds of trainers. He drew a pyramid, and explained that at the bottom of the pyramid were the Clueless. Most people, he said, are clueless. This includes even the most avid *fashionistas*, for whom sneakers — like sports, in general — tend to be an unknown field of expertise. I admitted that this was my category, Prada purse notwithstanding. At the top of the pyramid were a small group of people whom he called the Soho Trendies, because in London they tend to work in Soho or in neighboring Covent Garden.

"They live and die in a pair of sneakers," said Wharton, "and they won't be seen dead in the wrong pair of trainers."[3] Most of these people, he added, "have never worn a proper pair of shoes, except maybe at a funeral." According to Wharton, Soho Trendies usually work in the media and/or graphic design, sometimes even in fashion, although they are more attuned to visual style than fashion *per se*. In 1998, for example, they were wearing Nike Humaras — specifically, the Air Terra Humara, which *Vogue* described as "the hot high-tech shoe of the moment."[4]

Next in Wharton's list come the so-called Designer Bofs. "They have no brand allegiance," he says. "They wear the latest style." That could be the Nike Humara. Or the Adidas Badlander, which Wharton characterizes as "just

OPPOSITE Ironically, as we become less and less active as a society, sports wear and sports shoes, in all their variations, are becoming more popular. Illustration by fashion artist Tanya Ling.

ABOVE Adidas Gazelles — a sports shoe classic that is now worn as much for its nostalgia value as for the distinctive three stripes that have become a fashion icon. The adoption of the brand by rap and hip-hop groups has given Adidas shoes an image that is more about the street than about sport.

brilliant." The Badlander is a prime example of the trend toward combining a trainer with a mountain boot, like the Timberland Lumberjack, resulting in a union of flexibility and strength.

It is important to realize that when it comes to sports shoes, regular designer names are not the issue. Instead, we find logos — Nike's famous swoosh, the Converse star, Adidas stripes, Puma's panther, etc. According to Wharton, "You could write an entire book just on Adidas." We'll come back to this issue later.

The third category of people-who-wear-trainers Wharton calls "Football Lads." These are mainstream guys who wear trainers that are comfortable and classic. "They will never wear anything outrageous," he notes. Instead they favor crisp white Reebok classics or Adidas Gazelles. Although Wharton felt that there was "no female equivalent" to the Football Lad, women might also be attracted to these styles for the same reasons.

Although soccer (a.k.a. "football") is phenomenally popular in Europe, in the United States the really fashionable sport is basketball. Thus, within the United States, Wharton's categories would have to be modified to take account of the significance of basketball shoes. Moreover, since professional basketball is dominated by African-Americans, the significance of sports shoes in America has a pronounced racial component.

Next in Wharton's hierarchy comes the broad category of Sheep. Says Wharton, "Sheep will follow mainstream fashion, but they don't know why." Techno Urban Warriors make up the fifth category. They are young. They have

OPPOSITE Sole Poetry. Footwear label Stride emblazons the soles of its trainers with lines penned by rap poet Mike Benson. In doing so it aims to project irreverence and individuality.

BELOW Trainers by Acupuncture represent the new wave of sports shoe fashion, in which branding is of little importance. What does count are high-tech materials and structure, futuristic styling, originality, and exclusivity — in other words, knowing that they won't be spotted on the feet of the suburban masses.

no brand allegiance. "That lot have body piercing and wacky hair," observes Wharton. "They're very urban, very street, the kind who wear army pants and platform trainers. In the United States, they're often skateboarders. If a pierced Techno buys a Reebok classic, he'll look stupid." Rather than sports shoes, they are into sports *fashion*, so they choose fashion-oriented brands like Acupuncture, Buffalo, No Name, Stride, and Royal.

A London-based company, Acupuncture opened its first tiny shop in 1993. The label's meteoric rise was sparked off by a design of boy and girl teddy bears with exposed genitals, which was embedded in the soles of the trainers. Later trainers included Teef, which had a "love bite" sole, directly modeled from a cast taken of the designer's teeth, and Rumpriders, which featured an undersole depicting a pair of eyes with the words "We are watching you."

In 1998 Acupuncture got into hot water over an advertising campaign that featured a couple getting their sexual kicks by bashing a fellow foot fetishist to death with a hammer. The video, which had been shown in 500 shops stocking Acupuncture, was seized by the police on the charge of indecency. But it all made for great publicity for a brand that relies on an edgy, urban, and rebellious image.

Thirty- and forty-somethings are Wharton's last category. "They're still trendy," he says. "Look at bloody Mick Jagger. But if they've got sense, they will not go into Acupuncture. That's too young ... So they go into classics. Adidas Superstars. New Balance 576. Converse Jack Purcells. Those have been around since the 1950s, they're low-tech, old-school, but they look good."

OPPOSITE Since the mid-1990s, fashion footwear designers have increasingly focused on sports shoes. Here, Red or Dead's tongue-in-cheek trainer in ultra-bright colors.

Sports shoes are "the first new kind of footwear in the past three hundred years," says Wharton. But already one of the hottest trends is to revive classic sneaker styles from the past. Indeed, trend reports cite the retro jogger right alongside other hot styles, like the platform sports sandal. Clearly, a bit of history can throw light on current fashion trends.

Rubber-soled, lace-up canvas shoes were invented in the nineteenth century. These were the forerunners of sneakers or, as they are known in Britain, plimsolls. The first popular sneaker was introduced in the United States in 1917 under the name Keds, which "combined the Latin *ped*, 'foot', with a 'K' for 'kid'."[5] This was the classic "tennis shoe." The Converse All-Star with its boot-like high top was introduced two years later, and for many years was America's most popular sneaker. The high supportive ankle made this sneaker especially good for sports like basketball.

TOP The reputation of UK athletic shoemaker New Balance once rested on its excellent jogging shoes. But the fashion set in Tokyo, New York, and London now buy them for trend-conscious colors and funky styling rather than for sports performance.

ABOVE The classic French basketball sneaker by Spring Court, worn by those who favor old-school looks.

OVERLEAF Converse All-Stars — for many years the most popular sneakers in the US. Elsewhere in the world, they have long symbolized laid-back American style.

Meanwhile, in Germany, Adolf Dassler and his brother Rudolf had begun making running shoes, adding strips of leather to the upper for support. Jesse Owens was wearing their shoes when he triumphed at the 1936 Olympics. In 1948 the Dassler brothers split up: one brother founded Adidas, the other Puma. They never spoke to one another again, but each struggled to dominate the international sneaker market. By the 1950s both companies were giving free sneakers to famous runners. The competition between them reached new heights at the 1968 Mexico City Olympics, when track stars allegedly found $100 bills in their new Adidas. Significantly, this was the first time the Olympics were televised, and brand insignia were seen around the world.

ABOVE When Adidas founder Adolf Dassler added leather strips to give extra support to the jogging shoes he was making, he could not have imagined that those stripes would one day become instantly recognizable signifiers of urban cool, as evoked in Trevor Ray Heart's image of "Adidas" pumps.

Black Power was also at its height in 1968, and when athlete Tommy Smith was photographed with his Puma Suedes, the style instantly achieved street credibility. For the first time, a particular brand of sneakers had acquired cult status. Something similar happened in 1987, when the rap group Run D.M.C. had a hit with a song entitled "My Adidas." Partly as a result, Adidas Superstars — worn with the laces undone and the tongues out — acquired a very urban, hip image.

In 1971 sneaker technology took a step forward with the first Nikes. Named for the Greek goddess of victory, they featured innovative "waffle" soles, wedge heels, and nylon uppers. The development of these running shoes coincided with the fad for jogging. Experts disagree, however, about whether the craze for sports shoes began with joggers in America or with soccer fans in Great Britain. In 1978 trendsetting English soccer fans wore Adidas Sambas. Then soccer fans also traveled to Europe to buy other kinds of shoes not yet available in the U.K. The fashion for athletic shoes spread throughout urban Britain, and soon pop stars were wearing them, notably David Bowie in the video "Dancing in the Street."

Certainly, events within society contributed as much or more than techno-logical advancements to the growing popularity of sneakers. The 1980 New York City transit strike temporarily paralyzed traffic, with the result that many women began wearing sneakers to work, carrying their pumps in a briefcase. Even more influential was the fitness boom of the early 1980s. Olivia Newton John sang "Let's Get Physical," and Jane Fonda launched her

RIGHT Chanel's demure sneakers-cum-deck shoes are adapted from the label's signature two-tone pumps. Like more youth-conscious labels, they elevate the sneaker into something more than a shoe for sports. These, for example, are intended for little else save strolling down shopping streets in St. Tropez.

aerobics business. Even the Barbie Doll acquired new gym clothes. The majority of the people who began taking fitness classes were women, but there were no sports shoes designed for their needs.

In 1982 Reebok created the first athletic shoe aimed specifically at the female consumer. Reebok's Freestyle aerobics shoe was made of soft napa leather, and immediately became popular with women, who wore it both for indoor exercise and for walking on the street. In 1983 *Vogue* reported that "The latest outdoor sport to hit New York is walking, and more specifically, walking to work … in sneakers!" According to these arbiters of fashion, "the funky look sneakers give" was "part of their inherent charm."[6] Not everyone agreed, of course, and the French, in particular, laughed at the unfortunate taste American women had for wearing white athletic shoes with their business suits. Eventually, the look became associated with lower-middle-class office workers, and ceased to be fashionable.

As Reeboks and Nike competed to be number one, they produced an ever-increasing variety of athletic shoes, with different models for running, basketball, aerobics, and other sports. Sports stars also played an increasingly important role in promoting particular brands. In 1984 Nike signed basketball star Michael Jordan for $2.5 million.

BELOW Stylish sneakers by Spring Court have been made in France since the 1930s. Classic brands like this have found renewed popularity among a sneaker-buying public who find it difficult to keep up with the constantly changing high-tech styles.

OPPOSITE The phenomenon of the sports shoe as fashion accessory began in the 1980s, along with the advent of aerobics classes. Even Barbie got her own gym shoes.

The Nike Air Trainer was designed specifically for cross-training. An advertisement in *Cosmopolitan* (January 1989) explained what that meant: "You can run in it. You can walk in it. You can lift weights in it. You can play volleyball in it. You can play tennis in it. You can ride a bike in it. And yes, you can even do aerobics in it."[7]

Ah, but can you still walk to work in it? The "new" trend for athletic shoes actually goes back quite a while, but there have also been dramatic changes over the past fifteen years. Today's semioticians of style distinguish between: 1) the type of person who walks to work in white athletic shoes and sweat socks and then changes into pumps, and 2) the person who wears acid-green trainers not just *to* work, but *at* work. As Jennifer Steinhauer observed in *The New York Times*, women who wear high-tech trainers often "pair their shoes with a cell phone or a laptop," thus conveying the message, "I'm busy." Or as fashion historian Anne Hollander put it, "An athletic shoe … signals that you are a competitive person."[8] You still probably won't see Anna Wintour or Liz Tilberis wearing trainers at the office, but younger fashion editors often do.

Indeed, sports shoes have become probably the most ubiquitous category of footwear in the world — even on the boulevards of Paris. As Guy Trebay reports, "All of a sudden, French women who have never been shod in anything more *décontracté* than Inès de la Fressange moccasins are turning up in canvas Guess shoes, suede Pumas, old-school Adidas, even

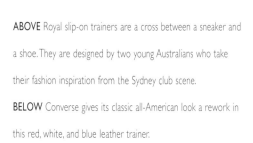

ABOVE Royal slip-on trainers are a cross between a sneaker and a shoe. They are designed by two young Australians who take their fashion inspiration from the Sydney club scene.

BELOW Converse gives its classic all-American look a rework in this red, white, and blue leather trainer.

RIGHT The obsession with sports shoes extends across all social strata. Chanel's dressed-up version of the high-top — complete with linked-C logo and trademark quilting — places the sneaker firmly in the realm of high fashion.

RIGHT Their origins may lie in street style, but the end result is high style — Gaultier's high-heeled sneaker and Hermès's leather sneaker, with a price tag aimed at the very well shod.

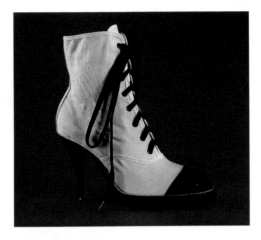

Sketchers."[9] The venerable French fashion company Hermès even produced a ripple-soled leather sneaker called Quick, which immediately sold out — at a retail price of $525.

"Inaccessibility ups a sneaker's hip quotient exponentially," reports *Harper's Bazaar*.[10] When the brilliantly colored New Balance 576 series became available only in Europe and Asia, that made them much more desirable in the United States. (Hence all those offers for Jennifer Jackson's cherry-red pair.) Similarly, the 1995 Nike Air Max reached a street value in the thousands of dollars after it had sold out in stores around the world. The autumn 1997 Air Max edition in futuristic silver caused a similar feeding frenzy. That was "really big for the fashion fraternity," notes Wharton.

Almost all *fashionistas* are pronounced "neophiliacs" — in love with the newest looks. Therefore, any fashion (including sneakers) becomes passé very quickly among this crowd. Yet few *fashionistas* are seriously involved in sports, so they have to keep an eye on the latest sneaker styles being discovered by sports mavens or other trendsetting groups. In many cases, of course, the newest style is an ultra high-tech sneaker, but old classics are frequently rediscovered by sneaker enthusiasts. These retro classics may have considerable nostalgic appeal for baby boomers. A third category of sneaker style is the new hybrid, i.e. a type of shoe or boot that draws heavily on sports shoe technology and styling. *Fashionistas* are becoming increasingly alert to the appearance of hot new sneaker styles.

Nike's Air Terra Humara was the subject of a major article in *Vogue*, which

OPPOSITE The style tribes that make up urban youth culture attach great importance to footwear. The more extreme the look, the less likely it is to be adopted by the mainstream.

ABOVE A conventional sneaker vamp is given a twenty-first-century edge with an exaggerated rubber ripple that looks more like a roller-blade base than a sneaker sole.

BELOW "Old skool" classics like these Puma Suedes are favored by thirty- and forty-somethings who fear looking ridiculous in the ever-changing trainer styles of street fashion.

left unresolved the question: How much of a sports shoe's popularity is based on function, and how much on fashion? According to reporter Robert Sullivan, "Nike wanted a trail running shoe that said stability and precision engineering. They called on Peter Fogg, who had designed the original Nike trail running shoe." The result was a design "based on a motorcycle's disk brake." Then Fogg did the sole, decorated with a swoosh-centered diamond. Last came the name, Humara — after the Humara Indian tribe.[11]

What about the split-toed design of the Nike Air Rift? According to *Harper's Bazaar*, Nike executives "will tell you that it was created for serious runners who clock forty-plus miles per week. Some of our editors think the shoes do best running from show to show in Paris and Milan. Today no one is really interested in their high-tech aspects, only in how they look." Puma's creative director Antonio Bertone agrees: "High-tech is burned out. Eighty-five percent of sneakers aren't sold for their athletic purpose. Some companies say their shoes are purely for performance, but why do they make the same styles for one-year-olds. Plus, overcomplicated shoes only go with one outfit." And Nikos Nicholaou, designer for Acupuncture, says flatly, "We design sneakers that have nothing to do with sportswear, just vanity and fashion."[12]

But have sneakers themselves become passé? An article in British *Vogue* entitled "Death of the Trainer" suggested that "Trainers have become too bourgeois; every middle-class suburbanite has a pair." Long a symbol of youth culture, "the trainer has become a lazy short cut to cool." As a result, trainers are in danger of becoming "the antithesis of cool." Or as the English

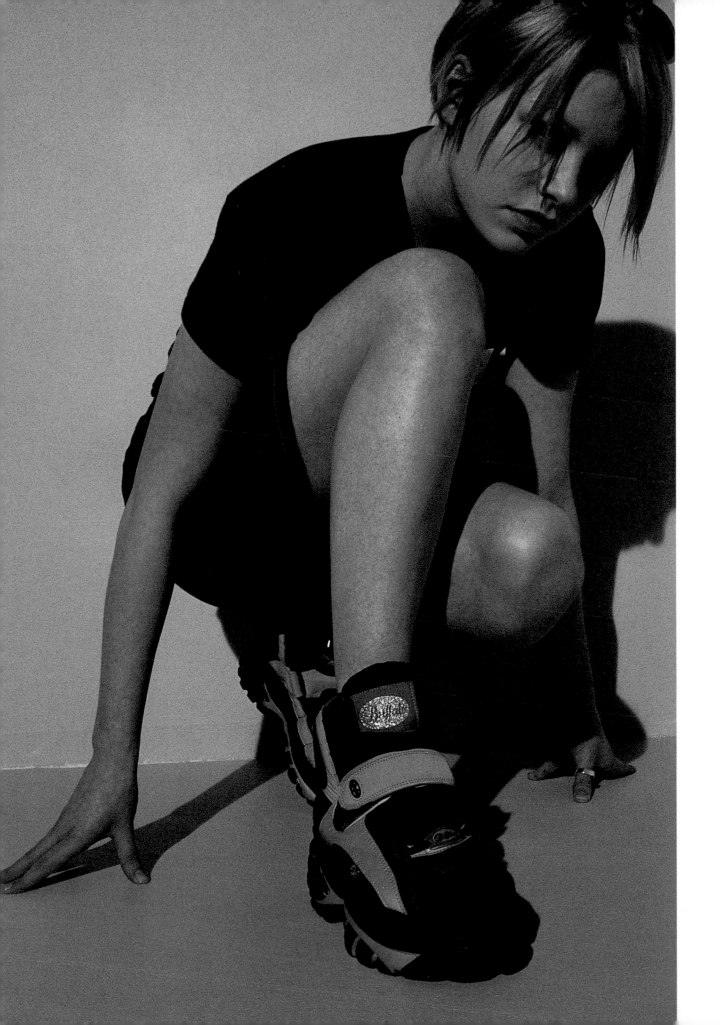

BELOW & RIGHT The appeal of sports shoes with upmarket branding such as the Air Max Triax and Air Max Metallic by Nike has very little to do with athletic function. However, trends change so rapidly that today's cult sneaker can quickly become passé. The Air Max Metallic started out as an icon of the street-smart set but lost its cool as soon as it was adopted by the mainstream.

OPPOSITE The future of the sneaker: high-tech materials, androgynous looks, and a melding of sports shoe and fashion design, as in this sleek style from Stride. The London footwear firm takes as its manifesto, "Modernism for the 21st Century."

music and style magazine, *The Face*, put it: anyone wearing Nike Air Max Metallics was "in league with the devil."[13] Certainly it is difficult for any style to retain its street credibility if it becomes too successful commercially. Nevertheless, although sales of Nike have slipped, and the Air Max Metallic may be dead, sneakers will undoubtedly survive as a hip fashion.

ABOVE & BELOW Sneaker fashion is increasingly diverging between high-tech styles, such as No Name's black and red space boot and low-tech styles like Patrick Cox's suede loafer.

The best sneakers "have rich histories and distinct personalities," writes sneaker aficionado Stephan Talty. Indeed, the very fact that Reebok dismissed sports celebrity Shaquille O'Neal from their ad campaigns "proves you can't fake a sneaker's soul." O'Neal's credentials as a basketball player were impeccable, but young consumers just weren't convinced by him. Advertising may be powerful, but the street prestige of certain sneakers emerges from within popular culture. "The ultimate trendsetters in the US, of course, are black New York teenagers (who are to sneakers what the Académie Français is to the French language)." Different sneakers have different looks and acquire different associations and constituencies. For example, "Pumas may not perform like Nikes or Adidas, but the Puma wearer looks dashing and confident. Alternatively, among the neon stripes and air pumps of contemporary sneakerdom, those who choose to wear humble, unadorned white Converse sneakers are the monks of sneakerland." Or as Talty puts it: "In the vast consumer culture, sneakers are one of the few things that signify more about you than your taste and income bracket."[14]

Footnotes

Introduction

1　**Amy Fine Collins,** quoted in Jennifer Jackson, "Sole Devotion," *Harper's Bazaar* (October 1995), p.82.

2　**Jennifer Jackson,** "Sole Devotion," p.84.

3　**Mimi Pond,** *Shoes Never Lie* (New York: Berkley Books, 1985), pp.83, 13, 18.

4　**Jody Shields,** "Shoes for Scandal," *Vogue* (March 1993), p.378.

5　**Geoff Nicholson,** *Footsucker: A Novel* (London: Victor Gollancz, 1995), p.24.

6　**Linda O'Keeffe,** *Shoes: A Celebration of Pumps, Sandals, Slippers & More* (New York: Workman Publishing, 1996), p.184.

7　**William Rossi,** *The Sex Life of the Foot and Shoe* (London: Routledge & Kegan Paul, 1977; Hertfordshire: Wordsworth, 1989), p.83.

8　**Angela Pattison and Nigel Cawthorne,** *A Century of Shoes: Icons of Style in the 20th Century* (London: Quarto, 1997).

9　**Linda O'Keeffe,** *Shoes.*

10　**Jennifer Steinhauer,** "The Shoe as Social Signifier," *The New York Times* (May 3, 1998).

Chapter One: High Heels

1　**Manolo Blahnik** quoted in *In Style* (March 1998).

2　**Tom Ford** quoted in *In Style.*

3　**Mario Testino** quoted in Frances Rogers Little, "Sitting Pretty," *Allure* (June, 1994), p.34.

4　Telephone conversation with Veronica Webb, May 30, 1998.

5　*High Heels* (February 1962), p.2.

6　**Ann Magnuson,** "Hell on Heels," *Allure* (September 1994), pp.130-131.

7　**Julia Mottram,** "F**k-Me Shoes," *New Woman* (December 1997), p.140.

8　**Jennifer Steinhauer,** "The Shoe as Social Signifier," *The New York Times* (May 3, 1998).

9　**Sarah Lyall,** "Talking the High-Heel Walk," *The New York Times* (Feb. 8, 1998).

10　Interview with Manolo Blahnik (May 8, 1998).

11　**Simon Doonan,** quoted in Steinhauer.

12　*High Heels* (January 1962), pp.7-11.

13 **David Bailey,** quoted in S. Bayley, *Taste: The Secret Meaning of Things* (London: Faber and Faber, 1991), p.145.

14 **Lee Wright,** "Objectifying Gender: The Stiletto Heel," in Judy Atfield and Pat Kirkland, eds., *A View from the Interior: Feminism, Women, and Design* (London: The Women's Press, 1989), p.7.

15 **Berkeley Kaite,** *Pornography and Difference* (Bloomington and Indianapolis: Indiana University Press, 1995), p.97.

16 **Barbara Lippert,** "Sexual Heeling," *New York* (November 24, 1997), pp.30-32.

17 **Wright,** *"Objectifying Gender: The Stiletto Heel,"* p.14.

18 **Holly Brubach,** "Shoe Crazy," *Atlantic* (May 1986), p.87.

19 **Beatrice Faust,** *Women, Sex and Pornography* (Harmondsworth: Penguin, 1981), p.49.

20 **Christian Louboutin,** quoted in Francis Dorleans, "L'Empire des Sens," *Paris Vogue* (June/July, 1998), p.128.

21 **Susan Kaiser,** *The Social Psychology of Clothing* (New York: Macmillan, 1985), pp.242- 243.

22 **Mimi Pond,** *Shoes Never Lie* (New York: Berkley Books, 1985), p.65.

23 **Elizabeth Toomey,** "Paris Heels Have Pointed Heel and Toe," *Toronto Globe and Mail* (28 December, 1953).

24 **Bernadine Morris,** "In Style and Comfort: Low-Heel Shoes," *The New York Times* (January 4, 1984).

25 **Katherine Betts,** quoted in Steinhauer.

CHAPTER TWO: SEX & SHOES

1 **Susan Bixler,** author of *The Professional Woman,* quoted in "Low Cut Trend in Women's Shoes is Exposing Toes to New Scrutiny," *The Wall Street Journal* (October 15, 1984), p.35.

2 *Ibid.*

3 **Susan Kaiser,** *The Social Psychology of Clothing* (New York: Macmillan, 1985), pp.242-243.

4 "Monsieur A-la-Mode," *London Magazine,* 1753, quoted in James Laver, *Clothes* (London: Burke, 1952), p.84.

5 **Philip Stubbs,** The Anatomy of Abuses (1588), quoted in **Colin McDowell,** *Shoes,* p.31.

6 Interview with Manolo Blahnik (May 8, 1998).

7 **Rupaul,** quoted in Linda O'Keeffe, *Shoes: A Celebration of Pumps, Sandals, Slippers & More* (New York: Workman, 1996), p.125.

8 **Manolo Blahnik** quoted in *Vogue* (January 1985), p.186.

9 **Barbara Lea Parent,** "A Mule is a Mule is a Mule," *Speak Style* Issue 2 (Winter 1998).

10 **Angela Pattison and Nigel Cawthorne,** *A Century of Shoes: Icons of Style in the 20th Century* (London: Quarto, 1997), p.94.

11 Macy's advertisement, *The New York Times* (March 10, 1991).

12 **Vanessa Friedman,** "Sole Man," Elle (January, 1998), pp.83- 84.

13 **Robert Clergerie,** quoted in *Friedman,* pp.84-85.

14 Letter from Robert Clergerie (June 8, 1998) to Valerie Steele.

15 **Tamasin Doe,** *Patrick Cox: Wit, Irony and Footwear* (New York: Watson Guptil, 1998), pp.7, 18-21.

16 Interview with Franco Fieramosca, June 1998.

CHAPTER THREE : ALMOST BAREFOOT

1 **Christian Louboutin,** quoted in W (January 1996).

2 **William Rossi,** *The Sex Life of the Foot and Shoe* (Hertfordshire: Wordsworth, 1989), pp.84, 232.

3 "Vogue Protests: Open Toes and Open Heels are not for City Streets," *Vogue* [American edition] (July 1, 1939), pp.58-59.

4 **Anne Hollander,** quoted in William Grimes, "The Chanel Platform," *The New York Times* (May 17, 1992), p.8.

5 **Geoff Nicholson,** *Footsucker* (London: Victor Gollancz, 1995), p.23.

6 **Shelley Winters,** *Shelley, Sometimes Known as Shirley* (New York: Morrow, 1980, p.117).

7 **Genevieve Antoine Dariaux,** *Elegance* (Garden City: Doubleday, 1964), p.223.

8 **Sonia Rachline,** "Que penser des compensees?" Paris *Vogue* (June/July 1998), pp.83-84.

9 **Ann Magnuson,** "Footnotes from History," *Vogue* (October 1989), p.128.

10 Interview with Manolo Blahnik.

11 **Peter York,** *Modern Times* (London: Heineman, 1984), p.124

12 **Colin McDowell,** *Shoes: Fashion and Fantasy* (London: Thames and Hudson, 1989), p.58.

13 Interview with Christian Louboutin.

14 Quoted in **Joanna Richardson,** *The Courtesans: The Demi-Monde in 19th Century France* (Cleveland and New York: World Publishing, 1967), p.56.

15 **Elizabeth Wilson,** *Adorned in Dreams: Fashion and Modernity* (Berkeley and Los Angeles: University of California Press, 1985), p.218.

16 **Patrick Cox** quoted in *In Style.*

17 "Tarsorial Splendor," *Time* (July 29, 1991), p.61.

18 **Rossi,** p.229.

19 Quoted in **Colin McDowell,** *Shoes,* p.64.

20 **V.S. Ramachandran, M.D., Ph.D.,** and **Sandra Blakeslee,** *Phantoms in the Brain: Probing the Mysteries of the Human Mind* (New York: William Morrow and Company, 1998), p.26, 35-36.

21 "Shining Color — at your Feet," *Vogue* (October 1978), p.341.

CHAPTER FOUR: BOOTED AMAZONS

1 **Ann Magnuson,** "Hell on Heels," *Allure* (September 1994), pp.128, 130.

2 **Geoff Nicholson,** *Footsucker: A Novel,* p.24.

3 **Mimi Pond,** *Shoes Never Lie* (New York: Berkley Books, 1985), p.55.

4 *The Shorter Oxford English Dictionary, Third edition,* 1968, p.203.

5 Quoted in Rossi, p.114.

6 Vanbrugh, quoted in *The Shorter Oxford English Dictionary,* p.203.

7 *The Random House Dictionary of the English Language* (New York: Random House, 1987), p.241.

8 **Octave Uzanne,** *The Frenchwoman of the Century* (New York: Routlege, 1887), p.202.

9 *High Heels 2* (1965), p.27.

10 "Letters from Our Readers," *Bizarre Life* (n.d.[circa 1966]), Vertical File, The Kinsey Institute.

11 **Roger Madison,** "Dig Black Stockings and Boots?" *Sexology 41*(1975), p.25.

12 **Genevive Antoine Dariaux,** *Elegance* (Garden City, New York: Doubleday & Comany, 1964), p.21.

13 **Charlotte Du Cann,** *Vogue Modern Style* (London: Century, 1988), p.66.

14 **Mary Trasko,** *Heavenly Soles* (New York: Abbeville, 1989), p.94.

15 **Nathan Joseph,** *Uniforms and Nonuniforms: Communication Through Clothing* (Westport, Connecticut: Greenwood Press, 1986), pp.122-125.

16 **Ted Polhemus and Lynn Proctor,** *Pop Styles* (London: Vermillion, 1984), p.15.

17 **Charlotte Du Cann,** *Vogue Modern Style* (London: Century, 1988), p.186.

18 **Catherine Milinaire and Carol Troy,** *Cheap Chic* (New York: Harmony, 1975, 1978), p.40.

CHAPTER FIVE: SNEAKER CHIC

1 **Jennifer Jackson,** "Sneaker Chic," *Harper's Bazaar* (April, 1998), p.218.

2 Ibid.

3 Interview with Richard Wharton, June 22, 1998

4 **Robert Sullivan,** "The Soul of a New Shoe," *Vogue* (May 1998), p.115

5 **Linda O'Keeffe,** Shoes, p.246.

6 "Keeping fit; walking to work in … sneakers!" *Vogue* (March 1983), p.326.

7 Nike Air Trainer advertisement in *Cosmopolitan* (January 1989), p.56.

8 **Jennifer Steinhauer,** "The Shoe as Social Signifier," *The New York Times* (May 4, 1996)

9 **Guy Trebay,** "Sneaker Attack," *The New York Times Magazine*

10 Jackson, "Sneaker Chic," p.218.

11 **Robert Sullivan,** "The Soul of a New Shoe," *Vogue* (May 1998), pp.115-120.

12 Jackson, "Sneaker Chic," p.222.

13 **Luella Bartley,** "Death of the Trainer," British *Vogue* (August 1998)

14 **Stephen Talty,** "Leather Uppers," *Time Out New York* (July 16-23), 1998), p.8-9.

Postscript

Shoes are appealing for myriad reasons that go beyond the basic function of the protection of feet. One can tell much about a woman from the shoes she wears. Shoes as symbols and signifiers is the subject of this book, and a topic which has long fascinated its author, the museum's Chief Curator, Dr. Valerie Steele. Happy for any reason to exhibit shoes, I was easily convinced to schedule a show to complement the book.

Shoes: A Lexicon of Style has also given the museum the opportunity to update the footwear collection and to share it with a broader audience. The many new pairs of shoes are a wonderful source of inspiration for designers and for FIT students of footwear design in the Accessories Department. We are most grateful to the many talented designers and companies who have generously donated all manner of shoes: stilettos and sneakers, beautiful and whimsical, sexy and sensible.

Dorothy Twining Globus

Director, The Museum at the Fashion Institute of Technology

Picture Credits

ABSOLUT VODKA ph Helmut Newton, courtesy of TBWA GGT Simons Palmer 151. ACUPUNCTURE ph Lee Smith 166. THE ADVERTISING ARCHIVES 146. ANNA MOLINARI ph Juergen Teller 46. BARBIE Barbie® dolls ©1997 Mattel, Inc. shown with permission 174. BRUNO MAGLI ph Mario Testino 85, 128, 150. BUFFALO courtesy of Buffalo Boots Ltd. 179. CANDIE'S courtesy of Candie's Inc. 71br. CESARE PACIOTTI ph Luis Sanchis 30-31, 61; 153tr. CHANEL ph Stéphane Cicéron 129, 144, 173, 176. CHARLES DAVID ph Dah Len 109t. CHARLES JOURDAN ph Seb Janiak, agency New Deal 52, 84. CHRISTIAN LOUBOUTIN 40b, 101, 120-121. CLIFFORD PERSHES shoe Todd Oldham 4. CONVERSE ALL STAR 170-171, 175b. CORNELIE TOLLENS/UNIT C.M.A. shoes Prada, styling Marije Goekoop/UNIT C.M.A. 116. DUCCIO DEL DUCA ph Fabio Coppi 87. EMMA HOPE 104. FASHION INSTITUE OF TECHNOLOGY ph Irving Solero: shoes Alexander McQueen for Givency, Museum purchase 155; shoes Andrea Pfister Couture, lent by Andrea Pfister 67b; shoes Ann Demeulemeester, gift of Ann Demeulemeester 138; shoes Bernard Figueroa, lent by Figueroa 142tr; shoes Bottega Veneta, gift of Bottega Veneta 75br; shoes Charles Jourdan, gift of Elaine Cohen 78tr, gift of Mrs James Levy 24t; shoes Christian Louboutin, gift of Christian Louboutin 153br; shoes Dolce&Gabbana, gift of Dolce&Gabbana 40t; fetish shoes, Museum purchase 25, 60; shoes Fiorentina, gift of Mrs. Susan Merians 75tr; shoes Fiorucci, gift of Gregory & Barbara Reynolds 143; shoes Franco Fieramosca, gift of Fieramosca & Co. 33tr, 78bl; shoes Goffredo Fantini, gift of Goffredo Fantini and Main Line Group 132, 141tr; shoes Halston, gift of Halston Borghese 103; shoes Helstern, gift of Elaine Abrams 94b; shoes Junior Gaultier, Museum purchase 177t; shoes Junya Watanabe for Comme des Garçons, gift of Comme des Garçons 78tl; shoes Manolo Blahnik, gift of Manolo Blahnik 19, 34-35, 64t; shoes Martin Margiela, donation from The Archive of La Maison Martin Margiela, Paris 139; shoes Martine Sitbon for Stéphane Kélian, gift of Martine Sitbon 133tl, 148r; shoes Prada, lent by Laird Borrelli 118b; shoes Richard Tyler, gift of Tyler-Trafficante 93t; shoes Rodolphe Menudier, lent by Rodolphe Menudier 37b, 154; shoes Roger Vivier for Christian Dior, gift of Arthur Schwartz 43; shoes Sigerson Morrison, lent by Sigerson Morrison 74l, 75mr, 111b; shoes Todd Oldham, gift of Main Line Group 123; ill courtesy of Valerie Steele 63tr; shoes Versus, Gianni Versace, lent by KCD 134-135. FRANK RISPOLI 115. FREE LANCE ph Thierry 51; art director Kevin Chow; ph Robert Allen 53l, 55, 118t, 124-125; ph Chris Edwick, 14-15, 16, 79, 136t, 149. FRITZ KOK photography/artwork at UNIT New York, shoe Talon Telescope by Thierry Mugler, Model Anne Pederson at Models One London 2. GEORGE LOGAN model Connie Chiu 44-45. GOFFREDO FANTINI ph Filippo Marconi,

courtesy Goffredo Fantini Italy and Main Line Group Corp. New York 147. GUCCI 50, 76, 100, 148l; ph Luis Sanchis cover; ph Mario Testino 26, 42, 127. HELMUT NEWTON shoes Chanel 17; 20. HERMÈS 177b. JIMMY CHOO ill Sandra Choi 36tl, 113br; ph Graeme Montgomery 27, 49l, 110t, 137. JOAN & DAVID 113t. JOHN LOBB ph Fabrice Bouquet 73. J. P. TOD'S 75t. KAREEM ILIYA 91, 187. LISELOTTE WATKINS/UNIT NYC 126, 157. MANOLO BLAHNIK 28, 41, 68-69 (for Andre Leon Talley), 109br, 184. MARY EVANS PICTURE LIBRARY 64b. MAURICE SCHELTENS/UNIT C.M.A.: shoes Michel Perry, styling Jos van Heel/UNIT C.M.A., make up Lydia le Loux/House of Orange, model Niki/Paparazzi 82-83; shoes Jeremy Scott, styling Lionel Bouard, make up Ellis Faas/UNIT, legs Miranda 39; shoes Versace, styling Ruud van der Peijl, House of Orange 65. MAX CARDELLI shoe Todd Oldham 119. MAX JOURDAN 53tr, 80, 81, 102, 106, 114, 117, 122, 152, 164, 178b, 181. MIU MIU 47. NANCY GEIST 6-7, 12. NEIMAN MARCUS shoe Donna Karan, ph courtesy of Neiman Marcus 112. NEW BALANCE ph 'Camera Five Four' Michael Minnifi 169t. NIKE 160, 180. NO NAME 178t, 183t; art director Kevin Chow, ph Jumiah Gayle 162. PATRICK COX 49, 94t, 133r, 141tl, 183br; ph Dah Len 48; ph Regan Cameron 72, 145. POLLINI ph Alessandro Dalla Fontana 66t, 129b, 136b. RED OR DEAD ph Martin Evening & Sara Hodges @ Davis Cairns 108; 153l, 168. ROBERT CLERGERIE ph Dominique Issermann 107; ph Roland Mouret 99. ROCCO BAROCCO ph Michel Comte, ad agency Baxter Fisher & Sparice, model Vanessa Lorenzo 92. ROMEO GIGLI ph Richard Avedon 98. ROYAL 163, 175t. RUSSELL & BROMLEY 71t. SALVATORE FERRAGAMO ph David Lees 9; 18, 24b, 66b, 95. SÉDUCTA ph Pierre Choinière, design New Deal 32, 97r, 144t. SERGIO ROSSI ph Miles Aldridge, art director Marc Ascoli 21, 33l, 56, 62, 86, 104t, 130-131; ph Fabrizio Fenucci 93b; ph Wahb Habkout 67t, 96, 105, 140t. SPRING COURT 169r; art director Kevin Chow, ph Eitan 161; ill Fred Crayon 173. STÉPHANE KÉLIAN 140bl; ph Roberto Badin 63b, 141ml; ph Patrick Trautwein 54, 90. STRIDE ph Caroline Hughes 158-159, 167, 182. SURESH KARADIA shoes Bella Freud 10, 58-59, 63tl, 70, 156. TANYA LING courtesy of Bipasha Ghosh/William Ling Fine Art 74r, 165. THEA CADABRA-ROOKE ph Ian Murphy 11. TREVOR RAY HEART cover of *Footballer's Wives*, published 1998 by Yellow Jersey 172. VALENTINO courtesy of the House of Valentino, ph Helmut Newton 29; ill Tony Viramontes 36b. VANESSA BEECROFT VB 26, performance 1997, Galerie Analix, Geneva, © Vanessa Beecroft 1998, ph Armin Linke 22-23; VB 29, Jesse, performance 1997, Le Nouveau Musée, Lyon, © Vanessa Beecroft 1998, ph Vanessa Beecroft 38. VIVIENNE WESTWOOD ph Niall McInerney 13, 37t. WALTER STEIGER 88-89. WHO'S ph Alessandro Dalla Fontana 57.

acknowledgments

Both author and publishers would like to thank the following for their generous assistance:

ABSOLUT VODKA\TWBA *(Bianca Phair)*, ACCESSORIES COUNCIL *(Sheila Block)*, ACUPUNCTURE *(Jo Reynolds\ Naihala Lashare)*, ADIDAS AMERICA *(John Fread & Avery Strasser)*, ANDREA PFISTER *(Sidney Sloane)*, BERNARD FIGUEROA, BOTTEGA VENETA *(Stacey Lockheart, Terri Marion, & K. Cooper Ray)*, BRUNO MAGLI *(Alberto Lanzoni)*, CANDIE'S INC. *(Monica Healey)*, CARVELA, CESARE PACIOTTI *(Antonio Giussani)*, CHANEL *(Joanna Strachan)*, CHARLES DAVID *(Rachel Taylor & Francesca Broglia)*, CHARLOTTE WILTON-STEER, CHRISTIAN LACROIX *(Nathalie Jalowezak)*, CHRISTIAN LOUBOUTIN *(Juliet Saffro, Andreas Siegfried & Malou Zogo)*, COMME DES GARÇONS *(John Storey)*, CONVERSE ALL STAR *(Wendy Rowlands)*, CORNELIE TOLLENS, DEITCH PROJECTS *(Elizabeth Iaropino & Courtney Cooney)*, DOLCE & GABBANA *(Donna Faircloth)*, DONNA KARAN *(Christy Hood & Marina Luri)*, DUCCIO DEL DUCCA *(Fern Demicer)*, ELISA ANNISS, EMMA HOPE *(Pauline Higgins/PHPR)*, ENRICO COVERI *(Mariadele Costa)*, ETRO *(Kean Etro)*, FILA *(Kim Axtell)*, FRANCO FIERAMOSCA *(Jaime Marr)*, FRITZ KOK\UNIT NEW YORK, FRATELLI ROSSETTI *(Diego Rossetti & Randy Rutledge)*, FREE LANCE *(Kevin Chow, Mandi Lennard & Tiphaine Macrez)*, GINA *(Sara Bruce)*, GIVENCHY\ALEXANDER MCQUEEN *(Jill Marshall)*, GHOST *(Emma Greenhalgh)*, GOFFREDO FANTINI\MAIN LINE GROUP, GUCCI *(Sarah Barber, Tor Gooder & Charlotte Sprintis)*, HELMUT NEWTON, ITALIAN TRADE COMMISSION\MODA MADE IN ITALY *(Sergio La Verghetta)*, J.P.TOD'S *(Jil Simon & Poala Vanin)*, JIL SANDER *(Valerie De Muzio & Marion Greenberg)*, JIMMY CHOO *(Tamara Yeardye)*, JOHN FLUEVOG *(Laurene Meehan)*, JOHN LOBB *(Marie/Halpern)*, JULIET SAFFRO, JUNYA WATANABE, KAREEM ILYA, KAREN HATCH, KCD *(Marybeth Schmitt, Alex Cohan, Marichris Paulin)*, KATE REARDON, KURT GEIGER *(Nina Savarez)*, GEORGE LOGAN, LUCIENE SALOMONE, LUCY FITTER, MAIN LINE GROUP *(Tasso Chriss & Brian Gureck)*, MANOLO BLAHNIK *(George Malkemus & Hilary Heard)*, MARIBETH SCHMITT, MARTINE SITBON *(Cécile Alizon/Michele Montagne)*, MARY TRASKO, MAURICE SCHELTENS\Unit New York, MAX JOURDAN, MIUCCIA PRADA, NANCY GEIST *(CHRISTOPHER MUSCI)*, NEIMAN MARCUS, NEW BALANCE *(Kathy Thurston)*, OFFICE *(Richard Wharton, Niamh Lyon)*, PATRICK COX, POLLINI *(Leila Palermo)*, PRADA *(Kim Vernon & Michelle Kessler)*, PUMA INTERNATIONAL *(Amber Fredman)*, RED OR DEAD *(Chris Wood)*, REI KAWAKUBO, RICHARD TYLER *(Lee Sippola & Rossimoda)*, ROBERT CLERGERIE *(Jean-Charles Barthomeuf & Carole Hery)*, ROBERTO CAVALLI *(Emanuela Barbieri)*, ROCCO BAROCCO *(Simona Lucernoni)*, RODOLPHE MENUDIER *(Marie Borniche/Laurent Suchel)*, ROMEO GIGLI *(Orsetta Leonardi di Casalino)*, SALVATORE FERRAGAMO *(Natalia /Aurelia)*, SERGIO ROSSI *(Gianvito Rossi & Ursula Giustino)*, SIGERSON MORRISON, STÉPHANE KÉLIAN *(Isabelle Abrard & Claire Neal)*, STRIDE *(Kate Rooks)*, TANYA LING, SUPERGA *(Sean Krebs/Crespi & Mariani)*, SURESH KARADIA, TASSO CHRISS, TDR *(Davide Manfredi)*, THE KEDS CORPORATION *(Tharon Cottrell)*, TODD OLDHAM, UNIT New York *(Jasper Bode & Tim Groen)*, VALENTINO *(Carlos Souza & Francesca Barsi)* VANESSA BEECROFT/DEITCH PROJECTS, VIVIENNE WESTWOOD *(Dai Bluett & Christine Harrison)*, WARREN EDWARDS *(Judith Agism)*, WHO'S.

The author also thanks her colleagues at The Museum at FIT, Dorothy Twining Globus, Irving Solero, Conservation: Shirley Eng, Glenn Petersen, Carmen Saavedra; Costume: Ellen Shanley, Joanee Boaz, Fred Dennis, Bret Fowler, Dorothy Rudzki, Lynn Sallaberry; Registrar: Deborah Nordon, Miranda Hambro, Sal Morreale, Ena Szkoda, and most of all Laird Borrelli, to whom this book is dedicated.